INSTANT CONNECTIONS

Essays and Interviews on Photography

JASON LANDRY

DOOLITTLE PRESS
Boston, Massachusetts

FIRST EDITION, 2013 (Doolittle Press)

Edited by Debbie Hagan
Designed by Visible Logic, Portland, Maine
Cover Image courtesy Gustav Hoiland.

10 9 8 7 6 5 4 3 2 1

Library of Congress Control Number: 2013951300
ISBN: 978-0-9900135-0-1 (paperback)
ISBN: 978-0-9900135-1-8 (eBook)

for Anne & Booches:

You've lived through all of these stories.

CONTENTS

PREFACE:
A CLICK OF THE SHUTTER

I've been called:
Jason,
J,
J-Dawg,
Uncle J,
Landry,
Lanrod,
Ling Lang,
Linger,
PH (short for Pecker Head)
Rod,
Rodney,
(and the most recent one)
Champion.

Why Champion you ask? From what I gather, the person who anointed me with this title saw an excitement and enthusiasm in me that was beyond normal. From his point of view, he says he calls everyone champion, but then again, maybe I just have selective hearing—or some kind of hearing loss. I do have this constant ringing in my ears due to some inner ear thingy that also makes my

equilibrium a little imbalanced. I should go buy some Dramamine. Siri: Set reminder. Go to CVS and buy some Dramamine.

A mutual friend of ours once suggested to me that he felt "he who shall be named later" enjoyed taking artists under his wing as a sort of pet project. When I thought about it then, and think about a few other people that he has worked with, and photography related projects that he has been part of, I realized I was his pet project. He saw that I wanted to do more in general for my fellow photographers and photography. I was a champion for the medium of photography—a maven, relaying information like a photo evangelist—and I guess he liked that. I have dedicated a whole chapter to this "photo weenie" later on in this book. We'll introduce him soon enough, but more about me first!

I want to inspire others. I want more people to understand the medium of photography as a collectable and serious art form, rather than something just stored in their camera-enabled cell phones or on their computers. Sure, there are other dealers and galleries out there that are doing their part, but we can always use more—more people who care! Some of the chapters that you are about to read are serious and pointedly educational, and some are humorous and entertaining—you folks in the photography industry should get a good chuckle. What you should know is, many of the stories came about because of connections—Instant Connections.

But let me warn you: This is not dense critical reading on the topic of photography like you'd get from reading Susan Sontag's *On Photography* or Barthes *Camera Lucida*. Nor are these stories coming to you from one of the A-list dealers who is tucked away in their New York digs with a staff of ten and would probably not consider writing a book like this. I respect those aforementioned authors and equally those art dealers, and I have nothing bad to say about them. Rather, I'm coming at it from a different view: think of me as the new kid on the block or a young contemporary. The angle that you're going to get from me is very approachable—experiences

from a person who was once a photographer and who's now an art collector and gallery owner.

My credentials are simply stated: I have spent the last twenty years working in the field of photography. As a photographer, I exhibited in galleries and museums. I consider myself a good photographer, but I know many great photographers. I earned a bachelor of fine arts degree in photography and a master of fine arts in visual arts. I've worked for a non-profit photography organization, participated on various boards of directors, helped to plan lectures, auctions, book signings, seminars, workshops, studio visits, and portfolio review events. I have written essays, conducted interviews, been on panels, and even helped get books published. I have befriended many important photographers and soaked up as much of their knowledge that I could. What about master of ceremonies or commencement address speaker? I've done that too! Crazy as it all seems, the last twenty years of my life have flown by and I wouldn't change it for the world.

All of this has been training for my position as owner and director of Panopticon Gallery in Boston, Massachusetts. Notice that I didn't call this my job, because it isn't. It's not a job when you love what you do and you're not forced to do it. I call it my passion. I get up each day and stroll into the gallery by 8:30 a.m., a good hour and a half before most art galleries open. Why do I go to the gallery that early? Because, what I do does not fall into a normal time schedule, and most people who own their own businesses will probably attest to this, plus I have an elderly dog that likes to get up at 5:30 in the morning. Friend and photographer Cary Wolinsky once said to me that my business cards should say, Jason Landry (on one side) and "I Get Things Done!" (on the flip side).

All I can say is that I try my hardest every day to help photographers and mentor students and emerging artists, regardless of whether I represent them or not, and provide an honest service to the public. I'm

always on the clock: I'm always trying to make connections, whether for me, or for someone else.

I care deeply about the artists that I represent, from the ones with the egos the size of Texas, down to the one artist who often writes at the end of her emails, "Thank you for wanting me." That sends me to the moon every single time.

I hope that this book attracts a few different demographics of people, the first of course are the photographers. For those of you who are that hungry to be fine art photographers, you should know that as a gallery owner:

I'm looking for the ones who are in it to win it.

I want to surround myself with like-minded people.

I expect to see you at the portfolio review events.

I expect to see your marketing materials in my mailbox.

I expect you to show up at the opening receptions at the gallery and introduce yourself. Don't expect to stay out on the periphery and think you'll be noticed, or exhibited, or published for that matter. When I see something that I like or want, I spring into action—so be ready!

I'm not spitting this arrogant diatribe for my own sake. It's for you, the determined artist who thinks you're special, has mad skills, but doesn't have an ounce of business know how. Why do you think that is? It's because *some* of the institutions that pump out artists don't teach enough business classes to prepare artists for the real world. Should they? YES! So many great, young artists leave school with no real clue what to do next. You can learn to take a photograph, develop the film or edit the image, print, and critique work, but if you don't

know how to market it or sell your services as a photographer, your education might have been a waste of time. Talent alone will not catapult you into mega-stardom. You have to have drive and a true and real social network of people who can help you. How will you connect yourself to the right people in the world—the ones that will help you in your career? Facebook and Twitter is one thing, but a core group of peers and mentors that you can talk to face-to-face who can push and motivate you is another thing. There are valuable things to learn from social cues and body language that you don't get from interacting on a website.

Did any of what I just wrote sink in yet? Photography + Business + Peers + Mentors + Networking—it all plays a part in how and why I wanted to open and operate a fine art photography gallery and write this book. I want to be able to help artists and photographers gain the exposure that they deserve. It's a great feeling to live vicariously through their successes. I guess you can think of me as a glorified P.R. agent[1].

Prior to owning the gallery, and before going back to school, I worked for a Fortune 500 company. The skills I learned there gave me the ability and motivation needed to succeed in this business.

The second demographic that I hope to reach, and who play a crucial role in keeping the medium of photography important are the photography collectors, patrons, and those who aspire to be collectors or patrons. You excite me as much as an emerging photographer does. Why? Because you help to strengthen the medium. I consider you the behind-the-scenes ambassadors! Face it, regardless of whether you own two prints or two hundred, once you begin acquiring prints, you are collecting, whether you think of yourself as a collector or not, you are—embrace it—we love you.

And lastly, I hope to reach those people who know nothing about fine art photography, the ones who take the occasional photograph

1 Public Relations

with their trusty iPhone or digital camera and post them to Instagram. You're important too.

"Write the book that you'd want to read." Have you heard that before? What an incredible statement. Whoever actually penned this quote, I thank you. This book came about after my wife suggested that I should jot down some of the things that I have experienced just in the past few years. We canceled our cable TV[2] and I began to concentrate on reading and writing more and the next thing you know—Blam-O!, a bunch of essays were born! And books—I love books now. I have read more books between 2011-2013 than all of the books that I read from grade school through graduate school combined. Books and reading suggestions come up quite a bit in this book—they are just suggestions. Be open-minded.

The title of this book came from a Polaroid-themed exhibition that I hosted at Panopticon Gallery in 2011. Through *Instant Connections*, we were able to showcase the "art stars" in the world of photography alongside the up-and-coming newbies. The title is fitting because everything that I have accomplished and do in the name of photography is through the networks and connections that I have worked to build in this industry. It's been a ripple effect— that is, being in the right place at the right time. If my current group of mentors didn't exist, I might not be a gallery owner right now, and I may never have hosted that exhibition, and this book, if I still wrote a book, would have ended up with a really lame title.

So here it is, my contribution to the world, and to photography: the good, the bad, and the brutally honest. I tackle some of the

2 To be honest with you, in my humble opinion, reality television dumbs down the viewing public and I felt it was dumbing me down. Who gives a shit about Snookie, The Kardashians or the Housewives of where-ever-the-fuck! For most people who watch these shows, *this* is a reality that many will never even experience. At least what I'm about to share with you is easy to read, somewhat educational and NOT Photoshopped! And by the way, the power of the written word is pretty great!

basics. You'll meet the cast of characters in my life who have acted as umbilical chords to the world of photography. You'll be in the front row during lectures that I have attended and interviews that I have conducted. You'll be along for the ride as they say—whisked away to many locations for photography-related events, and you'll get my personal spin on life as a collector and gallery owner. There are some autobiographical accounts in here as well and essays and stories that might not make sense at first until you reach the climax, or as the French say *dénouement*, meaning, the tying up of loose ends.

I write the way I speak and I also have a potty mouth, so I hope this doesn't offend too many people. I know there will be some people who will get their panties all up in a bunch about some of the reading—go ahead, roll your eyes—that's fine. I don't mind ruffling a few feathers now and again and there will be no apologies. As one friend tells me quite often, "You know my mantra...People Suck!" Or better yet, in the words of then eighty-year old photographer Harold Feinstein as he concluded his acceptance speech after receiving the Living Legend Award from the Griffin Museum of Photography in 2011—"Fuck you very much."

Oh, let's not forget to thank my artists, the ones that I rely on day in and day out, the ones who keep me in check, the ones who have the biggest egos on the planet. I'll try really hard not to let this book go to my head; however, it could happen.

This is not a grad school thesis (although there are a few snippets that appeared in mine), but for this version, I'm allowed to do and say as I please as long as my editor doesn't cut it out. This book is not laid out in a linear format, so feel free to skip around. I promise it will be an educational journey for you, as it was for me.

April 2012
Boston, MA

p.s...Some names and places are factual and have not been changed to protect the innocent. On the other hand, some names and places *have* been changed because some people might want to sue me. Please don't.

p.s.s...I love music and originally I had quoted more than a dozen songs throughout this book. After finding out how much it would have cost to get the rights to use just a snippet of each lyric, I either cut them out completely or disguised them.

p.s.s.s...I use Pantene Pro-V conditioner to make my hair look so damn good.

And one more thing...

"If you go home with somebody, and they don't have books, don't fuck 'em!"
 —JOHN WATERS

EXPOSE YOURSELF
AT A PORTFOLIO REVIEW EVENT

Tuesday—up at 4:30 a.m. Cab at six. Twenty minutes later I'm at the airport checking my bag.

At security, I dump all of my shit into the plastic bins. The TSA brass don't fuck around, even this early in the morning. They are loud and in your face like drill sergeants. Out comes the contents from my pockets along with my shoes, belt, hat, jacket, watch, change, gum, ChapStick, phone, and, oh yeah, a separate bin for my laptop, which coincidentally I once left in a bin in the Tampa International Airport, but didn't realize it until I was back in Boston. Whoops— deer maneuver[3]—that'll never happen again. After rounding up my belongings and redressing, I hit up the nearest Dunks, a.k.a. Dunkin' Donuts, for two chocolate frosted. Although these sugary, puffy treats are rather bad for me, in some sick and satisfying way, they calm my stomach. Waking up early always fucks me up!

My flight from Boston to Dallas was slightly delayed. They need to replace a seat cushion. By 7:50 a.m. we are airborne.

This was just one of many trips that I have taken to attend photography portfolio reviews. On this particular adventure, I am heading to Houston, but still had one connection to go before I reached my

3 You'll learn more about these fun words later on in the book!

final destination. Finding a non-stop flight anywhere these days is such a pain in the ass, but since someone else is paying, who gives a shit, right? The weather was horrible on the approach into Dallas. It felt like a fucking mosh pit up in the ominous gray clouds. All I could do to stabilize myself was shove my feet under the chair in front of me and stare at the "Fasten Seatbelt While Seated" sign on the seat facing me. There were no TVs to watch on this vintage steel silo, so I had to rely on my faithful and eclectic stream of music that thumped through my Dr. Dre BEATS.

All walks of life sit in the airport waiting for connecting flights. You could easily write a whole book just by what you can observe in an airport. As I snacked on my Auntie Annie's soft pretzel, I began to take notes of my observations—instant entertainment during this layover.

The men's bathroom smelled like piss and Old Spice. The businessmen are just traveling through, but stay long enough that their scent lingers and their pubes pile up in the little scented disks in the urinal. They float around and congeal at the bottom, and if you stare long enough you'd think there was a Vik Muniz commissioned piece called, *Medusa of the Pubes in Porcelain*[4] on display.

Oh look, there's an old Chinese woman dozing off on a chair. Her loud snores wake her up abruptly—then she begins to make ungodly hocking and snorting sounds. I'm just waiting for something to fly out of her mouth. Hello young mother standing by the magazine stand holding her kid. It's like clockwork. If a mother is wearing a low neckline shirt, the kid always grabs and pulls exposing a breast. Keep pulling kid. You'll eventually get that teat.

And then you got the packs of college girls in their Juicy sweatpants. Yes ladies, some of your asses *are* plump and juicy—keep it

4 There is no such work of art by Vik Muniz. I made it up. But you can envision it, can't you? p.s. Vik...you're a rock star!

classy. If I had a camera with me, I would have attempted to photograph each one of these moments. Hopefully my descriptions lead you through a mental photograph of my encounters. Time to wipe the pretzel salt from my pants—I got another flight to catch!

The next flight was thankfully short. No matter what, I knew I'd be okay because one of the stewardesses had an "I Love Jesus" lanyard holding her American Airlines I.D., a safe bet that this bird was being guided by a higher power.

Houston seems to be "the place" where many emerging fine art photographers flock like snowbirds to Florida. The event: FotoFest. The location: the DoubleTree Hilton in downtown Houston. It's the largest and most prestigious portfolio review event for photographers on the planet. It's dubbed "The Meeting Place" for a reason. Emerging artists are able to meet with so many people who have the ability to advance their careers. Over 500 photographers attended FotoFest in 2012, and met with over 160 professionals in the field of photography—museum curators, publishers, collectors and even gallery blokes like me.

Fred Baldwin and Wendy Watriss, who started FotoFest, have essentially designed the blueprint for photography portfolio reviews. Similar events are Photolucida in Portland, Oregon; Lens Culture FotoFest Paris; Atlanta Celebrates Photography in Atlanta; Photo-NOLA in New Orleans; and the New England Portfolio Reviews in Boston, which I once helped organize.

When I go to portfolio reviews, I keep two eyes wide open. One eye is focused on giving critical feedback to the photographers and finding artists who would be a good fit for my gallery, and the other eye is looking out for photographs for my collection. I actually wish I had a third eye on the back of my head to be on the lookout for stalkers—they're everywhere.

To be a successful photographer who exhibits in a gallery, has work purchased by a museum and becomes published in an art magazine

or book, you need to take several important initial steps. First and foremost, you need good contacts. Showing up at a gallery unannounced with a portfolio in tow is a no-no. Making an appointment with a museum curator or director is practically impossible without an entré by a gallery or a large donor. Magazines generally do not take unsolicited proposals, and book publishers get so many proposals that star power prevails, unless you are able to put some cash up front. Thus, portfolio reviews are THE BEST way to get in front of the most influential people in the photography industry.

Think of a portfolio review as the proverbial meat-market for emerging artists and artists looking for more exposure. It's a place where artists cut their teeth, and where some find book publishers and people to help advance their careers. If you are serious, hungry, and determined to make it in this industry, I strongly encourage you to sign up. Photographers attending FotoFest pay $850 for each session. This gets them sixteen guaranteed portfolio reviews plus additional ones that must be scheduled on their own time (that's if they are good at stalking reviewers). Individuals who don't have a problem with rapid paced meet-and-greet events (that feel a lot like speed dating) will find these very beneficial. A word of caution: prepare yourself...it's a shark feeding frenzy!

What are reviewers looking for? This is a common question. Each reviewer is different. I have certain tastes, but they could be swayed if I see something that either shocks or surprises me in a good way. Just imagine eating the same North Atlantic oyster all the time, and then be surprised when your server suggests you try a Hama Hama oyster from Washington state. As you slurp the West Coast bivalve, you swear that you can taste...cucumbers. That's what I'm talking about—SURPRISE!

We just hit the mid-day point of the review session, alas—lunch! Two things happen at mealtime: I fill my tank so that I can have enough energy to get through the rest of the day and secondly, I can

compare notes with some of my fellow reviewers. You don't think we just exchange business cards, do you? Oh no, we're talking about the photographers just as much as they are talking about us. I typically know a lot about the artists and their portfolios before they even sit across from me. Before I arrive at the event, I have already gone through their websites and took mental notes like Sherlock Holmes investigating a case. If I see projects or series on their website that I like, I pray that they bring them to the event. If not, I'll ask them about them. The artist will seem surprised, but they shouldn't be. Again, it's homework for me too. Watson: The game is afoot!

Portfolio events are a crapshoot. I've found my fair share of great artists, but I've also encountered enough banal portfolios to choke a chicken. I've been in these artists' shoes. I was a photographer, and I know how hard it is to prepare for something like this. So reviews tend to go one of two ways.

Right out of the gate, I have been surprised by some artists. I become really talkative and excited. I begin throwing out suggestions and ideas left and right. Those are the artists who have hooked me— congratulations! I probably already have an exhibition in mind where they'll fit right in.

On the flip side, when portfolios are not captivating me, my critique and questions will slow down and might seem rather basic. I begin asking a lot of probing questions to get down to the root of who the photographer is and what he or she is trying to present. As a reviewer, I try to be as polite as possible, but for those artists who I encounter who are not prepared, this might be a cue to rethink what's in their portfolios.

On day number two, I look directly across my table at an empty chair. It's supposed to be occupied every twenty minutes. I sit, take notes about the portfolios that I recently saw and then take a sip from my glass of ice water. I look around—all the reviewers are heavily engaged in their next meeting. My 3:20 p.m. appointment

has gone missing? One of the timers comes to my table to check my sheet. It's their job to track down missing artists. It is a real courtesy to show up on time...every minute counts in these reviews since they are only twenty minutes each. I hate when people show up late and then have the audacity to ask me if I will put them in an exhibition in my gallery. Photographers: It's unprofessional to show up late for meetings. Our time is just as valuable as yours. When you don't show up on time, it screams unreliable to me, and it also gives me sense of things to come.

The key term at these events is "portfolio," and it becomes more than just a term, but a tool to learn about who you are as an artist. I really like to look at a lot of work. So artists should have enough prints in their portfolios to show—and not hide work in their boxes that they've edited out beforehand. Most reviewers like to see everything! I'm a talker and love to hear myself talk. If I can't converse with the person that I'm meeting with for twenty minutes about photography, there's a problem.

Quality is important when looking through a portfolio. Prints don't have to be individually matted, but if they were, DING—brownie points! Gelatin silver prints are very nice, but I want to see stellar gelatin silver prints—spotted and pristine. Digital prints (the new C-prints) should blow my socks off—color corrected and sharp. If photographers are scanning their negatives and printing them digitally, I hope that they invest in good scans. When I mean good scans, I mean those created on an Imacon or a drum scanner. By now, photographers should be staying away from flatbed scanners, regardless of whether they think they have the hottest negative carrier on the market. They were fine while you were in school; however, school's over now. Pay someone to help you—this is your livelihood. The worst thing to see is a soft, slightly out-of-focus print due to an inferior scanned negative. I will not hang them in my gallery and collectors will not buy them.

With a show of hands, how many people are as surprised as I am that the contemporary trend to print big still exists? Bigger isn't always better. If you come to see me and unroll some 50" x 60" monstrosity, you'd better have a good reason for printing that big.

Oh, you know so in so? Good...for...you. As a reviewer, I'm bored when photographers throw around names of people they know. I am only interested in the photographers and their work. They must keep the conversation on the work. It's great if they had well-known photographers as professors, but they can't help you now.

One thing is a must: marketing materials. A business card, a postcard, a CD with images, an artist statement, and a C.V.—even a book all are excellent examples. There is no right kind of marketing piece. The more creative the better! I take all of this stuff home with me to study. On average, approximately fifteen to twenty percent of the photographers whom I meet at portfolio reviews will someday have an opportunity to exhibit work in my gallery. Make sure that whatever marketing pieces you leave with me will make me think twice before I throw them away, especially when I'm at the airline counter and they tell me my bag is overweight and they must impose a $50 fee!

On this particular trip, I reviewed approximately seventy portfolios, which included fifty-six scheduled reviews (fourteen per day) over a four-day period, thirteen additional reviews with people who weren't able to get me or convinced me that so-and-so said I should meet them, and one visit to a local artist's studio.

The reviewers are all located in a central ballroom area, rows of tables are set up with crisp white linens, a daily list of our scheduled meetings, and our name cards prominently displayed for all to see. When the timer announces that the reviews will now begin, hungry photographers stampede into the room like a cattle call, looking, running, and searching for their assigned meetings. This reoccurs every twenty minutes—one after another after another.

The event coordinator schedules in a few breaks during the day, lunches and of course dinners, however we never get to any of them on time. This is when you are stalked to review even more portfolios!
There they are!
At the elevator.
Sitting in the lobby.
Some circling like sharks!

I have had people offer me drinks to meet with them at the bar, leave me voice messages, slip notes under my hotel room door, and try to converse with me in the men's room. The best attempt of anyone trying to score a review outside of his or her designated schedule happened a few years back. From what I have been told, a photographer once slipped her portfolio under a stall in the woman's bathroom to try to score a review with a well-known museum curator. I'm all for reviewing as many portfolios as I can during these events, but by the third or fourth day, I can see why some reviewers hide in the bathrooms or the break-out rooms just to get a ten-minute breather. If not the breather, then for the warm chocolate chip cookies! Photographers...hit us up early.

Just when I think my day has ended, I realize the host organization has arranged a bus tour to local galleries, museums, and art spaces. Each rendition of FotoFest, which happens to run every other year, focuses on a theme or country. In 2012, the theme was Russia. The local participating galleries and art spaces featured work by Russian photographers, many of whom attended. In addition to the normal Chardonnay or Merlot being poured, some galleries had vodka on tap. Nostrovia! On the night when the Russian artists had their portfolios on display, they would also proudly show their cameras, whether they had a Rolleiflex or a Yashica next to their prints. I took it as a sign of pride. I love the old twin-lens cameras and enjoyed a lot of their projects. Square format gelatin silver prints were all the rage!

OK.................switch! The "portfolio walk" is when the tables are turned. All of the photographers attending FotoFest have a night when they all have an opportunity to have their portfolios out on display in the ballroom and the doors are opened to the public. As I meandered through the packed room, I was surprised to see a number of photographers at this event that I felt had already gained a bit of notoriety by having books published, gallery representation, and museum exhibitions. There is a gray area here that has been troubling me. Once an artist has gallery or dealer representation, shouldn't the dealers help the artist gain other opportunities? Apparently not, which is why the artists are spending money on portfolio reviews. It's probably cheaper to just find the right dealer or at least have an in-depth conversations with them.

In an email message that I received after the portfolio walk, one photographer told me that I had a very good reputation among the reviewed crowd. That made me feel really good, because I never know if what I say makes sense to the people who meet with me, or if they think I'm just full of shit.

Besides the fact that I own a gallery, I'm equally passionate about collecting photography. So some of the trip's highlights for me were the two evenings we had dinner at the homes of local collectors. Just imagine a Greyhound bus pulling up and parking on a residential street so that fifty or so people can get out and prance around your house.

The wide streets and the large houses screamed "oil money," but then again, I have no idea how some of these people earned their wealth. I'm just glad to see how the other half live. One house was decorated with Old World paintings and antiques (reminded me of the Isabella Stewart Gardner Museum), but then you'd enter their backyard and think you'd just been transported to Uncle Joey's Fourth of July barbecue—colored lights strung from the house and through the trees and tables and chairs everywhere. The only difference was this house came with a wait staff, and the coolers of Budweiser were missing.

The following evening we visited the home of some true photography collectors. The hosts were gracious and had excellent tastes in art. Everything from Cartier-Bresson to Bill Brandt, photogravures from Camera Work to some newer contemporaries were on display. They even slipped in a few family portraits here and there. The walls were all covered with photographs—living room, dining room, hallways, and even up the staircases. I felt right at home.

All of my photography-related trips have been true networking opportunities, but then again, almost all of the trips that I have been on in the past twenty years have been photography trips (to the chagrin my wife). I have met some great people including museum curators, publishers, collectors, gallery directors, and very talented and promising photographers.

These trips are also educational experiences. I pick up quite a bit about new trends in photography. I am introduced to new techniques and styles, and about new cameras and printers, because when you are engaged in a portfolio review, topics do tend to shift rapidly from what the project is about, to themes, to styles and so forth. I also got a sense of what's being taught at schools all around the world and that most students of the medium are being drawn, more and more, to digital photography. Although the digital age has changed how most people create photographs, there are still renegades clinging on to historical and alternative processes, with a glimmer of hope that their favorite paper or film company doesn't go out of business any time soon.

I did gain some insight from this trip too, insight that has solidified my thinking in that photography is growing in leaps and bounds over other art forms. It is one of the most used art forms on the planet and one that is becoming increasingly accessible to the masses.

Sunday morning—up at 4 a.m. Time to finish packing before heading to the airport. It was still dark when I hopped into the minivan taxi. I split the ride with another hotel guest—a savings for me since I wasn't

being reimbursed for the trip. I arrived at the airport, breezed through the security line, and waited a short time before boarding.

I walked down the ramp and onto the plane sans coffee, eyes still half shut from my lack of sleep the night before. As I found my seat, I placed my headphones down and noticed that the seat felt cold, as if this bird had been parked all night. I placed my belongings, which consisted of a twenty-pound bag of marketing materials containing CDs, books, and business cards from all of the artists that I met, in the overhead compartment, and then sat down. Nope, the seat wasn't cold...IT WAS WET! It was soaking wet. But it was too late. My ass was already firmly pressed into that nasty carpeted seat and if I got up, my light grey colored jeans would now be a darker hue.

I would have had no problem with this flight being delayed if it meant MY SEAT CUSHION WAS IN NEED OF REPLACING! I guess not all flight crews are as observant. I fired off a Tweet to my friendly @AmericanAir social media maven who apologized and told me to alert an attendant. Too late for that. I'd already left Houston and landed in Dallas, and I was about to board my four-hour connecting flight home with damp drawers.

Thankfully, I upgraded beforehand to the exit row and stretched out—the seat on my next flight was dry and absorbed moisture like a roll of Bounty. The connecting flights, the wet seats, the long days, the no-shows, the stalkers—I wouldn't change them for the world. These are just a few things that I've had to endure in the name of photography.

IT'S A ROLLER COASTER
WITH VARIOUS EXIT RAMPS!

Art was the only thing that I excelled at in school, and that's because I never really applied myself to anything else. Needless to say, that was and still is, a pretty stupid philosophy I might add. I'm sure there are people out there with similar stories. Maybe you were a little A.D.D. and had trouble studying so sports was more your thing, or maybe you had trouble making friends so you decided to join the theater group, or maybe you were an outsider that didn't quite fit into the mold of an ideal student and you hung with the metal crowd.

Although I was born in Massachusetts, my parents moved us to the Live Free or Die state of New Hampshire when I was about six. I grew up and attended grade school in Greenland, New Hampshire, and then attended high school in Portsmouth. From the age of eight until I was eighteen I was skinny and scrawny making me an easy target to be picked on and bullied during my adolescent years. I'm not suggesting that there was any one reason why I didn't apply myself when I was in school; I just didn't know what I really wanted to do or be. Woody Allen said, "Eighty percent of success is showing up." I made sure that I showed up for my high school art and photography classes. My only hope was that they would lead me somewhere.

My parents never pushed me in one direction or another, which was nice. It wasn't because they were free-spirited hippies or anything;

they just came from working-class families. My father was the foreman for a large steel fabrication company in our quiet little apple orchard ho-hum town of Greenland, New Hampshire, and my mother worked at the local grade school. Neither one of my parents attended college so they both worked hard to make sure that my brothers and I *did* go—two out of three of us went on to earn advanced degrees. Brother number three...well, that's another story.

In hindsight, I probably should have studied, read, and written more in school, but I was preoccupied—too much of my time was spent doing all those *other* things that you do in high school, or what I will refer to as "my alternative curriculum": dating girls; partying; skateboarding; camping; hanging out at the beach; working at a bowling alley, grocery store, department store, local pizza joint or my buddy's landscaping business; and attending metal concerts.

Yes, I was a metalhead through and through, and if it were a subject in school, I would have gotten straight A's. I had long, feathered, Sun-In dyed orange hair—a nasty experiment that went terribly wrong. As much as I'd like to tell you that becoming a "ginger" *was* the expected outcome, in all honesty, it wasn't. I wanted blond hair, but that doesn't easily happen when your normal hair color is dark brown. I've been told that I looked like '70s teen heartthrob and

PORTSMOUTH HIGH SCHOOL
Portsmouth, N.H.

1988-1989

Jason Landry
Signature

member of the Partridge Family David Cassidy (you'll have to look him up)—again, not what I was after.

Part of my metal persona was black concert T-shirts, jean jackets, leather jackets, and a loud-ass stereo blasting in my truck. Yup, that was me. Inside that big, blue Chevrolet pickup truck, the double bass thunder created by Metallica's Lars Ulrich, would reverberate through the dual Kicker subwoofers positioned behind the bench seat, physically massaging the backs of anyone who sat next to me. I'm not sure if my girlfriends ever liked that—I sure did. After installing the new Pioneer tape deck, I short-circuited the fuel gauge and the speedometer—I had no clue how fast I was driving or whether I had enough gas to get anywhere. I didn't give a shit if any of the gauges worked in the truck either, as long as the stereo cranked and I could drive fast. "Come on Landry, smoke the tires!"

Kudos to my mother who took me to my first metal concert, Ozzy Osbourne and Metallica at the Worcester Centrum—it was epic! That was April 25, 1986. Even though I'm now forty, it still isn't out of my system. And for the record, I had metal hair, not a mullet! For those of you who don't know the difference, here's a quick lesson. Metal hair would be described as long, feathered or teased or spiked-out with hairspray. A mullet is tapered and short on the side with a party in the back (see Billy Ray Cyrus, circa 1992). And another thing for the record, my wife tells me she would have never dated someone like me in high school. She's not joking either. "Jason, I used to call kids like you *skeds*[5]!"

Now that I'm a "grown up," I look back and wish that I could get a do-over—you know, do high school all over again. But on the flip side, what would I achieve by doing that? If I had applied myself in high school, none of what you are about to read would have ever

5 Urban Dictionary defines *skeds* as: {Noun} A form of burnout or metalhead found in northeastern Massachusetts mainly between the '70s and early '90s.

come true—it would start to fade away just like Marty McFly's photograph in the movie *Back To The Future*. I don't have a DeLorean with a Flux Capacitor, so this is my life. Sometimes you just have to work through all the kinks before the real magic happens.

In grade school, my life was a mix of metal and soccer—an alchemy that didn't always gel. Again, no academic classes captured my short attention span. I liked art and sports. I learned to play the guitar and tinker with computers (when we eventually got them—remember this was the '80s), and I learned to sew. Yes, I said, I learned to sew! All metalheads are good with the needle and thread. How else would they be able to get all of those cool patches from their favorite bands on their jackets?

The honor roll was a big mystery to me, and I didn't win any awards that I'm aware of. I do recall my social studies teacher tossing a mini-dictionary across the room toward me and asking, "Landry, can you look up the word *deranged*?" It was all in good fun...I think.

So I liked sports, but I never really excelled at them, except maybe soccer—but that ended when I hit high school. The coaches wanted us to run miles and miles before we even got down to practicing. I hated running, and still do, so after the first practice I quit.

There was hockey—that was more recreational. I signed up to play for a regional lacrosse team my junior year, but then I came down with a bout of mononucleosis and an enlarged spleen—no more contact sports for me. Last, I took up golf during my senior year. I was a duffer, and I was fine with that. Since the sports route didn't pan out, I concentrated on the arts.

I took drawing and painting classes in grade school and through high school. My paternal grandfather influenced me at an early age. He was a painter and played the violin, accordion, harmonica, and piano (all self taught). Though this might sound really cheesy, it was when my aunts took me to Walt Disney World in Orlando, Florida, for my eleventh birthday that I got to thinking about being an artist.

There I saw how movies were animated—how real people drew and painted cells by hand.

Sketching cartoons became my pastime. I owned many Disney animation books and bought all of the movies as soon as they were released on VHS in order to study and learn how to draw their facial expressions and movements. I don't want to say that I ate, slept, and thought Disney; however, I did have a hand-knitted Mickey Mouse sweater and had a few Mickey Mouse watches. I practiced and learned how to draw each character, step by step, from the initial circle, to the last whisker. You gotta start somewhere, right? Come to think of it, it was really cheesy, and you know what—I'm still cheesy to this day, and I'm very much okay with that.

In 1990, I took my first photography class. I had played with cameras before—my parents had a Polaroid OneStep and a Kodak 110 (remember those?)—but this was different. After drinking the photo Kool-Aid, I never picked up those poor pencils and sketchpads again—bye-bye Mickey Mouse sweater—cue the music!

Photography 101 at Portsmouth High School was where it all began. I remember my classmates, the small darkroom, the pungent smell of the chemicals—a nasal-burning cross between ammonia and vinegar, learning to develop negatives, building pinhole cameras out of Quaker Oats canisters, printing in the darkroom, and dry mounting images. I even remember flipping through books by photographer Jerry Uelsmann in amazement and thinking, "How the fuck did he do that!"

There's something magical that happened when I learned to master the process of creating a photograph. This experience went beyond what I could create with a pencil or paintbrush. It was like a science experiment. If you followed the directions precisely, you might succeed. If you skipped a step, or didn't measure your chemicals the way you were instructed, bad things could happen. I skipped a lot of classes in high school, and I wasn't the biggest fan in following

directions. Let's just say that there are no CliffsNotes for photography class. In hindsight, taking this class really did help me with a lot of other things in life.

The first good photograph that I ever took was on that first roll of Kodak Tri-X 400 film—the second negative out of thirty-six exposures. It was a vista of perfectly planted rows of pine trees, the landscape behind our home in rural Greenland, New Hampshire. My teacher told me that it looked like an Ansel Adams. Although Adams's work is beautiful and technically perfect, I'm glad I didn't let her praise inflate my ego too much.

There's one quite disturbing thing I recall from this photography class—a classmate, the sick bastard that I'll refer to as "Spanky"—Yup, this kid used to beat off in the darkroom. That's what I said—beat off! Gross, I know! Through the red glow of the darkroom safelight, you could make out the shadowy figure wanking away—one hand on a tong flippin' prints in the developer, and the other was flogging his dong! Since he was a much bigger kid, I wasn't going to say anything fearing that I'd get my ass kicked. Soon he moved from jerking off in the darkroom, to pullin' his pud under the desk, nicely concealed by his three-ring binder. I get the fact that photography class can be life-changing for some—it was for me—but for this particular classmate, I guess the excitement of learning how to masturbate trumps everything. I pointed out his deviant behavior to one of the girls in the class, and she alerted the teacher.

A few days later, that female classmate and I were summoned to the principal's office. I had been there often enough, but this time it wasn't about me skipping school or doing a smoke show in the parking lot. Imagine if you will our surprise when two plain-clothed police detectives showed up with a series of questions they wanted to ask us.

"So, can either of you tell us what exactly is going on in the darkroom?"

"Ahhh...Well...So..." I have to admit, that this was just one of a set of crazy questions that we had to answer that day and had to provide

a serious response. The student in question was removed from the class for the remainder of the school year. I watched as his father led him from the guidance counselor's office down the long corridor and out of the building. Now hold onto your hats folks, this is where it gets even creepier. That same female classmate and I were walking through the mall a few months later during the holidays and we were shocked when we noticed that Spanky was now moonlighting as the mall Santa Claus. How's that for coo-coo bananas!

When I was in high school, we didn't have digital cameras, Photoshop, or iPhones—cameras were all manual—analog baby! My weapon of choice was a Pentax K-1000—sounds more like a type of broom you'd find in a Harry Potter book. Come on Hermione... hop on! The camera had a metal body, manual lens and a built-in light meter—not even autofocus—all manual! I even had a Mickey Mouse neck strap that I picked up at Disney World—I know, stop it, right? In my opinion, this is how all photographers should learn how to make pictures—manual, analog, no autofocus (childish neck strap not included).

Sometime during my junior year, I began discussing college with my parents. I used to pick through all of the catalogs in the guidance counselor's office trying to figure out what I should do. Although I really wanted to follow my friends to Florida and attend college in the Sunshine State, I only recall applying to one art college that had a photography major: The Art Institute of Boston (AIB). With my lackluster grades and shitty S.A.T. scores, I put all my eggs in one basket. I took the ride down from New Hampshire to Boston—Kenmore Square to be exact—and met with then photography department chair, Christopher James. After he interviewed me and looked over my portfolio, he accepted me right on the spot! What a great feeling. I would be the first in my family to attend college, but not the first to graduate. Although my father would have preferred that I stay close to home and attend the University of New Hampshire, which would have been a significant

cost savings for an in-state resident, that wasn't in the cards. It was time for a change of scenery.

A side note, few years later, on the campus of UNH, I would meet my future bride, Anne. Yes, the same one who wasn't into head-banging metalhead skeds.

The first thing that I ever said to her was, "You have the biggest feet that I have ever seen...I love them!"

Her response—no lie—"I'm gonna marry you." Good thing I cut my hair and started listening to alternative music. I must have smelled like teen spirit!

Instead of shacking up in a dorm during my first year at college, I rented a two-bedroom pad, for $300 a month, from my uncle (a.k.a. Bobby Big), who owned a large brownstone in Chelsea, Massachusetts. I split the rent with my live-in girlfriend at the time. We played house for a bit and threw a few raging parties, but in the end, it just didn't work out.

My first full year at AIB was a blast! I started each day by taking a quick ride on the MBTA 111 bus from Chelsea over the Tobin Bridge into the city, jumping on the Green Line train at Haymarket to Kenmore and immediately hitting up the nearest Dunkin' for an ice coffee and three chocolate frosted donuts. I'd bounce into school all hopped up on caffeine and sugar, dressed in my black military bomber jacket and Boston Red Sox hat listening to the Beastie Boys *Check Your Head* CD through my Sony Walkman—R.I.P. MCA. This was my daily ritual. I remember that CD and the Red Hot Chili Pepper's *Blood, Sugar, Sex, Magic* as the two CDs that got the most airplay in the darkroom. Whenever I hear them, they bring me right back to school.

Kenmore Square has done a one-eighty since those days. The original Dunks where I used to go to is gone—it moved up the street, the Strawberry's Records & Tapes store—gone, and so is *the Rathskeller*, the dimly lit rock club dubbed *The Rat* that played host to so many bands including the Ramones, R.E.M., the Pixies

and countless others. All of that has been replaced by the beautifully boutique Hotel Commonwealth, two outstanding restaurants, Eastern Standard and Island Creek Oyster Bar, a lounge called The Hawthorne with the finest original art decor and craft cocktails, and is the current home of my gallery—Panopticon Gallery.

But there was something that I kept thinking about during that first year at school. I began to feel self-doubt. Was I as good of an artist and photographer as I thought I was?

When I first attended college, I quickly realized that I was no longer one of the top photographers in the class. The class was made up of *all* of the stars and *all* of the top pupils from high schools from all over the place—in essence, I was just another face. I had this mindset that I wanted to be the best at whatever I did. But after that first year, I doubted my own abilities and whether I could actually make a living as a fine art photographer. At twenty years old, I wasn't dreaming big. I became a statistic. I dropped out of school and got a job.

My aunt worked for New England Telephone, a spinoff of the Ma Bell evil empire, and hooked me up with a job in the collections department. I vividly remember my first day of work. I ran from the train station at Haymarket to State Street in a friggin' downpour. I forgot my umbrella and also forgot the direction of the office. I was drenched and pissed off because my new V-neck Gap sweater was soaked—those were the days!

This was my first big job working in a corporate environment and having my own desk. My job was tracking down all of the deadbeats who didn't know how to pay their phone bills on time. Tracking down people who have had their telephone's shut off is like detective work. They don't want to be found, nor do they want to set up a payment plan at $25 a month. Strange thing—I thought this would be a summer job and then turn into a night job to pay the bills once I returned to college. Ultimately, it turned into something a little more long term.

At first glance, one would think this might have been a bad decision, but to me, it was the exact opposite. The detour from the arts became a ten-year adventure into a Fortune 500 company that operated like a chameleon. Let's start with its generic term: "phone company." During the time I worked there, the phone company went through many mergers and acquisitions—from New England Telephone to NYNEX, to Bell Atlantic and finally to Verizon. The corporate environment was a different type of education. Company slogans went from "We're the one for you New England" to "Can you hear me now?" I learned a lot about the business world—sales, marketing, investing, personalities, unions, diversity, managing people, and lastly managing myself. I was a sponge. I wrung out the bad stuff as needed.

One perk was tuition reimbursement, and I took full advantage of that! I was able to enroll in some night and weekend classes at Northeastern University, dabbling in a few business classes here and there and picking through a few of the required academic classes. All of this—the work, the investing, and the classes—was all training for the bigger picture. Without it, I do not think I would be doing what I do today.

Granted, working for "the man" wasn't all rosy. I had a few managers that were great, and others that were not ideal fits. The person who inspired me the most was Mark Landers, who was my manager when I worked for Verizon in North Andover, Massachusetts. He was a true leader in every sense of the word. He reminded me a lot of the Robin Williams's character from *Dead Poets Society*. There's a classic scene toward the end of the movie when his students hop up on their desks and say, "Captain, My Captain." The phrase comes from a Walt Whitman poem, and it popped up again when I was reading the book *The Lincoln Letter* by William Martin. In our department, he was our captain. He was the first person to promote me to management, and a person I truly respected in that industry. The day that

he broke the news that he was leaving our department to accept a new assignment was a devastating blow to the teary-eyed managers sitting around the conference room table. It was never the same after that. I wonder who's driving the fucking bus now?

For a while, the company seemed to be going through mergers and acquisitions every other year. The company colors would change, slogans would change, and people would change. Just when things would start to quiet down, the company would go through a ton of RIFs, otherwise known as a "Reduction In Force." It's a politically correct word for layoffs (this is what happens when a company gets too big for its britches and then peddles backwards to save money).

The company would first decide how many employees to cut from each office. Next, management would check in with employees closer to retirement to see if by sweetening the pot they'd take early retirement. If some accepted, then fewer people would get the boot. But for management, if the company wanted to let us go, we would be offered an incentive—a cash buyout and stock options (if we had any).

I was getting a little fed up with the RIFs every few months, and, on top of that, watching more and more employees leave—I never knew when my card might be pulled. Once, *I* was actually RIF'd from one department (a blessing), then got picked up and promoted to a different department all within a week. I felt so disconnected from the company—my only outlet was when I decided to get back into photography. The strange part about this was while I was working and making money, photography was the furthest thing from my mind. I wasn't buying cameras or even making pictures. I wasn't collecting photography either (something I wish I had done a lot earlier in my life).

My wife and I had just built a large colonial home in Bradford, Massachusetts, and I hired my Uncle Joey, a contractor, to build a studio and darkroom in the basement. It was killer! Large sink, a few

enlargers, drying rack, exhaust fan—the works! It was my man town. I spent some mad dough that year at the photography supply superstore B&H Photo outfitting it. UPS made so many deliveries to my house—my neighbors had no clue what I was up to.

I was itching to find some inspiration, so my wife had suggested that I take a trip to visit my friend Drew Smith, living in California. I took a week off and I packed up my photo gear and left. Entranced is the only way to describe what I felt after dropping into LAX. My first trip to the West Coast was an eye-opening experience: pretty people, fancy cars, big houses, but most especially it was seeing all of the murals painted around Santa Monica and Venice Beach. Still to this day, that area has such a fantastic art vibe.

I began to photograph as many murals as I could find, trying to create interesting compositions by incorporating other aspects of their surroundings, including buildings, objects and people. On follow-up trips (I would usually go three to four times a year), I would rent my own car and go off on adventures. On one particular trip I had an epiphany. As I rolled up on one of the murals, I noticed a stenciled tagline on the wall. No, some punk tagger didn't add this later—the artist includes this text in many of his murals: *Remember Who You Are.*

Eureka! That's it! I do remember! I was meant to be a photographer! I *can* do this! I am determined to do this! OK...what should I do now?

The long flight home to Massachusetts was what I needed to compose what I had planned to spring on my wife when she picked me up. Gleaming with delight and charged with a newfound focus, I gave her my best sales pitch:

"Honey, the next time that they offer 'the package' in my office, I'm taking it. I'm going to go back to school to finish my degree and focus solely on photography!"

"OK...so do it." (If she only knew what the next ten years would be like, I wonder if she would have been so quick to encourage me...but then again, she's always been there for me...thanks Boo.)

This is how it all began for me—round two, that is. I got a second chance—an opportunity to make some photographs, a defining moment where things became clearer and a determination to follow my bliss. It's not the ideal scenario that you might have when you start a journey, but this journey continues to this day. As I said to someone recently, there are no perfect life plan formulas. It's a roller coaster with various exit ramps!

Embrace every single opportunity as if it were your last. Don't let something you opted not to try become a regret! I have very little regrets in life. I follow Sir Richard Branson's mantra: "Screw it! Let's do it."

CLAIM YOUR MOMENT

Each person has a message to deliver—a story to tell. I recognize this more and more when I watch TED talks. If you haven't watched any, do yourself a favor. Find a topic and sit back and watch. The videos are inspiring and motivating, and the TED mantra rings true. They do have "ideas worth spreading." I used to post TED talks on my blog once in a while when I felt the story was relevant to things that I wanted to learn more about, or had particular interest in. Essentially, once I watched and liked it, I usually wanted to tell someone about it. This is how most ideas spread, with one person telling someone else. I try to connect you, the readers, to people, places, things, and ideas that matter to me: It's one of the overall threads in this book.

Let's take a look at one specific TED talk: JR's influential talk and personal wish to, "Use Art To Turn The World Inside Out."

JR is a well-known street artist from France. In the last few years, he embarked on a global public arts project—his thesis: "Could art change the world?" Whether he was pasting large photos of people on the streets of Paris, Israel, New York, or in the favelas of Rio de Janeiro, Brazil, he was finding a way to leave his mark on society in a positive way. He was trying to educate the world through pictures: to tell the stories of others. It was his way of creating a global dialog

to connect the world through art and make people think about what they truly cared about.

The thoughts and ideas presented through TED talks are infectious and some find their way into the mainstream and go viral. They cause people to think. TED talks are short, usually around eighteen minutes in length. TED hand selects the speakers who present at their events. The speaker may be a well-known artist, musician, author, scientist, teacher, or could even your best friend's mother. Watch and listen to a few talks by people like Vik Muniz, Amy Cuddy, Andrew Stanton, Amanda Palmer, Chip Kidd, or Malcolm Gladwell. You'll get a sense that that person was put on this earth to present that specific talk—and the folks at TED know it too.

This might come off sounding a bit strange, but have you ever asked yourself, what message will I deliver in this lifetime? What story will I tell? I never imagined that I'd be writing a book, and here I am, knee-deep in one.

People go through various stages in their lifetime—events that show up as markers or barriers that are meant to be passed or conquered before getting to that next level, you know—before they find their true calling. These barriers are like chapters or stages in a video game, the more you master the game, the closer you are to the prize—or finishing the conquest. Each step, each stage, each chapter is a test that you must pass before you find your true path, true goal, true purpose in life.

Like a chick breaking out of its shell and taking its first step into the world, you need to chip away at the small stuff around the edges until your moment is there, right in front of you for the taking. Once you're free from the confines of the shell, a great big world is in front of you. Go out and conquer it. Experiment with what captures your attention. Try different things. Sometimes your "thing" won't be the first thing that you are good at—it often times will sneak up on you

when you least expect it. Who knows, your "thing" might just be the next big TED talk. As JR was spray-painting his name around Paris do you think that he knew that one day he would be the 2011 TED Prize winner?

Claim your moment. As Anonymous once said: There is no better time than right now.

FIND YOUR ART FAMILY

In 1992, I began my first stint at art school, enrolling in the bachelor of fine arts in photography program at The Art Institute of Boston. During the school's first open house, my parents came down for a tour. Art was displayed on every floor—illustrations, photographs, graphic design projects, and large paintings. It was visual stimulus overload.

After walking for a bit, my father proclaimed in his best New England accent, "This is a jail for *aht* kids."

Obviously he didn't get it.

Two decades later, in 2012, my parents finally got around to purchasing an iPad so that they could email and have face-time conversations with my brothers, their granddaughter, and me. I forwarded to my parents the email that I received from the Dean of the New England School of Photography inviting me to be the commencement speaker at graduation. My dad responded with his first-ever email account (in all lower case):

"congratulations, it's about time. can I retire now? dad."

A little better, no?

When I think back to his original comments, I remember how deflated my ego felt. I was so excited for them to see what I was doing

in college. To receive this kind of response was like popping all of my birthday balloons before I even blew out the candles. What would have happened if I would have taken what he said and stepped away from my dreams of making it in the art world? I decided that I was going to have to seek approval from a different and very specialized family in the future: an art family.

My second attempt at art school was at the Massachusetts College of Art and Design. I was labeled a "nontraditional student"; I was in my thirties when all my classmates were between eighteen and twenty-two years old. The "art family" concept will be different for everyone, and this is where it began for me. I prefer smaller, more tight-knit groups rather than a larger mass of peers. My very first class at MassArt was called *Visual Language*. It was taught by Marc Holland who wanted us to experience all art, not just the medium in which we excelled. He also was trying to help us build our vocabulary when discussing art. He was highly motivational and generally excited about teaching and about our progress as students. I felt a connection to his teaching style very early on. Without knowing it, he became one of my first art family members.

We took a class trip to NY and bopped around the art galleries in SoHo and Chelsea. One memorable stop was when we viewed an exhibition of large art installations by Tara Donovan. Somewhere during that trip, I saw a mobile by Alexander Calder. On the bus ride home, I was already thinking about creating a mobile for my final project. I was encouraged by Holland to look at various mobiles. My final design was a multipaneled mobile that was made up of photographs of me in a business suit on one side, and me dressed more like a casual art student on the other. As it moved with the wind, panels would move and the interplay would begin. As I was just transitioning from the corporate world to being a student again, Holland's initial motivation and opening of my eyes to seeing beyond the single frame helped me to find my place in this new environment. I'm not sure I ever thanked him enough for that.

Some artists and photographers will find their first "art families" are their college or art school classmates and professors. You click with some, but not all. You may also find yourself in a group portrait, naked, with some, but not all of your classmates, after a fun junior year large format photography class! Yes, this did happen. There's a lot of nakedness in art school. I never complained. In fact, I think it was a bonding moment for the class. For me, I was peeling off yet another layer of my former self and embodying what it was to be a student.

School is awesome while it lasts, but once you graduate and move away, your circle of friends shrinks. It will grow again when you find your art community. After I graduated from school, I continued to stay connected to the photography industry by befriending people and getting involved with organizations like the Photographic Resource Center, the Griffin Museum of Photography, and other local schools, galleries, and museums.

You may find your community through a gallery, a studio space, or a local art district. The people in your art family, (your personal connections), will keep you motivated. They will encourage you. They will feed you and sometimes house you. Your art family knows the road you are taking. They have either been there or know others who have traveled the same path.

Artists have personas that are often larger than life. This can be a good thing, if you are able to manage it well, or a really bad thing, especially for your family or significant others. You need to know that there will be many ups and downs in your career as an artist. The person you go home to, that is if you have a family/husband/wife/partner/girlfriend/boyfriend/significant other/or pet, is that they are always on the receiving end of your news. Your news and events come in waves and aren't always smooth. Be cognizant of this.

After I left the business world to go back to college, it seemed everything that my wife and I discussed had to do with me. This new persona was taking over, and my wife was feeling a bit left out. I had

put a strain on our relationship without even knowing it. Things could have easily unraveled for me right then and there. Luckily, we talked about it and I understood that I needed to figure out a better way to balance school and our relationship.

Your traditional family is different than your art family. If you neglect them, or forget to ask them how their day was, or listen to their stories and news as they do for you, some of your relationships just might not last. I tell you this because your art dealer (that is, if and when you eventually get one) does not want to be a marriage or relationship counselor on top of the other unofficial titles that they have.

I remember talking with an artist at a portfolio review event in Houston. She told me that she just had the best review of her career by an editor of a major photography publication, so much so that they hugged the reviewer after the session. An hour later as we sat on a bus, the artist got a follow-up email from that same reviewer. She was stunned. She turned to me to show me the email: it was a positive response to her portfolio and personal suggestions. The artist then fired off a quick email to her husband telling him the great news. The artist turned to me none too excited about the brevity of her husband's response. She showed me her iPhone: his return email read: *grt*.

For those of you who can't figure out email shorthand, he meant, *great*. Understand, that your spouses and partners hear your stories every day and although they are supportive and happy for you, they too have a life. Don't expect them to be super excited for every single event that happens in your life. This is why I urge you to seek out your art family.

When I acquired Panopticon Gallery from its original owner, I had an idea to host photography salons. I envisioned the salon as an event where I could invite local curators, critics, publishers, printers, art patrons, and collectors to meet the artists that I represent and look at their portfolios in a private setting. One key component of the salon is that I do not tell the exhibiting artists whom they'll

be meeting. All I say is that a bunch of people will be attending the salon, and they all like photography—just be you. This way, the artists won't get nervous if a curator from a major museum shows up, and on the flip side, the curator or guest won't get smothered and bombarded with too many questions from the artists.

The idea of the salon comes from the French. It's not new, but if it's new to you, then think of a salon as a *real* social network, not one on the Internet. Building a community is the main purpose of our salons—engaging people to learn more about the arts, specifically about photography, comes second. And from what I can see, so far, so good. Through our efforts, our community continues to grow with new collectors, patrons, and peers, building upon our already established art network.

Salon at Stephen DiRado's House. Image Courtesy Stephen DiRado.

When I was working at the Photographic Resource Center at Boston University, I befriended local photographer Stephen DiRado. He kept inviting me to take the drive out to his house in Worcester, Massachusetts, to one of his weekly salons. He had told me that for many years, he had hosted a weekly gathering at his house. Intrigued, I finally cleared a place in my schedule and took a ride out to his home with another photographer. As I sat around the table snacking, drinking, and observing his art family, I could see why he kept up the tradition. It was almost like being back in school—you're around a like-minded group of individuals all passionate about the same thing: photography. Besides the group portrait that Stephen created that night to commemorate the evening, I remember being introduced to a cowboy hat-wearing Texas transplant, photographer Frank Armstrong. He was holding court showing us how to exorcise the devil from an empty bottle of single malt scotch. In his signature drawl he instructed, "You just rub the bottle a bit to excite the devil then light the tip on fire until the devil's spirit emerges." In a way, this whole "devil" scenario is like a metaphor for when a teacher or mentor praises you for successfully completing a task. They are stroking your ego, and in exchange, you're jumping at the bit to be challenged so that you can prove your worth again.

This experience, this event, this "happening" had to be told. The next day I asked Stephen to write a piece about his salons for the quarterly PRC publication *In The Loupe*.

The Magic of Salon

For at least eighteen or so years my kitchen table has been home to a salon. What started out for a modest group to decompress after a long day of teaching, eventually evolved into a mix of creative people—the famous, the not so famous and patrons seeking community,

friendship, and conversation. It is part of the fabric of my life and a ritual savored by all of us.

Once a week, around 9 p.m., a loyal group of about fifteen people (ranging in age from their mid-twenties to late seventies) set up chairs and in the truest definition of salon, engage in stimulating conversations about art, life, and politics. Throughout the evening another five or ten people casually stroll in and find a place to sit or stand, occupying a room designed to hold a dozen people at best.

The house rules are simple; rich or poor, leave your ego at the door and contribute something to the table: a bottle, chips or a sampling of cheese will do. There is no agenda and you are welcome to come, to hold court— observe, participate, and or anything in between.

As I look back over the years, I'm amazed at the collection of humanity that has graced this table. In the early years, it used to be primarily photographers and a few patrons of the arts. Over time, the guest list expanded to include painters, sculptors, art historians, musicians, cultural leaders, bohemians, foreigners, journalists, photojournalists, science and humanities professors, theater directors, television/movie directors, actors, a playwright or two, and a quirky scientist. In the truest definition of salon, we are enriched by stimulating conversation, sometimes driven by art or creativity, other times sports or food. New friendships form, collaborations come about, personal relationships evolve.

Cameras are frequent guests at salon. They attempt to record poignant moments. Because as we all know, nothing stays the same forever. Everything eventually ends.

<div align="right">Stephen DiRado</div>

It's important to round up your art family early on in your career. Whether they are classmates or people you meet later, artists all have egos that need to be massaged on a daily basis, and your art family will be the ones you can talk to. Eventually, your art family may also include your spouse or partner, or possibly your other spouse—your art dealer.

More than ten years after my father's first comments about art school, he had came to my very first exhibition at the Schoolhouse Gallery in Newburyport, Massachusetts. On display was a series of black & white photographs that I took documenting murals in and around Santa Monica and Venice Beach, California. Neither he, my mother, nor most of my immediate family members had ever been to a gallery reception.

A few years later, he and my mother returned from a trip to Prince Edward Island and showed me a stack of photographs that he had taken with the new digital camera that I had bought him. As we were flipping through the images (developed at Walgreens), he asked,

"Hey...what do you think about that one?" It was a photograph that he had taken of a mural.

"I think it's great Dad."

"Maybe *I* should have an exhibition?" he joked.

I think he was beginning to get it.

I could have easily said, "nice 'aht' Dad," and left it at that. What I learned is that not everyone you will encounter will get you or the art that you create or even display in a gallery setting. Take advice, as they say, with a grain of salt, and be open to critique. You just might learn something new about yourself in the process.

THE GLADWELL THEORY

Even books that have nothing to do with photography are worth reading. You never know how they will apply to your life. I never was a fan of reading or writing. Yeah, when I was younger I may have picked through a few Stephen King novels, read a few classics like *The Great Gatsby*, and got sucked into some of Sir Arthur Conan Doyle's mysteries involving one Mr. Sherlock Holmes, but sitting around quietly reading—nope, I was too high strung to sit still for any length of time.

By the time I got to college, I started to do a little more reading and then BAM!—graduate school came along and I was forced into reading more than I could have ever imagined and writing papers every month too. Reading helped my writing; however, when it came time to work on my thesis, I was told that my writing needed a lot of work—ugh! I was told to visit the college's Writing Center. I went there kicking and screaming but in the end, I learned something—I learned how to be more articulate when I wrote. This helped me in speaking. When you are an artist, you need to be confident when you speak, whether that is in front of a crowd or one-on-one.

When I think about reading and photography, the first books that come to mind are the dense theory books that you are introduced to early on when studying the medium: Roland Barthes *Camera Lucida*; Susan Sontag *On Photography;* and others like *Ways of Seeing* by John

Berger. My essays on photography are not meant to be lumped into the scholarly critical theory primers of the past. My hope is that when you read them, you'll find ways that they'll connect with something in your own life.

The fact of the matter is, when I look through photography books, I'd rather let the image guide me. If the photographer is good at his or her craft, the image will sing and I won't need any text to accompany it. The photograph will make me work; it will make my eyes move about. It will teach me about the person, place, or thing that I am looking at. If the image doesn't do that, text is needed to guide us along, and with photography books, I just want to look at pictures—text just takes away from the overall beauty of what the artist intended.

I want to get back to my first sentence of this essay for a minute: even books that have nothing to do with photography are worth reading. As a photography student, collector, and gallery owner, I have undoubtedly read my fair share of critical reading about the medium. Today when I read, I'm usually hunkering down with a good memoir or maybe a historical fiction novel. It's a change of pace. You need to break your reading cycles once in a while in order to grow. One book that opened my eyes quite a bit was Malcolm Gladwell's *The Tipping Point*. It enabled me to see my photography art family and network of peers in a whole new light. Here's my executive summary of the book:

A tipping point, according to author Malcolm Gladwell, is "that one dramatic moment in an epidemic when everything can change all at once." It's the moment when "the unexpected becomes expected, where radical change is more than possibility. It is contrary to all our expectations."

To clarify his thesis, Gladwell categorized people into three distinct groups: Connectors, Mavens, and Salesmen.

Connectors are "people who link us up with the world," and "who introduce us to our social circles...Connectors know lots of people." They have an "extraordinary knack of making friends and

acquaintances"—they are the "social glue." They spread the word. They "are the sorts of people who don't need to be found. They make it their business to find *you*."

A *Maven* is a person who helps to "control word-of-mouth epidemics" and "who accumulates knowledge." Mavens have information on a lot of things. "They like to be helpers." A Maven becomes important "not so much what they know but how they pass it along."

Salesmen have "the skills to persuade us when we are unconvinced of what we are hearing." They find ways to seduce us without making it obvious. We become "synchronized" with what they are saying. Their "emotion is contagious."

In the art world, you will find individuals who take on these roles. Some may fit each category to a T. Some may be a hybrid of two, and some may act like all three.

Here's a fun exercise: list your art family, friends, mentors, and colleagues on a piece of paper. Then see if you can place them into Gladwell's three categories.

When you are trying to accomplish something in your career, who would you ask based on Gladwell's three categories? Are you trying to get people to attend your art opening—ask a Maven for assistance. Do you want to meet a curator from a major museum but you don't know how to approach that person, Connectors can hook you up. You just went to a lecture and you were totally inspired? Likely you just met a Salesman.

Remember these terms because I use them throughout this book to describe many of the people in the art world whom I have met, including some of my peers, friends, and mentors. If you fancy yourself as a photographer, you undoubtedly can take a photograph and print a photograph. That's the easy part. Your next step is building your brand. That's the hard part. How will you do it? Networking is key, but with the right Mavens, Connectors, and Salesmen, you just might create a winning hand.

WHO'S IN YOUR TOP FIVE?

Stephen Sheffield, Filter, 2010

Remember that catchy slogan from the T-Mobile television commercial: "Who's in Your Top Five?" Let's consider a similar question: Who's in your top five, in terms of friends, mentors, and heroes? Think about the five closest people in your life. If you're an artist or photographer, you'll probably look at your "art family," those people who understand who you are and your ultimate potential.

My five-card motley crew breaks down like a mixed bag of M&M's. Some are connected to the art world, and some aren't. One owns a business. Another is semi-retired. One runs marathons, and another hobbles around with a cane. The last one dabbles in photography and is a mean bike polo player. I have had at least five mentors and friends who have given me advice, support, and inspiration while I was attending college, while I was an emerging artist, and now as a gallery owner and photography collector. The number of individuals in your close-knit art family can be more than five. I just prefer a smaller group—quality over quantity. This reminds me of a great quote in the book *The Start Up Of You* which reads, "There is a big difference between being the most connected person and being the best connected person." The goal isn't to have a ton of people in your real social network. It's not Facebook or LinkedIn, plus when you consider Dunbar's number [6], quantity means shit.

For the most part, I've had the same number of individuals in my clique. I'm glad this cast of characters has stuck with me. They act as advisors, and they're generally there because they want to see me succeed. At least this is what I believe, and I try to reciprocate whenever

6 *Dunbar's Number* is a theoretical limit on the number of close social contacts an individual human can have. First proposed by British anthropologist Robin Dunbar, it is based on data from other primate groups where there is a strong correlation between group size and the size of the brain's neocortex. Thus, extrapolating from the human cranium would put Dunbar's Number somewhere between 100 and 200, with a commonly used value of 150. (cited from Wikipedia)

I can. These individuals know who they are, and I am forever grateful that they've given me so much knowledge, and, in turn, I only have to buy them lunch every once in a while. You'll read about them in this book.

Who better to start with than Jeffrey Keough. When I was attending Massachusetts College of Art, my aunt and uncle would tell me, "Jason, you need to meet Jeffrey Keough. He works at MassArt and he would be a good person to know." Did I do what they asked—nope. I'd done all that when I was in the business world. There, it was all about "who you knew" and clawing your way up that proverbial corporate ladder. I played that angle really well, worked hard, befriended the bosses, and landed a few promotions. But in art school, I was reinventing myself. This would be different. I didn't want any help, even if they were friends of the family. My theory was, if someone did help me, and I left college and tried to show my work out in the real world and it wasn't as good as I was led to believe, I would fail.

By my junior year, I felt more comfortable about my abilities as an artist and decided to pay Jeffrey a visit. What I had I found out was very depressing. He recently had had a stroke and was no longer at the college. All of the hype that my family had built up about him now felt like a deflated bubble. I began asking myself: why did I wait so long?

While vacationing at his island retreat on St. Martin, Jeffrey remembers his day beginning with a headache. Lucky for him, his former rental tenant had left a large bottle of aspirin in the cabinet. Those two little pills, according to his doctor, proved to be the difference between life and death.

Jeffery was the former director of exhibitions at the Massachusetts College of Art and Design. Why former you ask? Well, you can probably figure it out by now. As he puts it, "I had a little accident...I had a stroke."

Fact #1: He did have a stroke. That's not a joke.

Fact #2: He has a good sense of humor considering the circumstances.

Fact #3: It's safe to say that he is quite literally a little out of his mind.

Fact #4: Now that he's retired, I never can get a hold of him. Jeffrey: you're on my shit list!

A year later, he showed up at the college for a lecture. He sat in the back row, all smiles, holding onto an ornate wooden cane with a frog carved on the handle, and talked with one of the photography professors. I sat in front of him, listening to his stories and half listening to the lecture.

After the lecture, I went over to his replacement, the acting director of exhibitions, and asked if she would introduce me to him. She said, "Oh Jason, Jeffrey just returned back after having a stroke and he is a little hard to understand. I don't think this is a good time." As I sat there in front of Jeffrey listening to his conversation with one of my professors, I understood everything that he was saying. He didn't sound different to me, because I had never met him before and didn't know what he had sounded like. So maybe he sounded like a groggier version of Kermit the Frog—can you really fault him for that? It was obvious that if I wanted to make this connection, I was going to have to make it on my own. After most of the room emptied out, Jeffrey was still sitting by himself: I went over and approached him. "Jeffrey... Hi, my name is Jason Landry."

He almost fell off his chair with delight. "Oh-My-God. Your aunt and uncle have been telling me about you for years. I've been waiting for you to come for a visit. Please come to my new office tomorrow so we can chat. The office is in the basement next to the auditorium."

This initial meeting with Jeffrey began an endless stream of connections: it was the birth of my social network in the art world.

The basement office that Jeffrey shared with another school employee was like another classroom for me—but without windows. His side of the room looked almost like a freshman dorm room—lining the walls were posters from past exhibitions that he had curated and stacks of books and catalogs from those exhibitions. I'd pull up a chair and we'd talk for hours. He'd always send me home with something, whether it was a book, catalog or a flash drive with his manuscripts. He never knew when his dinosaur of a computer would quit.

This meeting was just one of many important introductions that would forever change the course of my existence. It sounds rather silly, but it's true. Actually, meeting Jeffrey reminds me of the parlor game, Six Degrees of Kevin Bacon. If you don't know who Kevin Bacon is, he is best remembered as the actor in the first rendition of *Footloose*. Anyhow, Jeffrey became my Kevin Bacon—minus the dancing.

The cafe at the Museum of Fine Arts, Boston soon became our new meet up spot. Imagine if you will a *Tuesdays with Morrie* scenario, except on Mondays. You'd normally find us bellied-up to the bar, a scene straight out of *Cheers*. We would try to get the two end seats, on either side of the bar, so that Jeffrey had someplace to rest his cane. If we were forced to sit in the middle, the cane would often slip from where it was propped up, and either someone would trip over it or it would just crash to the floor with a loud BANG—something that sounded more like an aggressive slap, echoing throughout the quiet cafe. Our lunches became about as predictable as our weekly visits: two bowls of the soup of the day and two baskets of bread. After a while, the wait staff knew what we wanted and didn't even have to ask. I'd order a Coke and Jeffrey would order his signature ice tea, but not before saying, "Jason, get an iced tea. They give free refills!"

Our conversations would usually begin by my telling a story about whatever was going on in graduate school or the world of art, and

then Jeffrey would finish it. Jeffrey is a storyteller, and he's great at pulling lengthy, fragmented passages from his archived stockpile of experiences, albeit slowly—his hard drive is corrupt, you know. He would start a story, "Back when I was at the college..." or "There was this one exhibition that I organized..." and I'd be done with my soup and bread before he could finish his story and bring the first spoonful of soup to his mouth. When Jeffrey would laugh, bread would fly out of his mouth like a little kid shooting a spitball,

"What the fuck Jeffrey...that hit my face!" He'd cover his mouth and mumble,

"Oh...sorry, sorry."

Sorry was the answer for a lot of things, and I believe *Sorry* is the title of the memoir he's been writing. Some of his stories had many layers—back stories that had to be introduced before the actual story would make any sense. All of his stories were true and I never doubted any of them—never. And then there were the stories that I could finish because I've heard them a few times. This never bothered me.

People from his past would often interrupt us during lunch to say hello and to see how he was doing, and Jeffrey would entertain them with a bit of small talk and then afterwards turn to me and say, "I'm not sure who that was."

Usually I'd finish my lunch before him, and I would duck into the MFA's bookstore to peruse the photography section and wait for Jeffrey to finish up.

Considering his circumstances, Jeffrey is one of the most upbeat people I've ever met. What he has accomplished since the stroke is inspiring. He has been actively redesigning his house and making art again, and pretty good art—can we say SKULLS! The crazy thing is, I never knew him pre-stroke, so I only can imagine what kind of zany, whack job this guy was then. I have only heard second-hand stories from family members who have been friends with Jeffrey for close to ten years.

This guy was always up for anything—and mostly no good! One year when I showed up at his house for his birthday party, we ended up doing shots of After Shock, a thick, syrupy liqueur that tasted like hot cinnamon as it burned down your throat. As the night progressed, he was coerced into chugging wine from a skull and spine funnel. You'd think we were at a college frat party. That year we gave him the "Skull Fucker of the Year" award, a skeleton trophy that he proudly displays at his house among other things and oddities. If he were your uncle, he'd be labeled the "crazy uncle."

During the next two years of lunches at the Museum of Fine Arts and meetings at Starbucks, I would often ask him an array of questions. He was always forthcoming and honest. This story about Jeffrey wouldn't be complete without sharing with you some of the most important things I learned about him. I have compiled it as if it were an interview. Although the questions and his responses are very serious in nature, we had a lot of laughs and still do to this day.

The Reintroduction of Jeffrey Keough: Version 2.0

Jason Landry: What should people know about you?

Jeffrey Keough: That I lost everything—my ability to walk, my ability to talk, my job, my marriage, and my mother all within one year. For most people, any one of these things could be the final nail in the coffin, but for me, I threw myself into a memoir, renovating a house, and began to create new art. This was the restoration of my creative self. These things have saved my life and they sustain me. To find something of value that you can't lose is fulfilling. There's an old cliché—a storm cloud with a silver lining. The stroke was a huge storm cloud, even though it was ninety-nine percent bad, it still has a small percentage of good. The lining was thin.

One of the biggest ironies is that I have never felt that I have as much to say as when I couldn't say anything. I subscribe to the same

statement artist Chuck Close has said in the past about doing art for art, and therapy for therapy. I don't want the art that I'm creating now to be therapeutic. I want people to be moved from the work first, and then find out later that I'm a little fucked up.

My goal is not to illicit sympathy in my work and personal traumas, but to connect to other people in a more shared experience.

I don't mean to be obtuse, cryptic, or evasive, the things that the stroke has taught me, has to do with communication, or the lack of communication, or the inability to communicate. Difficulty in communicating with others is a universal truth and experience common to everyone. Strokes are only an extreme example of this miscommunication or inability to communicate with others, which is why artists are drawn to people who have had strokes because they are the perfect metaphor to one's difficulty with connecting to the outside world and to others. Artists are attracted to the limitations inherent in strokes.

JL: What is your new artwork about?

JK: Loosely about communication or the difficulty with communication and the way that it connects to other relevant modes on the issue. The issues don't have to be so specific—themes of loss that all humans can relate to. The artwork is inspired by my stroke, but don't want it to be a literal interpretation.

JL: Are there specific artists who have inspired your work?

JK: I believe in an invisible apprenticeship. I feel the best apprenticeships are done without the knowledge of the student. William Wegman, Kiki Smith, Xu Bing, James Nachtwey, Tony Oursler, Abelardo Morell—too many to mention—also the students and faculty at the MassArt. I have been lucky to learn different things from different people. Apprenticeships go back thousands of years; you work with them and learn from them.

At the time when I was director of exhibitions at the Massachusetts College of Art, I wanted to give the most unique and insightful exhi-

bitions possible for each artist. I didn't realize at the time that I was absorbing something essential about art making. There is only one job that is higher than the level of director, and that is of the artist.

JL: I know this might be difficult to talk about, but how did your near-death experience change how you approach life?

JK: It changed my perspective dramatically. I know this is a total cliché, but life is never sweeter when death is hanging around the corner. I had to boil life down to the bare essentials to figure out what I wanted to do in the time I had left. This doesn't mean I have a bucket list. I don't want to go parachuting or ski down Everest or kayak the Amazon, but I put special value in a beautiful day, or walking down the street, or talking to a friend. Ordinary things are special.

JL: Where do you see yourself in five years?

JK: Alive. Honestly.

JL: What's your favorite Christmas song?

JK: Daryl Hall & John Oats—Jingle Bell Rock and Elvis Presley—Blue Christmas

JL: Have you learned anything from having a stroke?

JK: You learn something that is hard to describe or categorize, but you develop a hardened sensitiveness or a greater sense of apathy to others and other people's suffering or joys, successes, or dreams. I don't really trust words—actions are so much more important—they silence words. It's like yelling compared to whispering.

I learned quite a few valuable lessons from our meetings. First and foremost, listen to the person who's telling a story. Find mentors and listen and absorb anything and everything that you can from them, regardless of where you are in life—you're never too old to learn something new. Sometimes you have to endure a few spitballs and sit through lengthy stories that are fragmented, barely coherent, and have more holes than Swiss cheese just to gain something special. You never know when the door might swing open all because of a simple introduction or conversation.

The people that Jeffrey introduced me to and the knowledge that I have gained by listening to his stories turned into a life lesson. I credit him with my initial introduction to artist William Wegman and photography collector and MassArt Alumnus Jim Fitts, who in return introduced me to at least a dozen photography collectors, curators, and photography professionals, including Tony Decaneas who was the person from whom I purchased Panopticon Gallery. Our weekly meetings were just as valuable as the M.F.A. degree that I would achieve. Mitch Albom wrote in his book *Tuesdays With Morrie* that his visits with Morrie were like a second thesis. I truly believe that my meetings with Jeffrey became *my* second thesis. I remember during one meeting telling Jeffrey how lucky I was for all of the opportunities that had come my way.

I'll never forget what he said to me, "Jason, I can't count the times that friends or relatives of students at the college have come up to me telling me, 'Oh, you should meet so-in-so,' or 'You should meet my son or daughter... they're really great.' You have been one of only a handful that actually panned out. So when it comes to luck, Jason... you earned your own luck." This was only the second time in my life that I can recall that time stopped. It was also one of the greatest things anyone had ever said to me.

I think when you are a student of any subject; you are always looking for validation from your teachers. You may have some idea of how well you did based on the grades that are listed on your transcript at the end of the school year, but even those don't always paint an accurate picture. It's a whole different feeling when it comes verbally to you in a private one on one conversation. What they say about you doesn't have to be long: one simple sentence is like a masterpiece. It's more powerful than any "A" on a transcript, and I believe the feeling you get from hearing praise directly from someone whom you truly admire stays with you longer and propels you forward.

A GAME OF BASEBALL

It's a full count—three balls, two strikes. You try to remember every-thing your father told you: "Keep your eyes on the ball. Check your stance. Set your feet. Bend your knees. Get the bat off of your shoul-der." This stuff wasn't too hard to remember since my dad regularly umpired my Little League games.

The bat was now cocked and ready to connect. It's a fastball. You swing with all your might. At the crack of the bat, a deep fly ball goes to left field and over the fence. Home run!

That's how it always happened in my dreams anyway. I never got to hit a home run in real life.

If life were like a game of baseball, you would hope for a home run scenario every time. But in reality, there are some curveballs, knuck-leballs, change-ups and quite possibly some spitballs thrown into the mix to make things more challenging. But challenges are part of the game, regardless of whether you're playing t-ball, Little League, or the Majors. Challenges can also take you off-course, but don't let them. They're usually building blocks for something greater—something too fast to see when they're coming at you at ninety miles an hour.

GALLOPING WEIMARANERS:
WILLIAM WEGMAN INTERVIEW

William Wegman, *Untitled (Dog Wearing Boots)*, 1988

On an overcast December day, I took a bus from Boston to New York City to interview artist William Wegman. I rang the buzzer outside of his home and studio in Chelsea and then proceeded up the stairs. Greeting me were four full-grown shiny, silver-coated Weimaraners, galloping toward me at full speed—their barks echoed incessantly.

The two younger dogs, Topper and Flo, were rambunctious and playful, jumping up on me—their front paws reached onto my shoulders and beyond. When they weren't attacking me, they taunted the older dog. Once Bill tossed a handful of treats onto the floor, they calmed down. They were like children scurrying around picking up candy after someone broke the piñata.

Jason Landry: Describe an ordinary day in the life of William Wegman.

William Wegman: It has to be dominated by dogs, since there are four of them and they need to be fed and walked. So that starts the day. As far as work goes, I have to do some ordinary stuff, like tend to emails. Photoshoots tend to be scheduled in advance. I have my own studio downstairs.

Recently we did a project for a magazine, and there were a lot of props involved. The young dogs that I have need to work, and I'd like to keep that going. Whenever the studio is available we'll just run down and do stuff. I've been photographing the two young dogs in action play-fighting—they look like wild beasts! The problem is, when we're down in the studio and have the photo lights on, they behave too well and stop playing. So, I need to figure out how to get them to act natural. I guess this is an age-old problem in photography—how do you re-stage "action" to have it look spontaneous—from war photographs to just any kind of action shots.

To get back to your question, lately I've been painting a lot with these postcards extending the edge of the images, and that's a daily activity that goes on throughout the day when I'm not taking photographs.

JL: I heard that you have been playing a lot of hockey?

WW: I started when my son started to play, so that is when I turned sixty and he was nine or ten. I played all during my childhood, but didn't play in college because MassArt didn't have a hockey team. So I gave it up. I didn't play on a team until about ten years ago. My team plays two games on Monday and two games on Saturday night, I have a practice on Thursday afternoon with a pro, and then I play something called "open hockey" at any time at noon, which I do. The most I've played regularly was eight games a week, and that was last year...but that's too much.

JL: Do you have a favorite team?

WW: I don't really care about watching hockey. I like it before the Stanley Cup where you just watch it for the purity for the game—you don't root. The games have really changed even since the early '90s. Watching hockey now is very different than it was ten or fifteen years ago.

JL: You live in NYC for most of the year and Rangeley, Maine, in the summers. What can you do in NYC that you can't do in Maine and vice versa?

WW: I don't have the access to my staff that is here in NY when I'm in Rangeley. They usually run the equipment, and when I'm there I'd have to arrange for people to come up. Back in the day, before digital, I used to photograph using a two and a quarter negative, and could develop the film myself. Now with digital, I can't really do it myself. I probably could, but I've chosen not to, because there are so many options. I tend to bring smaller things up to Maine that I can be working on, such as text for a book.

JL: Do you approach photography differently than your paintings?

WW: Yes I do, and that's evolved and changed over the years. When I was working with the Polaroid 20x24 camera, up until a few years ago, that was a very different way of working that I felt was more like how I made my videos, and that was very different from

how I worked with the two and a quarter format twin lens camera. In the beginning and in the early '70s, I would make sketches, little thumbnails of what I wanted to set up. With the Polaroid, I learned to bring a few props and just fool around, start staging things there on the spot. I might have an idea, but would be very willing to abandon it in favor of something else. And that's how I pretty much worked with video.

JL: And with your paintings, I see that you're doing a lot with postcards. Where did that idea come from?

WW: It came from a nature book that I made on the parody of nature in the early '90s. On one page of this book, I extended some Rangeley postcards so that they met up with each other. I didn't think that much of it. It was kinda part of my collage thing. I think it came out of what I use to do with my own photographs—I used to alter and paint on them. So this was just a variation of that. I used to do it with greeting cards. There was this evil impulse to change things— to sabotage the greeting somehow—to make the greeting card say something that it wasn't intended to. So it comes from that spirit.

There was point when I switched from working on paper to working on wooden panels. I would temporarily stick the postcard up and begin exploring the connections with that postcard with another one.

JL: What is the first photograph that you remember seeing?

WW: That one's locked in the past. I grew up during World War II. My father was a P.O.W. actually. I didn't see him until 1945, until he was liberated. I'm sure the war photographs, the pictures of my father who was shown to me, one day I'll meet or not, so it was probably family pictures of my father in the Air Force. I remember seeing one picture that I'm still pretty attached to of my father reading to me and my two really pretty cousins when I was around five or four—it's a classically staged photograph. We weren't from a family that had cameras, so we'd have to arrange for pictures. Some families in the '40s and '50s grew up with cameras—we weren't one of them.

JL: So, that first staged photograph, do you think it has anything to do with the way you stage things nowadays, both in painting and photography?

WW: I think so, possibly also my connection with nature since I grew up in rural Massachusetts not suburbia. I grew up in a quarry town where there were these fantastic places to swim and explore, and I was always in the woods building huts and rarely slept inside. I liked to fish, and I had a dog and a paper route. It was sort of a classic, almost a Norman Rockwell but a more rural version of that.

My abilities in painting were recognized early on. I was known as "Billy the Artist," and that is why I went to art school. I didn't really take photographs until way after grad school because my roommates were Art Sinsabaugh and Robert Cumming, two really great photographers, and we used to argue whether photography was art or not, and I was on the nay side of that. I certainly did reverse my opinion.

JL: So you went from painting to video to photo. Do you remember the first successful photograph that you ever made?

WW: I certainly do. I had been making photographs at first to document some of the installations and performance-type pieces that I was doing. But I remember thinking, Gee, what I am doing is staging photographs and became aware especially when I began influencing how they turned out. I took one photograph that I titled *Cotto*. It was a picture of my ring finger reaching into a plate of salami. It was graphically very striking and it was also kinda strange, the idea of meat and design were kind of fused in that picture. It just jumped out at me and gave me the courage to do these just as photographs—just stage things just as photographs, which was new at the time. It probably had existed in my world in Bruce Nauman and other things that he was doing. I don't claim to be the first, but for me it was something that I discovered.

JL: What did your parents think about your career as an artist. Were they supportive? Did they get it?

WW: I'm not sure they got it, but were very supportive. I did very well in art school and kept getting scholarships, which made it easy on them. We weren't from a very wealthy family; I worked to put myself through school. I was a night watchman and did all kinds of crazy jobs. They were very proud of me. I was the first of our family to go to college, so it was a big deal.

JL: How many Weimaraners have you had in your lifetime.

WW: I think I'm up to ten now. The first one was Man Ray. I got him in 1970 and he lived until 1982, and then I got Fay Ray in 1986. I lived three years without getting a dog. I didn't want to repeat the Man Ray experience—that was perfect. I got Fay because there was something kind of haunting when I first met her in Memphis, Tennessee. I couldn't get this amazing face out of my head—I didn't think that I would be photographing her, but eventually I did. John Reuter at Polaroid invited me to the studio to try her out, and she loved it! It was a huge event for both Fay and I. The next stage was when she had puppies. She had a litter of eight and I became very close to three of them. Her daughter Battie is one that I kept; her son Chundo went to my sister, and I continued working with her, and the other girl, Crookie, went to the Rangeley dentist, and I worked with her. So those three, plus Fay, so now we're up to five, and then Battie had a litter that produced Chip. Chip had a litter that produced Bobbin. Bobbin had a litter that produced Penny, which involved Candy, and now I have two more, Flo and Topper, who are not related to the Fay line. Bobbin is the end of the Fay line.

JL: How do you know when it's the right time to bring another dog into the family?

WW: Last year one of the dogs, Penny, came down with lymphoma. She was having chemo treatments. She was eight years old. Chemotherapy is very successful for lymphoma, but it only gives you a year of life at the most; otherwise, you get maybe fifteen to twenty days. To cheer everyone up, we met Flo from a breeder in Syracuse,

and she was offered to me, and everyone thought that it would cheer everyone up, including Penny, which it did. When Penny passed away, I was left with two old dogs, Bobbin and Candy—they were twelve and ten, and Flo needed someone to keep up with, so we got Flo's half brother, Topper. Topper is Flo's dog...they play constantly. Both of these dogs love to work.

JL: From the photos, most would think that your dogs are the best-trained dogs in the world. Do you have a specific routine in the way that you train them?

WW: As you know very well, they aren't trained at all—they are wild and crazy. They like me. They like to see what I'm doing; they like to be around me. It's kind of a work ethic. When I'm down in the studio they like to be involved. With Flo, she got to see Penny working when we were doing the *National Geographic* cover. She would sit right next to her. When the strobe lights go off it's very Pavlovian if you then say "good dog" rather than hitting them. It is something that becomes positively reinforced. Someone said that I train them using my hands. And it's true, I'm always holding them or touching them or moving them into position, rather than using voice commands.

JL: Do you think the dogs know when it's time to work?

WW: Absolutely. When we use to go to the Polaroid studio, they used to walk a mile to work through all of these parks. They got to see their old friends—we probably worked at Polaroid every other week for a few days—we were regulars, but not a constant thing. It became special. The dogs were elevated, especially at the Polaroid studio where the dogs were on a platform that was brought up to the level of the camera. They like being tall. The studio is a special environment.

JL: Which one of your dogs was the hardest to work with, and which one has been the easiest.

WW: I think Candy because she is the most agile, but not the most

attractive (sorry, Candy), but she's a phenomenal spirit. She loves to work, but only for a second. You get everything all set, and you're about to click the shot, and she's gone—I'm done. I figured out that I could work with her doing action shots, and that has really led to a change in my work. I've done pictures where she looks like she is doing handstands or flying through the air, or doing these incredible balancing things—so I've found a new way to work with her. With the younger dog, Flo, she's very dominant—alpha female—and she gets very jealous when working with other dogs. She commands the space.

JL: Some artists have been noted as saying that their artwork changed once they had children. Did you see any change in your own art after you became a father?

WW: I re-edited all of my children's books when they were reprinted to be much shorter because I realized that you read children's books to get your child to go to sleep—you don't want to be up half the night reading a book! I did children's books a few years before I had kids. I did them because I was asked to do them, and they became fun, and they were a project, and I've always been better at projects than if I was left to my own devices. I remember these art classes in college at MassArt. I'd always do better stuff in the illustration and design classes than I would in my own painting classes.

JL: On your blog you often post "While On Hold" sketches. Do your sketches come from the topic of discussion that you are having on the phone, or are they just random?

WW: I guess I don't really know. I usually start with a hook nose, because there was a certain point in my childhood when I realized that I have a funny nose, and I when I was a kid I used to draw Indians with hook noses, and I didn't have one of those, So every one of my profiles has a hook nose on it.

JL: You have undoubtedly been interviewed many times and answered many questions in your lengthy career as an artist. What's the one question you hoped someone would have asked you by now?

WW: Any of those types of questions when they say, "Do you have anything else to say?" I really don't have anything to say. I like the response to a question, rather than thinking about one on my own. Right now I'm thinking, God, I can't wait to go up to Maine to go cross-country skiing with these dogs so I'm not constantly entertaining them. Last week, I was thinking about college because my son just got accepted to college. That was the biggest thing—where was he going to go to school.

JL: What's been the best bit of advice that you have received in your lifetime?

WW: "You ought to go to art school." That was from my high school art teacher and she recommended that I should go to MassArt. And I don't know what would have happened if I didn't go. I wasn't very good at pumping gas, and I wasn't smart enough to go anywhere else. It was a totally wonderful decision on my part. I'll be always thankful to Mrs. Laramie from Classical High School for saying that you should go to art school.

THE PROLIFERATION OF THE IPHONE

"No photographer is as good as the simplest camera."
—EDWARD STEICHEN

On November 1, 2007, I attended a lecture hosted by the Boston University School of Visual Arts—their speaker, contemporary artist Chuck Close. As I sat with a fellow photographer, I told him,
"When it's time for the Q & A section, I'm asking Chuck a question."
He was like, "No you're not."
Sure enough, as soon as they opened the floor for questions, my ass popped right up out of my seat.
Here's a transcript of my question and Chuck's response (you can probably still find a video of it on YouTube):

Jason Landry: Chuck, you call painters "orchestrators of experience." What do you call photographers?
Chuck Close: I'm so glad you asked that. I love photography. Photography is the easiest medium in which to be competent. Anybody can take a competent photograph, give'em a good point-in-shoot camera, and give'em several hundred shots. There's gonna be an accidental masterpiece in there someplace. Believe me there's never been a painting that was an accidental masterpiece....that makes photography

sound easy. But without touch, without signature style, without physicality, and pushing stuff around, it is the most difficult medium in which to establish your personal vision.

For all you photographers reading this: Not everyone can do what you do. There is an epidemic in the world of photography that I'm not afraid to address. Everyone with a camera-enabled cell phone or a point-and-shoot camera can be a photographer, and we wonder why some people question the prices that they see when they walk through galleries. The quote that I heard as this twenty-something girl walked through my gallery was:

"Why is it so expensive?" a question directed to her boyfriend as she glanced at one of the pieces hanging in the gallery.

He responded, "You don't get it...you don't get it?"

Her response, "No. Come on honey, let's go get a shamrock shake."

A shamrock shake...That's what it comes down to? You know what, go have your Mcjizm. And take a picture of it, because you know you will.

Right now, some hipster is posting a photo of his new pork pie hat on Instagram—Bro'...you're a pimp! On the other side of town, a young girl is taking a #selfie, a slang term for self-portrait. They'll make sure all of the key words in their posts have a hash tag, you know, the thing that looks like this (#). This is a way for people to follow current trends—they're known as tags. It also makes it easier for people to find and "like" something that someone posts. Why do I know this...because I do it too. What did people do before camera phones?

I read a statistic that over 200 million photographs are uploaded to Facebook every day! Add in Flickr, Twitter, Instagram, Tumblr, and the slew of other social media websites, and you get BILLIONS—all from digital media devices—that includes digital cameras and cellular phones, and none more popular than Apple's very own iPhone.

Photographs taken from these phones are instantaneous and can be shared and distributed on the Internet so fast that a picture of two squirrels humping in a park can go viral within minutes. I myself have had every iteration of the iPhone since its inception. So it doesn't surprise me that Apple has sold more than 350 million iPhones globally. It's a game changer for sure and I can't live without mine. Some of the photos that I've made from my phone, I have to admit, I would have probably thought twice taking if I were using a real camera.

Why? Simply because with a real camera I would always over-think the shot—plan too much—something that haunts many trained photographers. The iPhone basically taught me how to loosen up and play—just snap away.

The iPhone has excited a generation about photography. So does that help the medium we love so much or hurt it? I think the "I could do that" mentality needs a slight adjustment. Just because you can push a button doesn't make you a photographer. It is much more than that. It is learning about the history of the medium. It's understanding composition, and as Chuck Close answered for us in the lecture quoted above, it's having a personal vision. In the Spring 2011 issue of *Spot Magazine*, published by the Houston Center for Photography, Curator Anne Tucker was quoted as saying, "...everyone with an iPhone is a photographer, but whether we care about them or not, beyond their family and friends, is a whole other thing. Whatever craft we are using has to be intelligent and it has to be a fresh and engaging use of that craft."

Bravo, Ms. Tucker...I love it!

What impact has the iPhone and other smartphones had on photography and visual communication? For starters, it has given millions of people a portable phone with a built-in camera. I'll take it a step further: Even legitimate art galleries have begun to have iPhone-and smartphone-themed photography exhibitions. The resolution and quality of some of these images are now starting to catch up with the

digital point-and-shoot cameras. But can we consider photographs captured from a camera created from a tiny lens in a cell phone as good art? Would someone spend money on a print that was shot with an iPhone or smartphone? Ironically the answer is—Yes. In a way, the instantaneous nature of digital images has taken the place of the once popular Polaroid, a camera that took instant pictures that you could see in minutes. It's sad to say, but photographers are now trying to find new ways to stay relevant in an Instagram world.

What makes a Photographer a Photographer?

Let's change channels for a bit. Would you say that there is a caché to being a photographer? I surely think so. If you are a photographer reading this, at what point did you consider yourself a photographer? Was it when you received your first camera, or was it your first experience in the darkroom? Was it your first exhibition, or the first time you sold a print? For me, it was the day that I stumbled upon that mural in California with the tagline, "Remember Who You Are." That was my ah-ha moment—it was the moment when I knew what I wanted to be. Would a person who had just purchased an iPhone for the first time say that it was *an* "ah-ha moment"? Maybe.

To be a photographer is to be driven—visually literate. It's how you express yourself, your desires, and your needs. You are not a voyeur, although some have been called that. Alfred Hitchcock's *Rear Window* brought that idea into many households. Photographers look at everything as if they were composing a photograph. Okay, maybe not all of them, but when I see something visually appealing, I'm thinking of ways that I would photograph it. Photographers are always pointing their lens toward something—the good and the bad, and sometimes the ugly.

"I photograph to find out what something will look like photographed."
—GARRY WINOGRAND

To answer the question of "what makes a photographer a photographer," let's examine both sides of the coin. What photographers were doing 100 years ago varies tremendously from what they are doing today. In the twenty-first century, some photographers are concerned about their art projects, series, and assignments—we have to thank the art schools and colleges for drilling these things into their budding heads. Then there are those artists that Dave Hickey, writer and art and culture critic, ran into at Yale who had other ideas. Hickey is quoted as saying, "...when I asked what they planned to do, they all say move to Brooklyn—not make the greatest art ever.[7]

Folks, I'm sorry. This is a fucking problem. Whoever said this to him should quit what they're doing and find a different career. If all you wanted to do was join the big art gangbang in Brooklyn, you could have saved a shit ton of money on your Ivy League education and put a down payment on a quaint brownstone in Bushwick. With such an overpopulated grouping of artist egos, I'm surprised they can all co-exist! Who needs a roommate?

In the 1800s and early 1900s, photographers were learning to document times and events and seeing how things looked like as photographs, and none of them wanted to move to Brooklyn. Photographers weren't working in "series"—they were just making photographs. Their images are the building blocks of what we see today. There are days when I think that photographers are too tied up making projects and a good series that they forget what it's like to just see something and make a photograph of it. Please—somebody—shake things up...break the rules!

There was an article in the Saturday/Sunday, March 31-April 1, 2012, *Wall Street Journal* with a headline that read, "Is the iPhone the Only Camera You Need?"

7 *The Observer*, October 27, 2012

My response: One of these days that may be the case. That's what I think. Yes, the iPhone is great, and the camera built into it is great too, but it is not a Leica, Hasselblad, Canon, Nikon, Holga, or Lomo. It's not a Yashica, Rolleiflex, Polaroid, Mamiya, or Toyo either! Even if they have applications (apps) to mimic what an image from any of these cameras might look like and cool editing tools, it's the actual feel of the camera and the experience of using it in your hands that makes the difference. And on top of that, it's the output: the final printed image. I cannot see how an app on a smartphone will ever change that. The craftsmanship of some of the German, Swedish, and Japanese cameras, and the un-craftsmanship of the toy cameras are so different than a sleek rectangle device that slides nicely into your jeans pocket. What about the whole process of setting up a large format camera on a tripod, connecting the lens, leveling everything off, holding the loupe up to the ground glass, sliding the large film holder into place, pulling out the dark slide, and then pressing your thumb down onto the cable release— Oh the world looks so sweet upside down and under a dark cloth!

If some of the history of photography's greats such as Henri Cartier-Bresson or Ansel Adams were still alive, they would marvel at the invention of the iPhone, but I could almost doubt that they wouldn't give up their trademark tools to walk around creating photographs for the masses with a camera phone. Cartier-Bresson wouldn't be able to capture his decisive moments because it takes too long to turn the damn phone on and get to the camera app, and Ansel would hate the fact that he couldn't take an accurate light meter reading of the landscape to make sure his image would have a perfect tonal range—but then again, he would probably hire someone to design an app for the zone system and a technical light meter (and I'm sure by the time this book gets published, some developer will have figured out how to make one). On the flip side, I think someone like Dr. Edwin Land, the creator of Polaroid, would marvel at what an iPhone can do—seeing that he invented the Polaroid

camera after his young daughter asked why she couldn't see the picture immediately after he took it.

Technology is cyclical. Just like in the camera industry when a new digital camera comes out that will "revolutionize how you take photographs," the iPhone has competition too—albeit light. There's always some brand out there looking to knock you out of first place.

Now for a slight rant (you're probably thinking, what the fuck was everything else in this chapter, right?). For the novice, and I'm only trying to help you here, you drive me absolutely crazy when you are snapping away taking photographs while you are in full stride. If you see something that you want to save and remember for later—stop, compose the image, then shoot. Composition is very important. This is just another difference between a trained photographer and a novice. Photographers think about composition and know exactly what they are capturing, from edge to edge of the frame. A novice approach is just taking pot shots at whatever they want and have no idea what they are gonna get. Why bother taking the photograph? It will just be blurry when you look at it later—and before you say anything, there *is* a difference between intentional and non-intentional blur in photographs.

I am a huge fan of all things Apple and have been a stockholder on and off for many years. I have owned iPhones, iPods, iPads, Macbooks, and desktops (not to brag—just the facts), but let me just say this, you do not learn how to be a photographer by just visiting the Apple Genius Bar or downloading the coolest app from iTunes. If you are serious about studying photography, take a class, enroll in a local art school, befriend actual photographers, or intern for some. Being a photographer is a lifestyle. Now, when does that new iPhone come out?

DICTIONARY OF RECEIVED IDEAS

When I was in graduate school I kept a blog titled, "untitled at the moment." It's gone now—it got spam-jammed thank you ma'am. However, I was able to recover one of my blog posts dated August 6, 2008:

Gustave Flaubert, French writer from the nineteenth century wrote a satirical book called, *Dictionary of Received Ideas* (it's also gone by the title of *Dictionary of Accepted Ideas*). When you look up the word, "*photography*" it reads:

"Will make painting obsolete, (see Daguerreotype)."

Flip back to the word *Daguerreotype* and it reads:

"Will take the place of painting, (see Photography)."

Yeah...nothing's changed.

SLOW YOUR ROLL

"Errer est humain; flâner est parisien."
"To wander is human, to flâner is Parisian."

—VICTOR HUGO, *Les Misérables*

If you find yourself traveling, especially to Europe, you'll see people taking their time. They don't eat fast; they nibble and have conversation, often spending hours at the dinner table while having multiple courses. They don't shop fast; they browse and meander, lingering about without a care in the world. You'd think with all of the espressos that they drink, they'd be all hopped up—nope, quite the contrary. I suspect all of the cheese, bread, and wine counteracts that.

Transitioning from a fast-paced, high-stress corporate job into art student and photographer, I remember trying to slow down my pace and take in more. It was a constant struggle. After finishing my bachelor of fine arts, my travels took me to Paris where I lingered, soaked up the culture, and walked in the footsteps of the great Parisian poets, writers, and photographers. Yes—I was connected to Paris through the photographs of Cartier-Bresson, Brassaï, Atget, Doisneau, and countless others. Through the writers and poets like Baudelaire, Hemingway, and Wilde, I found a place where I felt comfortable

and yet disconnected all at once. Someone said, "Have fun being a flâneur." I had no idea what they were talking about.

I did some digging to better understand the term *flâneur* and its origins. It's a French word, which has no exact English translation, although the *Oxford Dictionary* defines *flâneur* as "an idler or lounger, one who strolls." Is it even possible to be a *flâneur* today?

The word earned notoriety in the nineteenth and early twentieth centuries in Paris, both in literary and photography circles. Flâneurs were individuals who were mainly concerned with the overall changes that were taking place in the city and wanted to document and comment on them. They were spectators, similar to fans that watch their favorite teams play; flâneurs are there to monitor the goings-on in their cities. I would also consider them to be like detectives, or in the art world like critics. They sit in the outdoor cafes with their seats turned outward to the majestic boulevards while they sip espressos and cappuccinos and watch people. Where do they get all of this leisure time? Doesn't anyone work anymore?

In the 1800s, poet Charles Baudelaire was the big Parisian flâneur. He was the quintessential artist-in-residence in this city—a passionate observer of all things. His poems are well thought out details of the city life and his surroundings. However, his stories are charged with a pulse of negative energy, specifically penned using the word *spleen* to describe the sadness and depression he felt around him.

In his poem, *To a Woman Passing By*, Baudelaire recalled the one who got away. I can totally imagine him in one of the many outdoor cafes in Paris analyzing each person passing by like a true flâneur would—in his case, with a sulking disdain and arrogance. As I read through the passage further, the poem could be about more than just one person that got away, but a lifetime of loss.

> Around me roared the nearly deafening street.
> Tall, slim, in mourning, in majestic grief,

A woman passed me, with a splendid hand
Lifting and swinging her festoon and hem;
Nimble and stately, statuesque of leg.
I, shaking like an addict, from her eye.
Black sky, spawner of hurricanes, drank in
Sweetness that fascinates, pleasure that kills.
One lightning flash...then night! Sweet fugitive
Whose glance has made me suddenly reborn,
Will we not meet again this side of death?
Far from this place! too late! *never* perhaps!
Neither one knowing where the other goes,
O you I might have loved, as well you know!

I was so moved by this poem that I did two things: I made a photograph creating a visual rendition of what I had read. Then I purchased a photograph of Charles Baudelaire.

Flâneurs were a part of their own counterculture, establishing their own views on society. Before his apparent suicide, writer Walter Benjamin was working on a book called, *The Arcade Project*. Among other things, it was an ode to the passageways throughout Paris. These passageways, still in use today, run perpendicular to the main streets and may cross multiple streets before they end. They are lined with galleries, cafes, and stores selling consumer goods—an elegant place to be a flâneur.

Flâneurs don't bother with the popular and picturesque. Rather they're more interested in the obscure and hidden—the stuff on the fringe of society—the stuff most people don't see. When you know a place as well as a flâneur does, and you live in it day in and day out, you can become blasé about the sights most people line-up to see. In Paris, I find it hard to escape the thrills of the city's history, punctuated by its world-renowned art and culture.

Flâneurs see through it and imagine something else. They'd be the first to tell you, Don't fall into the tourist traps. Skip the Eiffel Tower

and the stairs up Notre Dame Cathedral. Meander along the Seine. Get lost in one of the many arrondissements, sit in a chair in the Tuileries and watch the little toy boats in the fountain. For heaven's sake, do not go to Disneyland Paris! (Secretly, I still want to go.)

There were a number of well-known photographers who made a name for themselves in Paris, none more popular than Henri Cartier-Bresson. With a small, 35mm Leica camera, Cartier-Bresson was the roaming gnome—a photographic flâneur who'd walk aimlessly through the city taking quick images before most people knew what he was doing. Sometimes he'd sit and wait for what he called "the decisive moment." His photographs captured the exact moment when the magic happened!

On the flip side, there was Eugene Atget, a photographer obsessed with documenting the city in a more scientific and clinical way. Atget was a preservationist—a collector of details. Atget wandered the streets with a large format camera and tripod, cumbersome even by today's standards. For what he was shooting—mostly still, immobile objects—he needed all this equipment.

The process of using a large-format camera slows photographers down and makes them look and think of everything in the frame— perfect for a flâneur. Another positive aspect of using this type of camera is that it is able to capture greater detail. In Atget's case, this was important. His images were of details—door knockers, wrought iron railings, archways, storefronts, bridges, and statues. He captures the whole as well as its parts. Although Cartier-Bresson and Atget approached photography through different camera formats, they were street photographers after the same thing: preserving their Paris as they witnessed it.

Speaking from experience, I have approached photography through both camera formats and have found both viable and interchangeable when necessary. Students of photography, before digital, would usually start off with a small 35mm camera, then work their

way to the large format. This way they learn technique and to slow their process. They first "run and gun," then become a slow-moving turtle. Art imitating life!

In the fast-paced contemporary world, the flâneur has become virtually non-existent. Generally speaking, people are looking for things that are quick and cheap—frugal consumers on tight schedules with limited breaks. Digital toys—cameras and phones—have completely changed the photography spectrum.

The nature of the flâneur can be anywhere. In fact, you don't have to be an artist or a writer to be one. All you need is a set of eyes and some patience. Paris was the best place to jump-start my investigation, but flâneurs can be found wherever you live, if you take time to look.

Most of the photographs that I have made have come from walking around the various cities and towns I've visited. Each time that I created an image, I captured a moment in time unique to my eyes that cannot be replicated. It was my observation. Maybe I was a photography flâneur. I wandered about using my camera's lens to capture the scenes that my eye dissected into details that I would present to viewers. I am forever connected to the images that I made, and through these images, I'm part of these places.

To make contemporary photographs in the style of the great Parisian artists, working on their turf, was a very difficult task, because they, in a sense, were blocking my view. When I decided to come to Paris to make art, I took an unlikely path: I began photographing along the Seine. I didn't actually choose the Seine as my subject—it chose me. Two banks divide this river; the Right Bank, or *La Rive Droite*, is considered the financial and economic section of Paris. *La Rive Gauche*, or the Left Bank, is the artistic and more bohemian area. As I walked this river, crossed its many bridges, and watched this city as an outsider, I began to think about how this division pertained to me, once a businessman and now an artist. The Seine became my muse.

By taking the stance of the flâneur, I broke away from the cliché of the traveling tourist and explored seeing as the flâneur would, as a strolling observer. This self-guided analysis was my way of finding the photographic interpretation and relationship between the business career that I left behind, while searching for the artist I would soon become. I'm not only connected to Paris by a project, but through some of history's greatest photographers who I admire and through the photography events that the city plays host to every year. Although it's not the birthplace of photography, it's where many artists come to find inspiration and to create.

This city provided me with a moment of rebirth that I cannot dismiss.

ODDS AND SODS:
THE STORY OF A PHOTO WEENIE

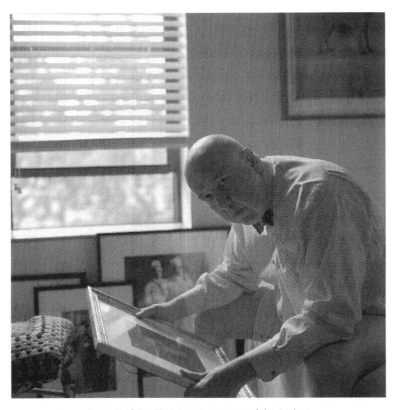

Portrait of Jim Fitts. Image courtesy of the Author

As one door shuts, another one opens. That is the saying, right? This also holds true for the people who have rotated in and out of my life. And with mentors, I try to hold onto them for as long as possible. Some are meant to be around for a while, while others come in, do their job until their job is done, and then move on to the next worthy subject. I learn from them because I want to be just like them. Having mentors are an important part of being an artist. You need people around you who can guide you and provide feedback. I value them as much as any class that I have ever taken.

Jeffrey Keough pulled me aside one afternoon to tell me that he had made an appointment for me to meet one of his friends, Jim Fitts. He said that he told Fitts about the photography book auction that I organized and hosted a few months prior at the college. Knowing how much of a tedious task it was to manage a benefit auction, Fitts was intrigued that a young student could have pulled off something like this. Jeffrey then explained to him that I wasn't any ordinary student—and I wasn't young. At thirty-four years old, the school referred to me as a nontraditional student.

Fitts is that person whom I referred to earlier in the preface as "he-who-shall-be-named-later." He is the former executive director of the Photographic Resource Center at Boston University. I had seen Fitts at PRC events before—tall, bowtie-wearing Mr. Clean type, but I had never spoken to him. When people address him, I've noticed that men call him "Fitts," women call him "Jim," with the exception of my wife who calls him "Uncle Jimmy." He was a MassArt alumnus from way back. I've since learned that alums tend to look after alums—other alums...take note of that.

On July 23, 2007, I took my portfolio of prints to the PRC to get a review from Fitts, who was at the helm of this barge. As I sat in the library waiting for him, I looked up to see the room was filled—all four walls—with photography books. My photographic heroes looked down on me. I recognized many of the spines of the books

because I had them in my own collection. The difference here was, these books were all organized according to the Library of Congress reference numbers, not by size of book or by artist.

When I met with Fitts, he wanted to know what had I been doing the past few years and what projects I had been working on. He commented on my print quality, saying that the work looked good, and he could see "me" in the portfolio of photographs that I had taken of my wife, but in my other projects "I" wasn't present. And he was right. I was more invested in the photographs that I was making of my wife and less of the other projects.

I don't recall anything more about my first post-college portfolio review, which lasted about an hour, except or the fact that it felt more like an interview.

Two months later, I approached Fitts at an opening reception at the deCordova Sculpture Park and Museum in Lincoln, Massachusetts. I was at the museum to network and see the exhibition, but the hour that I spent with Fitts at the PRC gave me some ideas that I wanted to discuss with him. I didn't know I'd be running into him there, however, I figured this would be a perfect venue to get someone's attention, in a public place, where I might not be pushed away that easily.

"Fitts, remember me...Keough's friend? Have you ever thought about including some younger members on the PRC Board of Directors?" He laughed. Then he asked,

"So who are these younger board members that you speak of?"

"For starters, you're looking at one of them."

Okay—I had no idea what I was thinking. I hadn't the slightest idea what a board of directors does or what a board member is expected to do. Certainly, I had never been one before. I don't remember exactly how the conversation ended—probably a little awkward.

At home that night, I typed out a two-page bulleted list of ideas and suggestions of things that I thought could benefit the PRC, such

as include some younger board members, create more young professionals events, bring its social media presence up to date. These were all things that I knew I could do—things that might entice younger individuals into becoming patrons of this great organization. These ideas just flowed, the exact same way the idea of doing a book auction for my class came to me—I write them down and present them. I never had any reservations about doing this—you only live once, and what harm could it do. A day or two later I got a call from Fitts. He said that he and the president of the board of directors wanted to take me out to lunch.

After going over every bullet point on my list, I was invited to the next board meeting and voted in. This was just another turning point in my life in photography. Joining the board of directors put me in front of so many important photographers, collectors, gallery owners, curators, attorneys, and corporate types—many of whom frequent my gallery and stay in touch.

Fitts's guidance and suggestions became invaluable to me during this pivotal time in my career. From our many conversations, he knew that I intended to open my own gallery. He told me to be patient and spend some time at the PRC getting to know board members and helping them become familiar with me. He told me that I'd know when the time was right to open my own gallery—and he was right.

The two years that I spent at the PRC, both as a board member and employee, was an important educational experience. I was assigned a few different jobs that enabled me to gain know-how that would eventually help me run my own gallery. I also implemented many of the ideas that I had sent earlier to Fitts.

In a bad economy, as it was in 2007 when I worked for this nonprofit, staying relevant, having funds to operate the organization, and maintaining members always seemed like a struggle. We needed members. We needed patrons, and, sadly, we needed people who could write checks. This is the case with many nonprofits in the twenty-first

century. Support is needed to keep these organizations running, whether it comes from a large, sustainable endowment, smaller gifts that underwrite particular events or projects, or hundreds of smaller checks that support general operations. Art organizations end up closing without this kind of support.

Part of the executive director's role, besides running day-to-day operations, was to ask for money, and Fitts was really good at it.

"Could you see it in your heart..."

"It's only a few hundred penny dollars..."

Oh, I can't even count the times I heard those statements. But seeing how he operated, almost like an entrepreneur, and how he spoke to people, as if they were friends or family, taught me a lot about how *I* needed to run my own gallery.

I have very fond memories of the lecturers we brought to town, the book signings, the annual auction, opening receptions, and even the nude people in the tanning booths—wait, what? Yup...this will need some explaining.

The PRC was tucked into a strip mall between a tanning salon and a pizza joint on Commonwealth Avenue on the campus of Boston University. There was a shared staircase between the tanning salon and the PRC, which both the gallery and business could access. The staircase led to the second floor offices for both businesses. One of the pluses to sharing the staircase with the tanning salon was the coconut smell that would waft through the salon, making our place smell great! It smelled like the beach—Honey, could you rub some lotion on my shoulders?

On most days, the salon door would remain shut. Our door was always shut. Still we could see the blue neon fluorescent glow through the crack under the door and hear the constant boom of rap music playing.

Imagine being in your office, banging away at a spreadsheet, and hear the loud echo of Fitts, "Champion...get down here!"

I'd run down the stairs and enter the gallery or library, and the door to the tanning salon would be standing wide open with someone buck naked getting a tan. I would have been a little suspicious taking my clothes off and lying in front of an open door—but I guess there are some exhibitionists who don't give a shit who sees them.

For me, it wasn't as awkward as running into someone just before or after a tan, while they are taking clothes off or putting clothes on (that hasn't happened yet to my knowledge). I have always felt that Fitts knew when the door was open and he called for me just to see what would happen. It happened way too often for it to be sheer coincidence.

All joking aside, we accomplished a lot at the PRC and also had our moments of fun. Fitts was well connected in the photography and business worlds and would always have a stream of guests stop by. Photographer Jay Penni was a regular—stopping by once in a while with his little chocolate penny candies or other treats: "Champion... get down here and try some of this smoked salmon!"

We'd devour that stuff and go home with heartburn. Photographer Keith Johnson would swing by to show Fitts prints and new lenses from Zeiss that he loaned to me to test. Rick Ashley, a.k.a. *Not* Rick Ashley, would entertain us with his newest photographs turned into oil paintings or photographs etched into glass sculptures that he had ordered from China. And then there was Rich Doucette. He would show up usually unannounced to reminisce with Fitts about their Mad Men days together in the advertising world...he seemed to be connected to everyone! There wasn't a person who walked through that door that Fitts didn't introduce to me. He was a connector for sure.

Fitts had always been a very private person and didn't really divulge much of his personal life. It was only when people from his past started showing up that pieces of the Big Jim puzzle fell into place. It wasn't any of my business by the way—I still don't know why I'm not allowed to call him Fitzy. After he left the PRC, and I wasn't reporting

to him, we became good friends. I've even evolved into his contact person—you know, the person who's called when he has to be picked up from medical appointments.

This private side to "The Noodle" (my new nickname for Fitts), many people didn't see. Besides being a member of *The Fabulous Wingtips*, a cover band that he used to play with, which reunited for his sixtieth birthday, he had one of the greatest photography collections in the Boston area. One afternoon he invited me over to his house to discuss a number of projects that we had been working on. It was then I realized what a photography collection *really* looked like. From Irving Penn to Henri Cartier-Bresson. From Robert Frank to Herb Ritts and Robert Mapplethorpe—these were photographs that I had only seen in museums and now they're right in front of me hanging throughout his house, or stored in archival portfolio boxes—it totally invigorated me.

Now that I own a gallery and Fitts is a semi-retired "photo weenie," I often have him co-curate exhibitions, assist in hanging shows, and meet with some of the younger, emerging artists. I talk to him more on a weekly basis than most people in my life. I'll call early in the morning or late at night and rant for a bit, and then he'll pipe in, "Are you done yet? Let me know when it's time for Fitts news."

We don't see eye-to-eye on every topic, and often we have drastically different opinions on the simplest of things, from design and layout on a postcard to dealing with artists' egos—but we both maintain an open line of communication, and that's the key. When he critiques work, especially with students, I hear that he often makes some of them cry. He is tough, but in the sincerest of ways.

"Did you make anyone cry today?"

He replies, "It's only 1 p.m. There's still a few more hours left in the day. What do you want me to do, be easy on everyone?"

One way he puts things into perspective, especially after I've told him one of my brilliant ideas, he asks, "Jason, what's your criteria for success?"

This is when I throw in the towel and listen and think. He never wants me to lose sight of the prize. What is the prize? I'm not sure. It changes daily.

He keeps threatening me that he's going to move to Thailand, get plastic surgery, and fall off the grid for a bit. I string him along by offering him a steady stream of champers, poo-poos, and soft serve (these are just a few of his vices, and we're talking about Champagne, appetizers, and ice cream—not all at once or in that particular order). He accepts, as long as he's not on Nutrisystem. Some days I offer to buy him a burrito, and then he'll counter and suggest a sit-down dinner. How do you say no, especially after receiving so much help and guidance?

Oh yeah, I once had to shave his head right before a big museum event when he forgot a spot on the back of his big shiny dome. I thought he was planning to grow one of those Harikrishna ponytails or something. I'll save that story for another book.

WITH TWO MINUTES TO SPARE

Fitts called out from his adjacent office,

"Champion, get on the horn with Larry Fink and make sure he's on his way."

Living in the Northeast, you'd figure we'd know better than to book lectures, seminars, and book signings between the months of November through March, especially when the artists and photographers are flying in from as far away as California, Texas, or even Pennsylvania. But oh no, we keep on truckin'.

Needless to say, December 11, 2008, wasn't any different. I was working at the Photographic Resource Center and Fitts gave me carte blanche to pick and choose the lecturers for that year's schedule. Seeing that the PRC had been around for over thirty years, I didn't want to keep bringing in people we have already had; I wanted to track down some of the finest photographers in the land.

For the most part, Fitts and I had similar tastes: we liked the classics—old school black and white photography. One individual we were both eager to hear speak was photographer Larry Fink, who had a few different, well-known bodies of work. He had a book, taken from a series called *Boxing,* and a book called *Social Graces,* which documented the Sabatines, a family in the Pennsylvania Hills whom he lived near for a short time. This book also included a section

that focused on dances and party scenes from New York to Washington D.C. His photographs freeze expressions—mid-discussion, mid-pour, mid-laugh, midnight. He had also spent time on the presidential trail following around soon-to-be President Barack Obama. Fink is a well-rounded photographer, who seamlessly incorporates fine art, documentary, and editorial all into one—a perfect mix for our members—students, collectors, working fine art, and documentary photographers—to enjoy.

Around 2 p.m. on the day of the lecture I got a call from Larry.

"Jason, my flight's been canceled. I'm gonna head back to my house."

"Larry, no you can't! We have a sold-out lecture tonight. I'll find you another flight."

"OK...I'll sit tight."

I quickly got on the horn to the airlines to check out the situation. They said that his flight was in fact canceled, but there was another one leaving in thirty minutes. I called Larry back and told him the new flight number and gate location.

"Jason—that one says canceled too. I appreciate your efforts, but it looks like we'll have to do this another time."

"No, wait! They promised that they could put you on the flight. Let me check with them one more time."

I called the airlines back, and they said, Yes, the second flight was canceled too. They explained that it had been snowing all day, and they would do their best to get Larry on the next flight out.

After about a fifteen-minute wait, Larry called back to tell me that he was on the plane and that he was scheduled to land around 6:30 p.m. The lecture was scheduled to start at 7 p.m. This might be tight.

With my "L. Fink" sign in hand, I met Larry in the baggage claim area at the airport as he came down the escalator. I immediately picked him out of the crowd. He had on a jacket, overlaid with a black vest and a pair of black OK-1 anti-vibration cut-off gloves on, the kind you would wear if you were either getting ready to go lifting weights

or ride your Harley Davidson or maybe you're cutting down trees with a chainsaw—who knows. We all piled into the car: Fitts drove, Larry took the passenger seat, and I hopped in the back—laptop on, preparing to set up his PowerPoint presentation. Larry handed over a flash drive and I popped it in.

The slushy drive from Logan Airport to our lecture hall, on the Boston University campus, took forever. Jim is a cautious driver and wanted to make sure all of us got there safely. Now if I were driving, I would have been speeding and probably slid around a bit as some of the roads were now slick. I kept an eye on my watch and began to get woozy cause it was almost show time. I hate being late. To tell you the truth, I'm never late for anything. The sheer thought of arriving late drives me crazy. I'm known for being punctual. We never start lectures late. We've had to cancel some because of bad weather, but never anything like this.

"We're cutting it close," I said. "I hope people don't leave." Larry, calmly and worry-free says, "Jason, sit back and relax."

From his side coat pocket, Larry whipped out a harmonica and started rippin' this bluesy tune. Through the rearview mirror, I could see Fitts gazing back at me. Although I couldn't see his expression, I knew he was grinning ear-to-ear. So was I.

We pulled up to the lecture hall with two minutes to spare. I jumped out with Larry, and we headed up the stairs to the lecture hall while Fitts went to go find a parking spot. I entered the room first and headed over to the podium to plug the laptop into the projection system.

Larry strolled into the room nonchalantly and said,

"I hope I'm not too late," and then whipped out the harmonica and started to serenade the audience with another blues-inspired tune.

Our board members, local collectors, students, and guests all began to clap, yell, and cheer. Another magical moment that I couldn't believe. I had never witnessed a lecture that began like that.

I took out my notes, stood at the podium, and introduced Larry. I took my seat, the lights dimmed, and he began his lecture. Then it happened.

A big "X" appeared on the screen. He looked up at it, then directly at me and said, "Well that isn't one of my photographs.

I jumped out of my seat and rushed to the front of the room to take a look at the presentation. The rest of the digital slides all had X's. The multimedia engineer that was assigned to that lecture hall stepped toward the podium and whispered to me, "Are you running the presentation off the flash drive? You're not supposed to do that. You've corrupted the drive!"

At this point I was losing my mind. Flop sweat, sick to my stomach—the whole bit. I scoured the room for Fitts, but he still hadn't made it back to the lecture hall. I looked up at Larry and then toward the audience and before I could say anything, Larry looked at me and said, "Don't worry. I burned the presentation onto a CD too."

He handed over a CD from his coat pocket, then whipped out his harmonica again and began ripping another jam while I set up the presentation all over again. He started to take questions from the audience before he had even started the lecture.

Someone asked about how he lit his subjects. He explained that he had an external flash attached to one of his gloves. When he was ready to take a photograph, he would pounce, like a frog flicking its tongue at lightning speed to catch a fly—whack! I sat back down in my seat and readied my embarrassed self for the lecture.

Larry clicked on the first slide, began talking, then the second slide, and then he stopped—stared back at the screen, then looked to me again and said, "Oops...I brought the wrong CD. This one is about my retrospective. Do you guys still want to see it?"

Loud claps and cheers came from the audience and the lecture continued without a hitch. Fitts finally made it back from parking the car, never realizing what kind of shit show had taken place.

I learned a few lessons that day. One, never run a slide presentation off of a flash drive—always move the files to the desktop first. Second, Be prepared for anything. And finally, roll with the punches. Things aren't over until the fat lady sings—and even then, someone might just whip out a blow harp and turn everything around.

A CONVERSATION WITH HAROLD FEINSTEIN

First published in the online magazine
Big, Red and Shiny
June 22, 2009

Harold Feinstein, *Coney Island Teenagers*, 1949

Before you get into the interview, I want to preface this chapter with how Jim Fitts and I became connected to Harold Feinstein.

Fitts was flipping through an issue of *Black & White Magazine* one afternoon while we were working at the PRC. He called me into the library.

"Champion, you got your degrees in photography and seem to know who's who. Who is Harold Feinstein?"

"I have no idea. Never heard of him."

Jim showed me the magazine article.

"Jim, these images are really great."

"Champion, he lives in Massachusetts. I'm going to write him a letter. If he responds, you and I are going to pay a visit to his home and you are going to interview him. If all goes well, I plan to assemble a team to help him find a gallery, get some press, and eventually get a book published of this work. Are you in?"

"I'm in."

Our mutual love for photography set us on this course. It wasn't something we were getting paid to do, nor did we know what the end result would be. It was a four-year quest to do all that we set out to do. Harold now has a few galleries selling his work—including mine. He has had international press, and with the help of Kickstarter, we raised over $40,000 and produced the monograph *Harold Feinstein: A Retrospective* with Nazraeli Press. The *Photo District News* (PDN) named *Harold Feinstein: A Retrospective* one of the best photography books of 2012. It's been one of the most enjoyable things that I've been able to do in photography thus far.

Now...on with the interview.

Forty-Five minutes north of Boston lives an amazing photographer. Far from the shores of Coney Island, a place that he frequented and photographed for more than sixty years, a new resurgence in the early black &

white work of Harold Feinstein has evolved. Recently I had the privilege of sitting down with him at his home for this interview.

Jason Landry: Do you remember the exact moment in your life that you knew that you wanted to be a photographer?

Harold Feinstein: When I looked through my neighbor's Rolleiflex camera. My first thought was, "This was easy." And that was it. I was about fifteen years old.

JL: I had read that by the time you were nineteen or twenty, you had met Edward Steichen and he began collecting your work. How did that come about?

HF: I just went to see him at the Museum of Modern Art (MoMA) and it wasn't a complex of a situation as it is now. Later on I read that he got the idea from Alfred Stieglitz that when they met a promising young photographer, they would buy two or three of their works as an encouragement, which certainly it was. Soon thereafter, Steichen was getting together work for *The Family of Man* exhibition. He invited me to be in it and selected seven or so images to be included. At that time, I was very puritanical and I said, "Look, a museum is a place where they should just show work because it is art, not because it fits I to a theme." And so I withheld my work.

JL: You spent over five decades photographing Coney Island. What was the initial attraction that brought you to making this body of work?

HF: I often feel like I fell out of my mother's womb onto the beach on Coney Island with a Nathan's hot dog in my hand with the sounds of kids screaming on the Cyclone. I just always loved that place as a kid way before I was doing photographs. It's loaded with people, and people are my favorite trees. My father would give me thirty-five cents on a weekend. I would take the trolley, which cost three cents for youngsters. And of course I'd blow it all in ten minutes. I started drawing portraits of people on the boardwalk for fifteen cents each.

This would build up more money, but I would blow that too, of course. So then I'd have to hitch on the back of a trolley to get home.

JL: The image of the group of Coney Island teenagers lying on the blanket with a radio is a favorite of mine. There is something seductive about the gaze of the girl with her finely plucked and stenciled eyebrows. I know we're going back sixty years, but what was your most memorable story from the Coney Island series?

HF: For one thing, people lying on the beach would say, "Hey mister, take my picture, take my picture." So I would.

JL: So it was more proactive, than reactive?

HF: I guess so, but that's a big word for me. With Coney Island, it was a continuous process.

JL: I was watching a photo documentary recently on the Ovation channel, and you were interviewed as being an assistant to W. Eugene Smith. Did his World War II images influence or inspire you to want to document the Army Draftees?

HF: No. But him as a man I loved. The main thing was he loved Teacher's Scotch, and I introduced him to a lower-priced Scotch and so that made life a lot easier for him.

JL: In your opinion, do you think that the responsibilities of today's war photographers covering events in Iraq are similar or different than when you documented events in Korea?

HF: When I was in Korea, I wanted to go wherever the war wasn't. My main war story was that I had an ingrown toenail when I was sent to the front. And it was serious...it hurt like hell. They shipped me down to Pusan to be treated. That week they were painting the ward where I was in, so they shipped us to Kyoto, Japan. Once I was in Kyoto, before going back to Korea, they gave me my records with my military occupational specialty numbers on it. I changed the number from *Infantry* to what I thought was *Photographer*. However, the number that I chose was for *Illustrator*. It was perfect. My company commander would make me paint signs for the battalion commander and so on. Nobody knew

where I was half the time, and all I did was carry around a T-square and some paintbrushes. I ended up meeting this wonderful Korean woman and moving in with her for most of the war.

JL: Is there an image from the Army Draftee series that sticks in your mind more than others?

HF: I'm in the process now of assembling my old black & white work. There are so many images that I love. The primary activity in the Army is waiting. There is one image in particular where there is one GI lying on the ground with his feet propped up and I'm right at his feet looking down at him as he's smoking.

JL: Turning to something more recent, you've embraced the digital capture in your new work. Are you happy with how the photography medium has evolved?

HF: I love the digital world. I was considered a master in the darkroom, but you couldn't get my ass in the darkroom if you forced me to. I love being able to sit in front of a screen and darken and lighten images and edit them in a lit room. It's not the answer that purists want to hear.

JL: Was there any photographer that you ran into back in the day that wasn't so nice?

HF: There was a show at MoMA called *70 Photographers: Look at New York* and I was one of them. This guy Arthur Fellig walked over towards me, you might know him as Weegee, he said, "Hello... I am the greatest photographer in the world." And of course I didn't say it, but I thought I was. I have a lot more respect for him now than I did then. I feel he did do extraordinary work, but I had an attitude then, and I still do.

JL: What is the most important lesson today's photography student or emerging photographer should know?

HF: "When your mouth drops open, click the shutter." That will lead you to your particular way of seeing. That's what it's about. Being free enough to trust your inclination to trust an impulse and just go with it.

OHHHHH, BEARS!

"You made me get out of bed and get dressed and come down to the gallery on a Saturday with this magazine that you wanted to see, so you're gonna buy me fucking lunch."

"Yeah, let's go grab some salads."

"No, you're buying me a fucking meal and a drink."

That's Fitts. He knew I was gonna buy him lunch. I had offered that up earlier in the day. I just like razzing him a bit. And this lunch was worth it because after telling him that I had sat with our friend Jeffrey, the day before, reading him one of my essays, he said,

"You should write that bears story you told me about. You know, the one from your photo class. That's a funny photo-related story."

And he was right! It was funny (after the fact) and embarrassing all at the same time. But then again, I bet many people have at least one embarrassing story in their repertoire.

Let me set the scene: Senior year, Massachusetts College of Art, senior seminar. This seminar was the final photography class that we had to take before graduation. We had a large senior class, and on top of that, we had some students from our collegiate neighbors next door, the School of the Museum of Fine Arts, that had signed up for the seminar. We were all part of the Colleges of the Fenway

consortium that allowed students to cross-register at area schools. The faculty was forced to divide our class into three sections: one professor I already had, one professor I didn't want, and one professor I really, really wanted. Guess where I ended up?

We had just finished a semester working on our final projects. My series was called, "A Monumental Supply: Water Towers in the North American Landscape." I had spent a semester driving around the Northeast—Massachusetts, New Hampshire, Maine, and Canada—photographing these metal and concrete monoliths. This project was a departure from the photographic series of portraits of my wife that I had been working on. Portrait versus landscape photography—I'm still not sure which one I liked better. I think my professor was trying to break me out of my shell by suggesting that I photograph something else other than my wife. He knew I'd be heading off to graduate school soon. Maybe his suggestion was a good thing. On the other hand, maybe it wasn't. What I know for sure is that the modus operandi of many graduate schools is to break the students down and build them back up again. With that said, it all worked out in the end.

As we stood around the room on the last day of classes, after a rather lengthy critique session, the professor began asking each of us what we planned to do next—essentially, what was the next photography project that we planned to work on. When it came time for one of the Museum School transfer students to respond, he said, (paraphrasing): I'm going to spend the summer photographing bears.

Ok...now, cut to me, Mr. Non-traditional Student standing up against the radiator by the windows with my arms crossed staring at the student with a puzzled smirk on face.

I say as bluntly as possible, "Where the fuck are you going to shoot bears?"

Every single person in the class including the teacher turned toward me and stared—straight-faced and silent, and it wasn't because I used the word "fuck" in a sentence. I was known for my potty mouth.

After a few seconds, someone said, "Jason...think about what you just said."

Then it dawned on me. I realized what he was talking about. In the most dumbfounded way, I blurted out, "Ohhhhh, *bears!*"

Hey, look, I'm not the brightest bulb in the bunch. I'm like thirty-five watts to everyone else's sixty. It seems like a logical question doesn't it? Because, shit, Boston's a major city, and it's not like we have fucking grizzlies roaming around the Fens.

Unfortunately for me, I was not up to date on today's gay lingo. Bears are big gay men usually covered in body hair and some facial hair, also known to guzzle beers while wearing cut-off Daisy Dukes and flannel shirts unbuttoned half way down. Younger, less hairy, smaller gay men who are "down" with the bear culture are known as cubs. Think Yogi and Boo-Boo: a tisket, a tasket, a pic-a-nic basket.

In my defense, I have to say that I'm not privy to everything about gay culture: Bears, Cubs, Otters, Wolves, Twinks—Kingdom, Phylum, Class, Order, Family, Genus, Species. What wonderful names will they come up with next? Now, if I were still working for the phone company, it would have been a different story. I might have had *some* idea what he was talking about because I used to have a lot of openly gay coworkers who were truly fun to work and hang out with. On the flip side, there were plenty of gay students who attended college with me too, some in the closet and some out, but we never had conversations about these things in class or in the lunchroom.

You can't be part of the arts community without interacting and appreciating LGBT culture. My wife and I support our gay friends the same way we do our straight friends—we really don't see any difference. One of the most memorable gallery openings that we have hosted was for our *Dress Up* exhibition in 2013. Our artist Keiko Hiromi had spent the past few years documenting drag queens at Jacques Cabaret in Boston. In a surprise to all, five of the drag queens showed up dressed to the nines for the gallery opening reception and

spent time getting their picture taken with many of our guests. It was great to be able to introduce "the ladies" to our patrons—interacting and connecting. It's what we and they do best!

Another way we support the gay community is by attending the annual Pride Parade in Boston. Frankly, it's the best parade that this city has. What? You haven't been? It's not every day that you see men in drag walking the parade route in clear platform shoes, people standing around just in their underwear with the words, "I Love Dick" on them, or a rolling flatbed truck covered in speakers pumping the gay

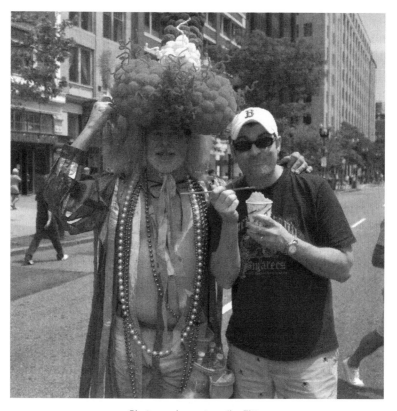

Photograph courtesy Jim Fitts.

bump through dozens of subwoofers while leather-clad men dance to the music.

One year we ran into Fitts taking photographs at the parade.

"Champion, go over there and let me take a photo of you with him," pointing to this guy wearing Mardi Gras beads, rainbow-colored booty shorts, and orange wig and a tall hat made out of colored pom-poms that looked very Dr. Seuss-like.

"Alright."

"Don't be afraid if he gives you a bear hug. He's probably not interested in you anyways."

FUNG WAH ISN'T A DIRTY WORD

The Fung Wah[8] is the Asian-operated bus service that travels the Boston to New York City route every hour, on the hour. Whether you pick it up at South Station in Boston or in Chinatown in New York City, it's a four-hour trip. For the first two hours, it smells like Chinese food and body odor. For the last two hours, it's McDonald's and body odor. It's always the same, regardless of which direction you are heading.

I heard Fung Wah means *magnificent wind* in Cantonese. Let's break that down for a second. Sure, magnificent wind—exactly. It's the smell that emanates through the cabin when someone opens the lavatory door. Not! No dookie allowed on the bus—that's the unwritten rules of the road. Or, better yet, maybe it refers to the fact that these buses go as fast as the wind, which is why they have been cited for speeding and crashes so many times in the past. May I suggest rebranding?

If it's summertime, dress light because the air conditioner takes forever to cool. In the winter, layers are a must. The heat rarely works. I wonder if there is a Mr. Fung Wah?

8 As of March 2013, federal authorities have shut down Fung Wah Bus Transportation Inc. It may in fact be up and running again by the time this book is published. But as of right now, they are out of business.

Everyone from every walk of life in Boston takes this bus. Fifteen bucks each way. It's the best deal in town, especially in an economy where gas prices are above four bucks a gallon. You get the college kids, old Chinese women wearing medical facemasks to block out whatever colds they have or don't want to catch. There are the business people and budget-conscious travelers. It's almost always sold out. There have been a few other competing discount charters, including Lucky Star and the newest, Bolt Bus, but they're all the same—stuffy, econo-class, rolling boxy bullets.

A word of caution: when the bus stops at the rest area (this is when the McDonald's smell comes into play), don't linger in the bathroom too long. And by lingering in the bathroom, I'm not talking about the random hook-ups that are notoriously known to occur at rest and truck stops. It's a warning—the bus *will* leave without you. If the driver says, "fifteen minute" (and that's singular, folks), they *mean* fifteen minute—not a second longer. We'll be at some rest stop in Connecticut and the bus driver will walk through the bus counting heads—eeny, meeny, miney, moe. Obviously some of them must lose track of the original count because the next thing you'll see him plopping back into the driver's seat, pulling the lever to shut the door, slipping on his sunglasses, and stepping on the gas. Off we go.

As I peer over the seat, I think to myself, something's not adding up. I could have sworn someone sat in front of me.

I glance out the window and sure enough, some knucklehead with McDonald's takeout is running full speed like a Kenyan in the Boston Marathon, hands waving, hoping someone will notice.

"STOP THE BUS!"

My friend Yoav Horesh used to teach photography classes in Boston and New York City—sometimes during the same week. He calculated that during any given semester, he spent the equivalent of two full weeks traveling on the bus. He was the quintessential road dog, always with suitcase in tow—and eventually it paid off. He

scored a nice gig in Hong Kong where he got a full-time position, a permanent place to stay for a few years, and a much easier commute. I wonder if the buses smell the same in Hong Kong?

Yoav was a good connector. He introduced me to what would be one of my mentors during graduate school: Thomas Roma, head of the photography program at Columbia University. He was married, one son, and lived in a cozy Brooklyn neighborhood. He is an entertaining character, boisterous in every way. His voice *always* overpowers all conversations. He is also a great photographer, published many times, and connected to some of history's greatest photographers, one being his father-in-law, photographer Lee Friedlander.

I first met Tom when he lectured at MassArt. As the story goes, he began making pictures after a terrible car accident where he almost died and was confined to his house. His brother bought him a camera, and he would point the camera out the window and photograph whatever he could see. After taking a few rolls of images, he brought them to the drugstore to be developed. The person developing the prints said there was nothing on the rolls. When he went back to his brother to tell him that the camera must be broken, his brother admitted to him that he knew it was broken—we didn't think you were going to make it.

I took the Fung Wah to New York City for our first meeting—I believe it was in January or February 2008. I arrived at Columbia University the night before. They had converted a few floors in one of their dorms to be like hotel rooms, where visiting guests and scholars could stay at a much cheaper rate than staying in a city hotel. The next morning I walked through the Ivy League campus and entered Dodge Hall. I showed up at Tom's office where three of his graduate students were sitting around shooting the shit. He sat behind his desk, dressed in a suit, quoting from Robert Frost the poem *Two Tramps in Mud Time*. I jotted it down so that I could look it up later:

But yield who will to their separation,
My object in living is to unite
My avocation and my vocation
As my two eyes make one in sight.
Only where love and need are one,
And the work is play for mortal stakes,
Is the deed ever really done
For Heaven and the future's sakes.

The attention or more like interrogation turned to me. I sat there on the couch with my box of prints and notebook and Tom said, "OK Jason, why are you here?"

I responded, "Well, I chose you as a mentor because I was hoping that you could..."

Tom interjected, "Jason, let's begin again...why are you here? It's a simple question."

Again I proceeded to respond, "I'd like to gain feedback about my projects and discuss..."

"Jason, you're not getting it", raising his voice. "Why are you here?"

Now I'm a little nervous. His grad students peered at me, smirks on their faces. I tried once more.

"Tom, I am hoping to find my voice..." In the loudest voice, which echoed down the halls, into the darkroom and out into the courtyard, Tom proclaimed:

"Your VOICE! Your VOICE! You are BORN with a voice! You PROJECT your voice! You do not FIND your voice!"

There were about ten seconds that I sat and stared at him and all I could think was, Oh My God. Holy Shit. I am in trouble. I sound like a dope. Why am I here? I'm sweating. He hates me. Was this a bad decision?

After my anxiety subsided, I thought, nope, this was my decision. There's a lesson to be learned. He leaned forward, looked me in the

eyes and said in a very calm voice, "Jason, the answer that I was looking for was *change*. You are here because you want to change." I nodded my head in agreement.

Soon, our meetings would be conducted at his home in Brooklyn, where his wife would make us lunch—me, tuna fish sandwich and chips, and he, phony bologna. Our meetings would last four to five hours. We'd talk about photography, books, his beloved Yankees, his hobbies, which included building cameras, tinkering with motorcycles, and creating custom wooden baseball bats for his son. As I sat and listened attentively to his every word, my eyes would often wander to the photograph hanging on his dining room wall: *Rue Mouffetard, Paris 1954* by Henri Cartier-Bresson. This image is of a young boy with a smirk on his face carrying two bottles of wine. When I look at it, I'm always wondering if the boy is smiling with pride that he gets to carry these two magnum-sized wine bottles for someone, or if he was just told a secret or a funny story.

Tom's stories were entertaining and almost impossible to believe sometimes, but I never questioned any of them. I was always worried that Tom wouldn't take me seriously because I would either be smiling or smirking at every story that he told—just like the little boy in the Cartier-Bresson photo.

When I told my friend Yoav my concerns, he told me, "Don't worry about it. Tom knows you're serious."

One of his best stories was when he told me how he picked a fight with photographer Garry Winogrand at an opening reception at the Museum of Modern Art one night just to get the attention of then curator John Szarkowski. It's like photography folklore.

During one of our meetings the attention turned to literature, one book in particular, *The Doctor Stories* by William Carlos Williams and then a short story called, *Cathedral* by Raymond Carver. I began to actually see how a visually literate person like myself could be influenced and inspired by the written word. Just like how details are

an important part of a good photograph—you know, those photographs that engage you and make you work—the same thing applies to good literature. Those details and descriptive words hook the reader into turning the pages.

When it did come down to photography, one exercise Tom wanted me to do is to ask myself three things whenever I attempted to create or look at a photograph:

1) *Where am I?*
Does the photograph tell me something about the place? If this piques my interest, go to the next question.

2) *Who's there?*
Meaning, *who's in the photograph?*

3) *What are they doing?*
What is taking place in the photograph? Is it interesting? Would I stand in line to go see it in a gallery or museum? Would I buy the print? Would I buy the book?

"Jason, write this down. From my perspective:
You do not make photographs for yourself.
You are not making photographs for your friends.
You make photographs for others to enjoy.
Your images should make your friends question what you are doing and your enemies worry."

Back on the Fung-Wah I would always have a few hours to reflect on my visits with Tom before I arrived back in Boston. Well, except those times, every now and again, when I would peer over to my right at the person who had fallen asleep on my shoulder. "Did you have a nice nap?"

The time that I spent with Tom was much more than I ever expected. It was bigger than just photography—it was another life lesson. The "change" that he was looking for in the beginning was starting to take place and I began to move outside of my comfort zone. And in an instant, what Frost said in his poem, "uniting my avocation and my vocation" all began to make sense.

A NASALLY VOICE

My editor told me that this essay doesn't have anything to do with the rest of the essays in this book. I'm just going to include it here and you can think of it as halftime, like in a football game. You can skip over it and head to the concession stand and grab some overpriced popcorn and beers! Or better yet, go stand in that really long line to use the bathroom. Make sure you wash your hands before you flip through the rest of the pages. You don't want to leave any funky shit on them, because you know this book will end up in some used bookstore eventually and some unsuspecting cheapskate who didn't want to pay full price will buy it and then they're left with some stank-ass mold spores growing in it. Eeewww!

Just read the essay and continue.

Say cheese. That's the cliché in photography for the mom or dad taking a picture of their kid as they get ready to blow out their birthday candles and many other scenarios as they grow up. They want to remember those special moments as happy moments—rarely do they capture those moments like when you were five and you cut your lips in half trying to shave, or when your aunt pulled your arms out of their sockets playing patty-cake—two events from my childhood with no photographs to prove it, just stories and scars.

In contemporary photography, it's the exact opposite: rarely do people smile in contemporary fine art photographs. It's "lips together— look at the camera." That's about all the direction a photographer gives. In nineteenth and early twentieth century photographs, smiling wasn't prohibited; the fact of the matter was exposure time was slow, which meant people had to stay still for long periods of time. Even if they did try to smile, the outcome would be a ghostly blurred grin. As someone who has been on both sides of the lens, I never smiled, and this story will explain why. I have never been a fan of going to the dentist or doctors. I think doctors' offices and hospitals smell way too clean, and the dentist, well, all they want to do is hurt you. All these doctors are intertwined somehow. I know it. I figured that if I ate somewhat healthy, exercised, brushed twice a day and rinsed with mouthwash once and a while, I would be free from visiting these white-coat-wearing agents of good health and hygiene. NOPE!

Now that I'm in my forties, my body isn't what it used to be. "Don't Fear the Reaper" was a song by Blue Oyster Cult. When I go to the dentist I would sing, Don't Fear the Dentist.

My wife and I enjoy spending time with our friends, specifically the friends who don't have any relatives nearby. So on holidays, such as Easter (we call it Feaster, short for Fuck Easter) or Thanksgiving, we get together with our friends and have dinner. Our friend Katherine, who owns the largest unit in our brownstone, usually hosts. She invites some of her friends, we invite some of our friends, and then we eat like pigs and then on occasion, hop in the car and drive down to Foxwoods to gamble—I digress.

One year, Katherine invited over Kamand, her friend and dentist. Kamand loves to gamble and ride dirt bikes. That's correct—dirt bikes! We talked after dinner and I told her about my issue with the space in my teeth. Ever since I was a kid, I have had a big space in between my top two front teeth. It bothered me so much that I very rarely smiled in photographs, which resulted in a big smirk. No one

ever made fun of me; I never heard, "Here comes the buck-toothed Bucky Beaver" or anything else. It was just my own insecurity. If the topic came up, most people would say, Oh Jason, the space between your teeth is a sign that you're a creative type. Look at Madonna or Elton John or so-and-so. Yeah, I know all about them, especially Madonna. She comes up later. Part of my job in being a photographer was getting people to smile. How do I ask them to smile if they never see *me* smile? All I wanted was a straight set of teeth.

Thus, Kamand told me that she could fix my problem, and somehow I was able to convince my wife that I needed to do this.

In the fall of 2012, I made my appointments to meet with the dentist and get the smile that I always dreamed of having. A couple of shots of Novocain, and she got to work. She began by shaving down the front of each tooth that we planned to replace with veneers. These veneers are made of zirconia, the stuff that they use to create fake diamonds—yeah, that stuff. But before we got to the veneers, she needed to create a temporary "grill" that would stay on for a week before the new teeth were created.

Kamand said, "Try not to eat with your front teeth."

"I won't"

"Chew with your back teeth. If you hear a crack, it's OK."

"OK—I'll be good."

"If you have a problem, call me."

"Ok—I will."

After one day, the "grill" became loose—you know the kind of loose like when someone can rattle their dentures in their mouth to gain a quick laugh from their friends.

"Kamand, it's Jason..."

I drove back to her office to have it re-glued in my mouth. On the fourth day, I went out to dinner with friends, and not thinking about it, bit into a piece of bread (at my favorite restaurant no less) and the grill shattered to pieces in my mouth. I ran out of the restaurant and

into the bathroom. I spit out a bunch of tiny chicklets mixed with bread particles into my hand and sifted through the mess and put the pieces in my pocket.

I returned to the restaurant and with my hand blocking my mouth I told my friends, "I gotta go." Down the street I went.

My friends, wondering what was wrong, called a minute later to check on me. I told them what happened then hung up—then began dialing another number.

"...please leave a message—B-E-E-P! Kamand! It's Jason..."

Back to the dentist the next morning. They fixed my grill and once again reiterated that I should stay away from biting.

"Kamand, I'm going on a liquid diet for the rest of the week!"

It's crazy, this whole smile thing. When the veneers were finally and permanently secured into place, the dentist asked me to smile. My cheeks trembled—the muscles had lain dormant for so many years. They weren't used to all this action. I couldn't wait to work those muscles into shape.

AN INTERVIEW WITH VIK MUNIZ

First published in the online magazine
Big, Red and Shiny
April 27, 2009

Portrait of Vik Muniz. Image courtesy of the Author.

Okay...I better set up this interview for you in advance so that my editor doesn't have a cow. This will explain how having a lot of connections isn't as important as being the best-connected person.

I made a comment to Jeffrey Keough one afternoon that I thought it would be so cool if I could interview Vik Muniz. Both Keough and I were big fans of his work and he is one of the most popular contemporary artists working today.

"You're a friend of his on Facebook. Send him an email," Jeffrey said.

"Jeffrey, he has a lot of friends, I highly doubt he would respond to my request."

"Well if you tell him that you know me he might."

"You know Vik Muniz?"

"Sure. When I was the director of exhibitions at MassArt, he visited the school and I assisted him on his photo shoot when he used our Polaroid 20x24 camera. Send him an email and tell him that you and I would like to meet him at his hotel for an interview prior to his lecture. He'll respond."

I did as Jeffrey suggested and got an email back the same day from Vik. This showed me that no matter how many virtual friends I may have on these social networking sites, sometimes knowing someone personally will open doors for you. And without further ado, the interview:

Vik Muniz is one of my favorite contemporary artists. He was in Boston, Massachusetts, for two sold-out lectures at the Museum of Fine Arts, Boston. Jeffrey Keough and I had the opportunity to spend the latter part of the Wednesday, April 15, 2009, with Vik. Here are some questions transcribed from the recorded interview.

Jason Landry: You make the subjects that you photograph, as opposed to finding them. How has that expanded or constricted what you say?

Vik Muniz: I don't know if finding and making has a significant difference. If you are looking for it, there is a lot of making in that process as well. I don't think that subjects just fall in your hands for absolutely no reason. People usually think that my work is harder than the regular photographer, which I think it quite the opposite. I facilitate the process, instead of going out and trying to find it. There is an interesting metaphor in Chinese scholars' rocks. The artist is out there and not making anything. He is looking for a shape in a rock that can somehow translate a feeling or a sensation or a mood and a philosophy of what he's trying to say. Once he finds that object, he finds a way to present it. It is interesting to see what is found and what is made. You only find things you are looking for. It's impossible to find something you are not looking for. The other part of the work is finding ways to present it.

JL: Is there a work of art that continues to inspire you?

VM: It would be very hard to mention one particular work of art. I am inspired by works of art but also by things of the mundane kind. I am very inspired by painting. I'm married to a painter...I watch her paint. Painting takes a lot of skill. You have to put down your pride. As a photographer, sculptor, and one who draws, I could never paint. I've tried several times but it is something I cannot do. And maybe that's the reason why I have so much respect for it. You have to start something out of nothing. I need a few clues of something there for me to work with. Starting with just a blank canvas is very hard to imagine for me. When you look at a painting, it's an arrangement of very simple things. It is mostly stuff that you dig from the ground, sometimes some organic bindings and with those things on the piece of cloth brings you something that can be related to a mood or feeling, but most important you can see something in it that appears as a representation. You can always go back and just see paint. You have a dichotomy right there...you can choose what to see. It's there...it's

right in front of you. It's like the difference between cinema and theater. If there is something that continues to inspire my work, it would be the whole subject of painting.

JL: What role do your self-portraits play?

VM: A smaller role than they are supposed to. Normally, if I am starting to play with something I'm not sure about, I try a self-portrait. For one thing, it's a convenience. The subject is readily available. I can look in the mirror and take a picture of myself. If it's not good, I'm not going to offend anybody. It's interesting to see versions of yourself through different materials. There isn't anything philosophical about it, when you come to think of it. It's just a convenience.

JL: Have you ever had a "surprise encounter" when creating a work of art?

VM: I have had very many surprise encounters that were mostly not of the nice kind. You'll be making something and then something goes awfully wrong, like a cat walks on top of it. Or you're working on something for three weeks under an 8x10 camera and then your sleeve hits the latch on the lens board and the lens falls breaking both the lens and the drawing. I could go on and on and on. Good surprises are harder to find. Sometimes they are products of a previous failure. Sometimes, if something doesn't work, it's because you have your mindset locked in a certain way and you ignore all of the other possibilities of working with that particular material. In many instances, I was trying to do something with a material and I could not do it, then months later or years later, I would be trying to figure out a problem with a subject and then that material comes to mind and I figure out how to do it. So whenever you have a nice surprise, it's usually related to a previous failure.

JL: Has there been a collaboration that either delighted or horrified you?

VM: It very hard for me to even find coherence between many of my schizophrenic personas. To find a way to work with somebody else,

it's almost impossible. If I had all these people telling me what to do, there's only one guy to do everything. I tried to collaborate with my wife several times. I remember one day we were supposed to do a show in Germany. On the train I knew exactly what I wanted to do and I was explaining to her how the collaboration was going to be done. And then she said, "I haven't even got there. I don't know the place. I have to be there to start thinking about it." I said, "How can you do that? We only have two days." I realized it wasn't going to work. The only collaboration we ever managed to do was when we had a double show. We agreed that the best thing to do was to make a picture of our daughter.

When I started collaborating with assistants, which is quite new to me, I found it has helped me a lot. When you start working with assistants, you start to communicate and open up to another person what you really want done. You always have editing power over them, which is the best part. It's different than actually collaborating with another artist. This system is something that is part of your own production. I am very controlling. I've been working with people for over six years now. After six years, they are so tuned; they know exactly what I want. They know what I want to emphasize...it's very easy to work with them. Even when I am trying to figure out a new process, I can throw in their hands my ideas and they can start it up and come up with some samples, and it saves me the troubles of experimenting on a very early stage and can see what can or cannot be done a little later on.

Right now, for instance, I am working on a series of photographs in China. We're shooting people...and I've never really worked with people before as a unit to make pictures. We are shooting a thousand people at a time, nine times, and each person accounts for two pixels. At the end of the process, you end up with something like 18,000 pixel resolution. We can create a picture with the complexity of ten grays. We give everybody a list of what they have to wear...big

oversized sweatshirts or sweat pants. They lay down on the ground and then I go over them with a cherry picker and take a picture. I shoot things very simple. I shoot for sharpness and resolution. I shoot things in a copy-like way. Although they look simple, they turn out to be technically challenging most of the time. I can already foresee a number of things that can go wrong...instability, movement, or wind. When we worked with an 8x10 camera on a tower in Brazil to shoot these junk pieces, we have to figure out when the streetlights close, so the buses won't hit the potholes and we can have a steady 10-second shot. These are all things that we have to deal with that aren't written in any book. I love the fact that you can create this amount of trouble for yourself.

JL: I went to your Verso exhibition in 2008 at Sikkema Jenkins & Co. What prompted you to want to recreate the backs of many of the iconic paintings and images?

VM: This was something that was in the works for over forty years. The first museum I had ever been to was the Museum of Art of Sao Paulo. The curator at this museum did not want the work to be just seen serially. What she did was create these glass panels so that when you come out to the hall of the museum, you see all of the paintings at the same time facing you. So it looks like a maze. It shakes up the story. It makes it almost impossible for you to see the same narrative each time you visit the museum. When I went there at the age of eight, an eight-year-old doesn't really care about painting. I would just run around the museum. But since the paintings were hung on glass panels, you could see the backs of them. They looked like filthy, old things with some kind of secret markings and spider webs. For the imagination of an eight-year-old, that was much better than the front. I never forgot that. That visit to the museum was very important to me...I kept thinking about it for a long time.

Forty years later I am walking in the Guggenheim museum, and I see that they have off the wall, Picasso's *Woman Ironing,* which happens

to be one of my favorite paintings. I asked if I could look at the back. The curator said, "Sure." I thought it was amazing and then asked if I could take a picture of it. They said, "Any time you want." "Can I bring my big camera?" They said, "Sure." The initial idea was to just take photographs of it. I had these photographs pinned to my studio wall for four years. I then had a studio visit from someone at MoMA, and they thought the images were great and said I should photograph the MoMA collection. It has become an ongoing series. While the front looks like it came from the mind of the artist, the back just looks like his studio.

So, what you may not know about what I made...they are photo-realistic. We worked on them in increments of four square inches. Every single hair on the back of it is like the original. Nobody fakes the backs of paintings. The best forger will know or have some kind of knowledge of the backs and the labels, but will invent the backs and won't be too precise about it. If I make an object that is photographically correct then I am making something that is quite new. I am making a three-dimensional trompe l'oeil. The back of the painting tells its life, almost like a passport. I thought the show was real cool. People would come and they would get so confused. Some people would walk in and think the show wasn't installed yet. I gave instructions to the gallery, "Don't tell them." They'll come back if they want to.

JL: Did you collect anything in your childhood?

VM: I didn't have enough money to collect anything. I can't remember my whole childhood, but only remember having three or four toys. My parents were very poor. I didn't have anything that I wanted, but had everything that I needed. We made toys. I was forced to be more of the creative kind. If we wanted to fly a kite, we had to make the kite. If we wanted to spin a top, we had to make the top. I actually think this was a good thing.

JL: On the topic of collecting, do you think there is a unifying threat that connects people who collect things?

VM: It's human. I was just in Egypt, and I realized what collecting is really about. The pharaohs had it so easy. They didn't want to die. They wanted to take everything with them. They are the master collectors. They made a tomb and put everything they ever owned in it and tried to hide it, unsuccessfully of course because everybody would find it one day. There are humble farmers near our country house in Brazil who have collections of photographs and they love those things. The photographs are the subjects of conversations. They define them. It gives them meaning beyond what they can explain.

JL: Does the role of the immigrant or the outsider give you a different vantage point to engage culture in a unique way?

VM: If you are not an outsider or an immigrant, you should try to figure out a way to become one. The word *outsider* implies that you can see the thing as a whole. I feel that you have to have a little bit of both. My perception of American culture is that it's the best place to be in the twenty-first century for an artist. For the twenty-six years that I have been here, and living in New York, I was always trying to fool people, trying to make them not notice that I had an accent. But after a while, I found that having an accent was the best asset I could have.

I don't have a specific public when I make art. The great challenge is how to make smart, intelligent art that can speak to everybody.

TOUCHED FOR THE VERY FIRST TIME

"The photographs don't arouse me. All I can think about is the hard work it took to make them."

—HELMUT NEWTON

Oh you dirty dog! You thought by the title that this was going to be some sex-fueled chapter, didn't you? Nope, there's no talk of sex, or me losing my virginity in this book, nor any *Fifty Shades of Grey* references here—but I may have consulted with E.L. James's writing guide to make this chapter the tongue-and-cheeky steam room that it is—(I highly doubt it). Plus, no one wants to read about my sex life. You'll understand where we're headed in a minute.

Collectors will be the first people to tell you that it's a natural instinct and comfort to first collect what you know, and I urge you to do so. As I began to meet more and more collectors and read up on collecting, I realized that most photography collectors had *themes* to their collections. I knew someone who collected double portraits, another who collected regional art, and then there was one who collected images of children, and a few that collected homoerotic art. The Buhl Collection in New York collected photographs of hands, and well-known collector W.M. Hunt concentrated on the "unseen eye," photographs where the eyes or the face is obscured.

After a few years of filling our home with photography, I noticed a similar thread in what I was collecting—images of the female: portraits, figure studies, and nudes. Some are masked or veiled—and, oh, there are a few backsides in there as well.

The study of the human form, whether clothed or nude, still or in motion, continues to move me, because I am passionate about intimacy, both in life and in art. I am drawn to those pictures that capture the human body in its most provocative and natural form. As a student of the arts, I photographed it, and now I collect it—I surround myself with what I love on a daily basis. Luckily for me, my wife doesn't seem to mind. The nude as a form is the purest aspect of all humans—I think we can all agree on this. I have tried to analyze what captivated me into collecting images of women, or more specifically masked or veiled women, rather than, say...landscapes. P.S.: I do have some landscapes, just not many.

During my undergraduate studies, I admired the great photographs of Harry Callahan and Emmet Gowin. These two photographers were known for their beautiful and touching portraits of their wives, and that was something that I was doing, photographing my wife and documenting our relationship. I began to study other artists who photographed their wives or muses: Nobuyoshi Araki, Edward Weston, Helmut Newton, and Nicholas Nixon—just to name a few. I began collecting photographs of women in part because of my photographic influences, but also I was older than the rest of my class and married. Marriage is a sacred union, and you learn a lot about yourself and your significant other behind closed doors and from behind the camera. But still, I wanted to delve a little further and dig a little deeper into my collecting habits. In order to do this, I needed to take a trip back in time to the 1980s.

My earliest recollection of seeing a nude was in *Playboy* magazine. My father subscribed faithfully for many years—a rite of passage for

many straight males.[9] Back in the day, the magazine bore the tagline "Entertainment For Men" and its cover was wrapped in a discreet brown paper sleeve. It was the only magazine delivered to my house this way. I'm pretty sure most people knew it *wasn't* their next issue of *People* magazine. As I got a little older, *Playboy* changed its packaging—it came sealed in a plastic bag that was blacked out so that you couldn't see the cover. Hef, surely this wasn't your idea. When I got off the school bus, it would be my job to retrieve the mail from the mailbox. Every month when those wrapped magazines arrived, I tried to peek. It was intriguing. The most memorable issue, the one that I finally got my hands on and flipped through was the one with Madonna on the cover: September 1985. I was thirteen.

By then, Madonna was a global music sensation. Young girls mimicked her style wearing plastic bangle bracelets, fluorescent-colored sunglasses, lace gloves, and of course, rosary beads. I'd heard rumors about the *Playboy* issue from my friends—most of them older and as curious as I was. They knew my dad was the only person in the neighborhood who subscribed.

I climbed up on a chair in the kitchen so that I could reach the magazines, which my father kept on top of the refrigerator. I stared at the cover, it read, "Our last stapled issue. It's a keeper" and "Madonna Nude, Unlike a Virgin...For the very first time." I flipped through the magazine and it opened to a page with actor/comedian Bill Crystal posing with some bobbleheads—nope this wasn't it. I flipped again— What! I was shocked. This is her? What's with all of the hair—not only in her nether region, but also under her arms? What the fuck? This can't be her!

9 My mother made my father give away his entire collection of *Playboy* magazines once both my middle brother and I got old enough to sneak them off the refrigerator. (I can't imagine how much the whole lot would be worth today!) My Uncle Joey on the other hand still has his. He gave me the Madonna issue as a keepsake.)

At this point in her career, everyone knew her as the "Material Girl," the bleach-blond, sex kitten self-proclaimed Boy Toy who crawled across the Radio City Music Hall stage in a wedding dress during the 1984 MTV Music Awards moaning about being touched like a bride on her wedding night. Ironically, the photographs in *Playboy* made her look like the evil twin: a dirty doppelganger that was separated at birth. I honestly had to do a double take. Was this really Madonna? In the six years since she'd posed for these images, a lot had changed for her, including the trimming of the overgrown jungle under her arms. Publicists, stylists, and agents can sometimes work wonders.

In the fall of 1992 when I was attending the Art Institute of Boston, there was a buzz when Madonna's *Sex* book was published. OK—here's your "sex" reference people—go get your rocks off! It was a wire-bound stainless steel covered photography book of a much sexier, a much kinkier, a much prettier, a much hornier, a much more open Madonna. This was one of the most talked about and anticipated photography books in a while to hit the market. Shot by celebrity fashion photographer Steve Meisel, the book included cameos by Vanilla Ice, rapper Big Daddy Kane, and supermodel Naomi Campbell. That sounds like a Hot Fudge Sunday to me!

Similar to the wrapped *Playboys* of the past, this limited edition book came in its own special wrapper: a silvery Mylar bag—and yes, I got one! It glistened in the sun like ice, baby. In 2011, thirty years from when the *Playboy* images were actually taken, I happened to be invited to Paris for the Lens Culture FotoFest portfolio review event. On the last day of the reviews, I met Martin Schreiber, who had photographed Madonna in the 1985 issue of *Playboy*. He was one of the two photographers featured in that issue—the other being Lee Friedlander. After talking to Schreiber for a bit, I found out that he paid her $30 dollars to pose for the session and that they had dated

briefly. Our meeting in Paris ended with Schreiber handing me a condom with one of his Madonna images on it. After a few back and forth emails, Schreiber agreed to consign some work to my gallery in Boston—serendipitous!

I guess, in some weird, twisted way, Madonna is loosely—and I'm saying "loosely" in the cleanest sense of the word—linked to why I collect photographs of women. Thanks Madge! I can telepathically feel a million readers rolling their eyes right now[10]. In a psychological way, memories and life-altering moments shape how a person processes future decisions and forms their beliefs. It can also form decisions on what a person might collect, and why they collect. This is a fact. So I think about those brown paper sleeves on the Playboys and the silver Mylar bag on the Madonna *Sex* book and it brings me right back to my desire to see what I was forbidden to see as a youth. The protective sleeves on the magazines and books act as masks or veils, protecting me from the women inside. So you can see, even though this Madonna story of mine sounds a bit fruity, it's the truth and I cannot dismiss it.

That takes me back to collector W.M. Hunt and his collection of photographs with the theme of the "unseen eye." He said in one interview that his desire to collect was intuitive. He wanted something that was secretive. He stopped into an auction one day and didn't know anything about photography. He flipped through the auction catalog and saw a picture by Imogen Cunningham. He saw this image that was dreamlike, veiled, and Madonna-like. He bought it. Something from inside sparked his desire to purchase this image, even when he had no intentions in buying anything when he showed up at the auction, and didn't even have enough money to really buy it. The other day, I received an email from W.M. Hunt with a little bit more to add to his past collecting habits. He stated,

10 Wouldn't be awesome if I actually sold a million books?

"The quick answer (about his passion for collecting photographs with the theme of "the unseen eye") might have to do with the Freudian response that I was always blindly searching for my mother. But let me clarify the "secret" part, which does not have to do with any kind of clandestine approach to collecting but rather my feeling that great pictures are collaborative. They hold secrets for the viewer to discover and find meaningful. Great photographs live uniquely and personally. We see them with our mind's eye. I respond to enigmas. I am drawn to what's behind the veil."

In looking back over the photographs that my wife and I have collected, they're not all women and nudes. We also have many images of females with their clothes on, as well as male portraits too—so don't chastise me all at once. I'm not a perve. You do not have to be nude or showing your naked bits or even having intercourse in a photograph in order for the image to evoke a feeling of beauty or eroticism—and this goes for images of women or men. Sometimes the imagination alone can take care of that. The body as an object is the building block for some of history's greatest portraits and sculptures.

You know, not all regions of the world have issues with the nude. Thousands of visitors flock to Florence every year to stand in line to see the statue *David* by Michelangelo, and in Paris, Edouard Manet's *Le déjeuner sur l'herbe* at the Musée d'Orsay.

I'm not trying to put women on a pedestal or objectify them as some feminists might think. I don't even know why I'm trying to defend what I collect. I'm merely celebrating the female, and why not celebrate them? They are, by the way, the vessels from which all humans have entered and walked this earth. We don't celebrate International Women's Day on March 8 just for the hell of it. It's not like there's an International Men's Day. (Editor's note: Yes, Jason there is.) Whoops. Sorry guys.

Okay, so wrapping this up, a little recap:

Collect photography.
Follow your intuition.
A "theme" may begin to unfold.
"Sex" is a three-letter word.

(End note: Some women like to be natural and do not shave. I have nothing against it. ~~Oh, yes I do!~~)

"The difference between the casual impression and the intensified image is about as great as that separating the average business letter from a poem. If you choose your subject selectively—intuitively— the camera can write poetry."

—HARRY CALLAHAN

FOR THE BIRDS

One morning I awoke to the sounds of chirping birds, one distinctly sounded like a police siren, which immediately caught my attention. Usually the dog wakes me up. She's my built-in alarm clock, but today the fluffy Lhasa remained curled up, sound asleep at the end of our bed. My wife didn't even budge.

It was May—spring in Boston. We had a light shower the previous night, and from my penthouse, I could see the damp-coated black tar roofs that cover the brownstones in the Boston skyline. There weren't a lot of cars on the streets yet—I could see a few joggers and a person walking a dog.

I am not a bird aficionado but I can identify some of these feathered loudmouths. My grandfather used to keep a bird identification book on the rollaway dishwasher, adjacent to the back window in their Everett home. They kept nearby a pair of binoculars with black electrical tape around the eye mounts. My grandmother would save the grease from whatever feast she was cooking for the family and let it harden in a pan on the back porch for a week. My grandfather then would wrap the lard in an old screen or in a pair of mesh nylons and hang it up in the tree with some birdseed. I love the sounds that birds make. They remind me of my childhood home in rural New Hampshire. My wife on the

other hand absolutely hates the chirping, almost as much as she hates wind chimes.

You know, during my early teen years, I had a bird. His name was Fred, a white and light yellow cockatoo. This bird could whistle and talk and peck through sunflower seeds, spitting and flipping the shells all over the place. My uncle gave the bird to us when he moved. This bird would pace back and forth in its cage while whistling "Yankee Doodle." You had to drape a towel over his cage at night so that he'd go to sleep. I swear that bird mumbled too! One cold winter day, Fred passed away. I remember my father calling to my mother, "Carol, keep the kids upstairs for a minute." Down into the basement he carried Fred. I remember hearing the annoying high-pitched creak of the wood stove door opening. I was old enough to realize—Fred was being cremated.

On Sunday night, we headed to our car—Monday happens to be street sweeping day in our neighborhood, and we had to move it.

"What the fuck is that—a dead bird! Why do they have to fall on *my* car! J—get rid of it!" my wife moaned.

Poor little guy didn't even get to enjoy his first solo flight—must've fallen out of the tree. With a folded up leaflet pulled from under my windshield wiper, I peeled his sundried carcass from the hood of our Mini Cooper and flung it into the street.

The wild bird sanctuary, otherwise known as Boston's Back Bay, attracts these feathered worm eaters. (Just kidding—it's not really a bird sanctuary, but Boston's key tourist and shopping area.) The finch, robin, and, loudest of the bunch, blue jay all hang out here. They conduct their early-morning conference calls in the alley behind our building, in the trees. I distinctly remember a pack of them last spring all perched on our ledge right outside our window at 6 a.m. just yappin' away. After they cut down the big oak out back, the area opened up quite a bit, and now the chirping birds that once were buffered by the tree and its any leaves now reverberate like screams down into the crevasses below.

When we first moved into our building, I could hear a person in the back alley calling out to someone or something. I opened the window to see him five stories below, looking up toward me, calling to his bright green pet parrot who had flown out his window and into the tree. The bird was perched twenty feet in the air on one of tree branches and seemed a bit confused as to how to get down. I don't even know how he retrieved that bird.

Our newest aggravation is a pair of pigeons that have been fornicating underneath the base of our ledge, right outside our bedroom window. We can't see them—all you can hear is their constant deep moans. And it goes on and on. These birds can go at it for quite a while. What stamina!

From our roof deck we have a panoramic view of Boston. We have sea gulls that come inland to pick on the trash behind some of the restaurants on Newbury and Boylston Streets, and then I've even seen a few hawks. On two occasions I have seen them in trees, perched on a branch, one claw holding on while the other is dangling a rat over a crowd below, all with their cell-phones out taking pictures in amazement. And let me tell you—this was a huge crowd watching this bird tear apart this hairless varmint.

One day we lay in the sun, soaking up some rays on our roof deck, when two Canadian geese flew about ten feet above us. Typically during my walks back from the gallery, I see geese grazing in the green, grassy knoll under the bridge, parents protecting their goslings. Green shit litters the sidewalks—poop bombs everywhere!

One afternoon at the Esplanade, my wife and I sat on a bench and observed this mother duck putzing around one of the watery inlets on the edge of the Charles River—in tow were twelve ducklings. They followed her everywhere like parents who have their kids on leashes in the mall. One little kid noticed them and ran to the water's edge scaring them with a loud and obnoxious ROAAAAAR! My wife and I sat back just waiting for the kid to either fall in the

river or get attacked by the mother duck. Oh please let this happen. Pass the popcorn.

Other birds fly overhead in July. We've had The United States Air Force Thunderbirds and F16s do fly-overs. They blast over our building on the Forth of July, as the Boston Pops are finishing up the National Anthem. These birds fly low. I try to take a video of them every year as they rip over, vibrating the roof deck and setting off car alarms in their wake.

On a Sunday in May, I drove to my niece's First Communion. I was driving by myself, towards the church in West Newbury, Massachusetts, headed down a tree-lined winding road, when I came upon a clearing called Crane's Pond Wildlife Management Area. It was quiet and serene. You wouldn't even know that a major highway is just two miles from here. I felt as if I were transported to another place—a place as rural as where I grew up. Cars were parked off the shoulder, and as I slowly crept down this bumpy, unpaved section of road—crushed gravel popped underneath my tires like firecrackers. I stopped in the middle of the road and peered through the passenger's window to get a view of the landscape. I did not see or hear anything. Actually, I didn't know what I was supposed to see. Everything was calm. I didn't see any marsh birds: not a crane, duck, or loon. The reeds in the marsh stood still—there wasn't even a breeze. The scene was like a perfect landscape photograph—poetic and vast.

I could see people with binoculars sitting in their cars, looking out across the marsh. Right then I wished I had my grandfather's old taped-up binoculars with me, or better yet, an 8x10 view camera where I could hide under a dark cloth, even if it was only for 1/125th of a second to permanently frame this memory.

Haven't you ever stared at something for so long that it becomes ingrained in your mind? As someone who looks at dozens of photographs daily, I'm still amazed by images from the history of photography. Some are so memorable that I'll never forget them.

When I began working with Harold Feinstein, helping him reintroduce his vintage black & white photographs to the public, I viewed his images so many times that they started to become burned into my memory.

Bird In Hand (1955) is one such image. At first glance, you see a classic black & white photograph of a pair of hands holding a white homing pigeon—easily identified by a round, metal ring attached to its leg, above its clawed foot.

On closer examination, the bird appears cleaner than the person does, its feathered coat is snow white—the human hands are thick and tan with dirt under the nails as if the person had been digging in the garden all day. The bird is cupped in the man's right hand while three fingers on his left comforts the top—reminiscent of how a player gets ready to tackle the buttons of a trumpet. The bird essentially is frozen in place and cannot move. The black markings that surround the bird's eye contrast shockingly with bird's iris—not black, but a bright white. This scarred, wide-open eye is the only sign that this bird is still alive.

Some of the simplest images can carry a lot of baggage and weight if you let your mind wander. Feinstein's *Bird in Hand* is much different from his other imagery—he's mainly known for his vintage images from Coney Island and New York City. When patrons see the bird image in a show amongst his other works, they always stop and stare. They're hunting for something. The image seems out of place. They ask, why did you include this image? My usual response is, I'm drawn to it. They'll usually counter by mentioning the bird's eye. I'll shake my head in agreement.

The bird is simple and immediately recognizable to all, but when paired with other works by Feinstein in an exhibition, it evokes a different feeling—I think compassion is the first thing that comes to mind. We as viewers may not have been to Coney Island or New York, but we have all had a connected experience with birds—we've seen

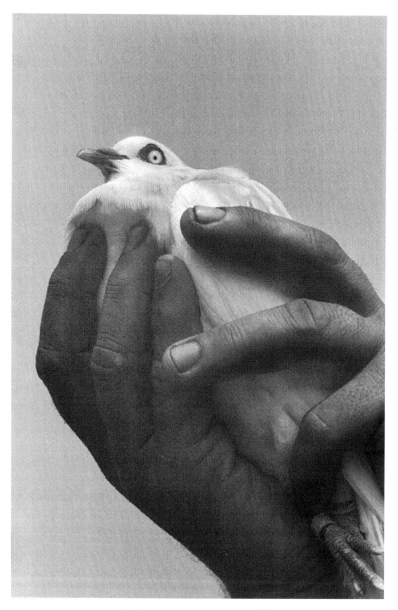

Harold Feinstein, *Bird In Hand,* 1955

them flying around, perched on a tree branch, walking on a beach, and maybe even in a cage at your house. Some of you may have even been pooped on by a bird in your lifetime—I know I have. My friend Eileen says it's good luck and that I should go play the lottery. Imagine, this story was set in motion by an experience I had with one chirping bird. Sometimes all you need is one good experience that can influence and change you for a lifetime.

WHAT I THINK ABOUT...

There's this book by Haruki Murakami called, *What I Talk About When I Talk About Running.* When I started running with my buddy, neighbor, and pseudo-coach Mark Barbee, I purchased and read this book. You need a coach when you despise running as much as I do. Coaches are like mentors, they guide you through life's big adventures. I never asked him to be my coach—he just is. Our friendship started with running, and he quickly became one of my confidantes and is a positive influence on my life. It's not that I have a bunch of bad influences, it's just this guy is extremely straight-laced—smart, honest, and loyal.

One afternoon, my wife and I were coming back from a walk, and walking down the steps of our brownstone, all dressed in his running gear, came Mark. Being the friendly neighbor that I am, I yelled out,

"You just go running?"

"Yeah, I'd love a running buddy," says Mark.

"Go get dressed. I'll wait for you."

He thought I had said, "You wanna go running?"

My wife turns to me with a smile and says, "Looks like you're going running now, J."

Shit. Shit. Shit! What the hell did I just get myself into? I was never a runner. One and done was my motto (meaning I'd run one mile

and quit)—and that was whether I was running on the street, track, or on the treadmill at the gym. I went into the house cursing up the five flights of stairs and changed and came back down with my iPod and headphones and hesitantly proclaimed in the most sarcastic way, "OK, let's go."

He responded, "Well I guess I'll be talking to myself the whole way."

Looking at him with a blank stare I thought to myself, we're going to run without music? I had never run any distance before without listening to music. Could I do it? Well, I guess I'll have to try. I locked my iPod in the mailbox and off we went.

At first, I couldn't talk when I began running with Mark. Not that he wouldn't allow it. I just couldn't catch my breath long enough. He would be yapping away, and I'd throw in a few Ah ha's...OK... Really...Huh. Soon my breathing got to the point that I could get out a few short sentences, followed by a few huffs and puffs. After a few months of regularly scheduled runs, I was able to carry on normal, long conversations—finally being able to defend against his constant ribbing and comments against my local team, the Boston Celtics. I was sick of hearing about his beloved Los Angeles Lakers.

Now it's Teflon pants for when it's raining, 5k, 10k, half- marathon—Ugh—new Nikes every six months or 500 miles, winter pants, winter gloves, hats, jackets, a watch that keeps track of miles and calories burned courtesy of a chip in my sneaker, anti-slip wicking socks, and, of course, BodyGlide (don't ask). For someone who hates running—that's a lot of shit!

Mark's different than some of the other art-related people in my circle, and I'm not talking about his eccentric behavior like keeping spreadsheets of his running schedule for the entire year, eating all of the French fries on his plate before taking a bite out of his favorite fried jalapeño boom burger, or his cowboy boots. It's the fact that he's a highly focused individual—a crossbreed of a connector and a salesman. He supports what I do at the gallery by coming to openings

and events, and he has even purchased some art. He clips and saves photography-related articles in the *Wall Street Journal* and *New York Times,* making sure that I see and read them. This guy is constantly asking me questions about the business of photography, helping me analyze data when I'm contemplating something outside of my grasp, and he also lets me bounce tons of ideas off him. I know that if I needed just about anything, I could count on him. Remember, you not only need to have friends in your field of expertise (whether its art, photography, or something else), you should include in your circle other experts. Just make sure if you go running with them, you can keep pace.

Here are a few things I *think* about when I'm running:

- Man, I hate running. I'll do it, but I still hate it!

- What's for lunch? (About nine miles through my second half-marathon, I remember asking Mark this question as we headed over the Longfellow Bridge. He yelled, "Focus, man. Focus!")

- What's for dinner?

- Maybe I should run in the morning.

- I'm so tired; maybe I'll run tomorrow.

- Did I stretch enough?

- If only I could learn to eat better I wouldn't have to do this.

- What do I have to do to prepare for tomorrow?

- Did I respond to every email that I received today?

- Ooof! That burrito was a tad bit too heavy today.

- How many more Smoots to go before I get over the Mass Ave Bridge?

- Man, my hat smells!

- Will my wife be mad that I didn't do the laundry, dishes, or clean today?

- What artists can I put in upcoming exhibitions at the gallery?

- Did I return all of the voice mail messages that I received today?

- Oooh. Another idea for the book!

- What am I gonna read next?

- What print would I buy next if I had the money?

- Keep telling yourself...only one-mile left!

- Is that woman running and talking on the phone?

- I'm gonna have a rash for sure!

- Would I run faster if I were chasing a pack of hot chicks running?

- Who's coming to the gallery tomorrow?

- Can I convince my wife into walking the dog tonight? (No, this isn't code for sex.)

- Can I convince my wife into having sex tonight? (No this isn't code for walking the dog.)

- Will anyone like this book that I'm writing?

- Maybe we should get Ben & Jerry's tonight!

- Is that pregnant woman really keeping pace with us? Is that good for the baby?

- How is this person running in flip-flops?

- I'm never running again after today!

- Did I tie my shoes too tight?

- Look at that idiot running in shorts! It's fucking thirty degrees out!

- Why can't I figure out how to stretch this muscle!

- Wait a minute...wasn't the wind going in the other direction just a minute ago!

- How fast can I sprint over the Mass Ave Bridge?

- Oysters would taste good right about now!

- Why am I not losing weight after all this running!

So what does running have to do with photography? If nothing else, it requires discipline, focus, and accomplishment. At the Chuck Close lecture, Chuck said that he does "Art for art, and therapy for therapy"—a fine philosophy to follow. Being an art dealer gives me a sense of accomplishment and pride when I can do something nice for someone or mentor an emerging artist.

Supporting the arts will always be my "art for art." I have found running to be my therapeutic outlet. That's why I do it. If it's not going to help me lose weight, then at least it'll help clear my head once a while so that I can focus on the big picture. It's better than paying a shrink to listen to all of this crap! In life, you must find your yin to your yang. There must be a balance. Too much of one thing is never a good thing. Search for an outlet that will strengthen your mind and your body. You will need both to succeed in life.

PLAYING WITH WEAPONS

I've always been curious about what things I remember and what things I can't. I can remember bits and pieces of my childhood as far back as the first grade, but anything before that is a blur. What if you could remember everything—everything you've experienced, everything you've read, everything you've seen and heard? Everything!

The strangest events and instances in my life have brought back good and bad memories. I wish there was a way to permanently suppress or erase bad memories. Unfortunately, this isn't an episode of the X-Files.

The deepest memories pop into my brain from a variety of sources during the day, from looking at photographs to reading books. As soon as they hit me, I usually jot them down so that I can use them in a blog post or story or essay later on. Some memories surface when I'm having sex, on the toilet, driving the car, or just listening to music. My gallery assistant once wrote a blog post about photographs that reveal and conceal. Photography does this—we humans are able to recall stories from looking at photographs often times better than pulling memories from our fragmented brains. Prior to Photoshop, you could pretty much assume the photograph you were seeing was factual. Every single detail is there, right in front of you, available to interpret and examine. Nothing is forgotten.

The following is a story recalled from my childhood, triggered by an event and a single word: archery.

Greenland, New Hampshire, had a population of around 2,500 when I lived there in the 1980s. This rural town was covered in fields, farms, apple orchards, and woods—most sold off to real estate developers who have saturated the landscape with oversized colonials.

Back when I was a kid, though, it wouldn't be unusual to see runaway cows or horses galloping down the street or hunters with bright orange jackets and rifles perched in trees on the perimeter of your property quietly waiting to gun down a buck, or kids ripping up and down the streets on dirt bikes. So playing in the backyard with weapons, from buck knives to bb guns, was pretty common. My uncle Bobby Big once gave me a few m-80s, and you should have seen the divot they created when we blew them off in the backyard. Yes, fireworks were even weapons. I once watched two neighbors shooting roman candles at each other—dumb, I know. Every kid I knew had some type of weapon. My neighbor Ron had ninja stars that he ordered from some mail order catalog (we didn't have Internet back then). We used to fling those across the yard into the big oaks. I also had yellow fiberglass bow and arrow. Now, I'm not condoning the use of weapons in any way, but this is a story—a true story.

My neighbors were hunters and they had a hunting dog, a German short-haired pointer named Alex. This dog was fast. He would often run alongside cars up and down the street when he wasn't running around the yard with us. He would try to catch anything that we threw in the air: baseballs, tennis balls, and even snowballs. He also had a habit of gnawing on rocks and big sticks, leaving his mouth and gums constantly bloodied.

Archery, the practice of shooting an arrow from a bow, takes skill, and we were practicing. We weren't hunting—at least I wasn't. We used to draw bull's-eyes on empty cardboard boxes and practice archery in our backyard. One afternoon, Ron's brother Chris and I

were having target practice, when out of nowhere the family's trusted hunting dog ran right in front of the target—THUD! The arrow struck Alex right in the side, and he kept on running like a bucking bull. Chris and I chased after Alex and by the time we caught up to him, the arrow had already fallen out. There was blood, but not a lot. It didn't even faze Alex.

We rushed into Chris's house, and he dialed up his father. I watched as the long coiled chord on the old AT&T trimline phone stretched and coiled back up, expanding and retracting as Chris paced back in forth in the kitchen until his father answered. Tears streamed down his face as he told his father what he had done. I stood in the kitchen listening to their conversation with some dopey adrenaline infused smirk. This event wasn't funny or amusing at all. As someone who has owned a dog, I take real offense to the cruelty or endangerment of animals. But I was a kid and didn't know how to act in this situation.

Chris's father assured him that the dog would be ok. Luckily for Alex, it was only a flesh wound, and he was lucky that Chris wasn't playing with his compound bow. That would have been a kill shot.

Many years later, a friend suggested that I read the book, *Zen and the Art of Archery* by Eugen Herrigel. As soon as I saw the title of the book, the first thing that came to mind was this incident from childhood. It's strange what triggers a memory.

Although the book *Zen and the Art of Archery* is one man's quest to learn "the Great Doctrine" of Zen Buddhism, taught through the learning of archery, it is about much more. It inspired me, and I learned that you could substitute any form of art in place of the word "archery" and it would apply. Each chapter is filled with at least one great lesson to help you master the Zen of your chosen art. For example:

> "...the right frame of mind for the artist is only reached when the preparing and the creating, the technical and the artistic, the

material and the spiritual, the project and the object, flow together without a break."

Now think of that statement in relationship to photography. It's telling you that you must be focused, prepared, have an understanding of your equipment and how to use it properly, some knowledge of the history of the medium and an idea about what the finished image will look like. If this is all clear to you, you have a great chance of creating something special. Everything is connected!

I reference many books in this book, because they relate to how memories are recalled and connections are made. Keep that in mind. Also, make sure your dog isn't running in the backyard when you are playing with weapons.

A DAY IN THE LIFE

I won't assume that you know what an average day of a gallery owner looks like. Some days start kind of like how I'm about to described. One friend told me that before he knew me, he guessed that gallery owners just hang exhibitions and sit around for someone to show up or call. I'm sure a lot of people probably think that's all we do—but that's only part of it.

I'm awake and it's now early Saturday morning, and from where I sit—that's in a black, leather club chair by my living room window, I can hear the constant hum of countless air conditioner fans swirling around working overtime on the roof above me. The sound drains out all other sounds, the birds, the cars, and the passersby. This sound is somewhat reminiscent of the exhaust fans that would run nonstop when I'd be working away in the darkroom. You didn't want to be breathing in those chemicals over a long period of time. They are kind of toxic.

We live in a penthouse in the heart of Boston and today it's supposed to reach 101 degrees. My nose is congested and I'm not sure if it's from the air conditioner or the ceiling fan that hovers over our bed—both stay on to circulate the air. My wife complains that I snore. Mental note: some gallery owners snore. Allegedly, my constant snoring keeps her awake at night. I still don't believe I snore, but I'm

sure that it's partly due to the orbital cyst in my sinus cavity that my dentist discovered in an x-ray or maybe it's my deviated septum. Bad deviated septum—bad, bad, bad, bad, bad! I adjusted the wooden slats of the shutters to let in some light but also to feel the heat emanating from the outside on my back and shoulders. It's time to thaw.

I'm sitting in my underwear eating my yogurt, applesauce, and banana—I'm a light breakfast kind of guy. Maybe you didn't need to know about the underwear part, however, I said it—I own it now. I stare at my feet, which are propped up on the ottoman, and I can see one half-painted toenail—my wife painted it for good luck. She did this to me at least a month ago while I was sleeping and now only half the paint remains. My toenails grow fast! Notice that I didn't say anything about my fugal toenail that hasn't grown back in five years—oh, you didn't want to read about that! I tip back my cup of coffee to get that early morning shot of adrenaline. The bitter taste lingers in my mouth. I slosh the coffee back and forth in the cup watching the cream create interesting designs on the surface. I can almost see the bottom of the cup now. The decorative "A" font glazed onto the outside of the cup stands for my wife Anne who remains asleep in the other room. Our dog just finished her breakfast and lies patiently at the base of the bed protecting her royal highness. My wife is my queen and all good men should take care of their queens. For Best Supporting Wife in a Nonfiction Memoir or Romantic Comedy or Book of Photography Essays and Interviews, the award goes to: Anne DeVito.

After breakfast, I turn on my laptop. It rests against my bare legs—overheating and practically singeing the hairs while I type away. I check my email first and then skim through Facebook and Twitter. I get all of my news through social media—we no longer have cable TV. Social media has become the new means of getting the word out about gallery-related news and events. We maintain it twenty-four hours a day. The public is hungry for information, and, by god, I'm going to deliver it to them like their virtual paperboy!

Most galleries open at 10 a.m. If I waited until then to start my day, I'd never get anything done. This is one reason why I'm usually there by 8 a.m. Another reason why I go to the gallery so early is because it's located inside a hotel. Hotel guests walk through my gallery to get to the restaurant for breakfast. Fact: I sell more artwork between 8-11 a.m. than any other time of day. Fact #2: I sell more artwork to hotel guests and former guests of the hotel than any other demographic, including local collectors. You'd go in early too if you were in my shoes, wouldn't you?

Another thing that is important: Red Sox season. The hotel where my gallery is situated is steps away from Fenway Park—home of the Boston Red Sox. If there is a home game, I need to know that because foot traffic will quadruple that day. We live and die by the Red Sox schedule.

Siri, is there a Red Sox game today?

(Beep-Beep) Let me check on that.

There is no set time schedule when you own a small business—especially when you are the only employee. You work when there is work—and that seems to be always. One artist whom I represent is an early bird like I am and will send me e-mails at the crack of dawn. I'm sure he's happy to see that I respond to them promptly, minutes from the time they are sent. You have to at least give the appearance that you are working for them—always!

Okay—a couple more things then I'm ready to go. Iron shirt, check. Shower, check. Brush teeth, check! Give the dog her daily pill and take her out, check–check.

My wife drops me off at the gallery usually around 8 a.m. on her way to work, but today is Saturday, so that means, "You're walkin', bitch!"

Upon arriving at the gallery, I go through my daily routine—open doors, unlock filing cabinets and flat files, fill up the water bottle, check the mail, and then organize the rest of my day's agenda. My day planner should already have my scheduled appointments for the

day and any action items that need attention. I've used the same type of daily journal for the past four or five years. It's a black, soft leather moleskin day planner. I've even turned some of my past interns onto this lovely book—dates on the left side, notes on the right side.

A new addition to my daily routine is packing my lunches, something that I once frowned upon. I now realize that it's better for me to have smaller snacks every few hours rather than a large meal three times a day. Most of you will figure this out as you get older. Your metabolism will start to change and you will begin to gain weight. It catches up to you without even knowing it. And another thing: you start to become cranky if you wait too long in-between meals. And from what I'm told, I'm "Mr. Cranky Pants," so feed me already!

It's very quiet in the gallery in the morning. There might be a random hotel employee steam-cleaning the carpets and the faint music from the adjacent restaurant, but other than that—nothing. I greet every guest heading down to breakfast with a "hello" or "good morning" or "the bathroom is at the end of the hall on your left"—that happens twenty times a day, at least! On top of being a gallery owner, I'm also a pseudo concierge desk. So besides being in the fine art business, I'm also dabbling in the hospitality business. I never know who will be buying art. I don't judge anyone who walks into my gallery. I do however judge a book by its cover.

(Ring-Ring). Oh, a call.

"Small Business Owners. Press 1 to update your business listing with..." (Click). I get those calls at least twice a day. Telemarketers suck! Now I don't bother answering the phone unless an actual name comes up on the Caller ID.

Most days at the gallery are spent meeting with artists, planning exhibitions, designing web pages, shipping prints, framing prints, writing stories or press releases, designing postcards, invitations or advertisements, returning phone calls, answering emails, reading articles, doing portfolio reviews, meeting with printers, retrieving the mail,

making connections and paying bills. Once in a while if we're not busy, I like to pop into the photography school across the street and do surprise critiques with the students. This isn't a glamorous life, although some of my friends get a kick out of that fact that I hang out with what does my friend Mark calls "the art world glitterati." As I have explained to them and him in the past, artists don't act like celebrities; they're worse than celebrities because their egos are much larger!

Today I'm planning one of our future exhibitions that will be called *On First Contact*. I will be showcasing photographers who use large format cameras who will be only printing their work as contact prints, and other artists who will enlarge some of their contact sheets. This exhibition will be quite the lesson in photography because patrons will be able to get a sense of how a photographer works—they'll actually see the process behind the final image selection.

If I get through all of my action items for the day, I'll usually cut out around 4 p.m. and walk home. I check the mail, take the dog out and feed her, then concentrate on "women's work" which has now turned into "men's work"—the dishes, the laundry, etc. Alas, I sit back on the couch with my laptop nestled on my legs and get back to work. There is always work to be done. And then my queen comes home from work, we eat, and then the cycle continues again.

Pete and Repeat were on a boat, Pete fell out, who's left?

Repeat.

ZEN AND THE ART OF IRONING A DRESS SHIRT

Wanna know a secret? I am a creature of habit. My wife will attest to this and so will my closest friends. One thing that I do almost every single day (and I will not let anyone else do this) is iron the dress shirt that I will wear that day. A warm, freshly ironed shirt, especially on a cold New England day feels so good. When I put it on, I feel good: I feel positive. Go ahead, put on one of those wrinkly balled-up shirts that was on the floor in the corner—yeah, the one over there by the side of your bed. Now look in the mirror. Can't you hear your mother saying, "You can't wear that! You look like you slept in it." Wrinkled shirts make me feel negative too. I vote for ironing.

The dress shirt is the only holdover from my days in the business world—no more suits and no more slacks. My shirts of choice are Brooks Brothers. The reason for this, besides that fact that they are quality shirts for professionals, is that they actually fit the bodies of *normal* sized individuals. I'm not skinny, I'm not athletic fit, I'm not a twink, and I'm not big & tall. I'm normal, or in the case of Brooks Brothers, "original fit" or "classic fit." My measurements: 16½" neck, 34" length. In 1896, Brooks Brothers made history by inventing the original polo button-down dress shirt. This shirt changed the history of fashion design. It is the staple of many business suits.

Ironing is a Zen-like experience that clears my head before the start of my day. The only true disturbance from this Zen-like state is when I open and close the ironing board. The loud screech of metal on metal as the board opens would wake someone in the deepest sleep. In fact, this is the alarm my wife wakes up to every morning. Companies that manufacture these boards should invent the secret squirrel silent opening mechanism—stealth mode!

I plug in the iron. Mine takes about sixty seconds to warm up. When it's hot and ready, the iron makes a soft sounding "pop." I iron each shirt exactly the same way. There's no starting with the collar and then moving to a sleeve—nope, there are steps to enlightenment. And before I begin my daily ironing ritual, my dog always comes into the room and curls up at my feet.

Here is a step-by-step guide to ironing a shirt for men and women by Jason M. Landry.

First, you iron the front of the shirt that has the pocket and the front center placket. The placket is the strip that runs down the center of the shirt where the buttonholes are located. I stretch the shirt so it lies flat on the board and then after the iron is at just the right temperature, I start from the bottom of the shirt and move my way up. If you start from the top and work downward, the tip of the iron will get caught on the top of the pocket and you'll fuck it all up. You'll throw unnecessary wrinkles in the pocket and those are a bitch to get out without starch. Oh yeah—no starch unless the shirts are white. That is a rule I made up— the Niagara stays in the cabinet. I cannot begin to tell you how many times I have knocked the can of Niagara off the ironing board and broken the tip, rendering it useless. Raise your hand if you've done that too. And one other thing: some of the Brooks Brothers shirts are labeled noniron, which means, or at least they claim, that they don't need to be ironed. I find that to be a misnomer and misleading.

Next, iron the other side of the front of the shirt—the side with the buttons. If I were facing the shirt, it would be on the left side.

Now this one is tricky cause you don't want to bust a button. I start on the outer edge of the shirt then work my way toward the buttons. Pretend like the shirt is a driveway covered in snow. You need to plow between the buttons with precession—drive toward them, then with the tip of the iron, go in between them like you were pushing the snow blower between two cars in a narrow driveway, then walk it back...walk it back. Start a new path and go in between the other cars in the driveway—walk it back...you get it.

Next, the collar. I'm partial to the button-down collar shirts. I wear them open at the top. The spread collars are okay, but I don't like the fact that they fly around and don't stay flat all the time—and they look sloppy without a tie. To tackle the collar, I usually flip the shirt over so that I'm facing the collar from the back—you could also approach the collar from the front too. I like a flat, wrinkle-free collar. I know you have heard the term "ring around the collar." This becomes more evident in white shirts. Sweat causes the yellowing of the collar. When it starts to become real noticeable like a bad set of stained teeth, time to discard that shirt and hit the store for a new one. It's up to you, but I like to leave the tiny buttons at the tips of the collar buttoned. You bust one of them little bitty baby buttons and you'll be pulling out another shirt to iron!

The back of the shirt is pretty easy. There's a large piece of real estate back there so you want it to look nice, like a well-groomed lawn. Start toward the tail and work your way up. In the middle you need to deal with the box pleat and make sure the lines stay with the natural crease. Note: Don't make more work for yourself by screwing with the natural crease. If you do, the back will look like an accordion and anyone who stands behind you will know that you suck at ironing.

Now...onto the right sleeve. There are natural pleats in the sleeves as well. Lay the sleeve flat and make sure not to mess up the pleats. Both sides are ironed evenly and the cuff ironed smoothly making sure to avoid any unnecessary creases. The sleeve placket is just above

the cuff and will usually have at least one button on it. Don't lop it off by pushing the tip of the iron on it too fast!

"Honey, I'll be right there," I yell from the bedroom where I'm ironing. My wife calls from the shower to see if I plan to jump in after her. Now, I would absolutely stop what I was doing if she asked me to join her, but that never happens. She likes scalding hot water and I can't handle it. You must weigh your options thoroughly when seeking enlightenment—third-degree burns or shower fun—hmmm?

Where was I—oh yes, the left sleeve. I take my time with the left sleeve and repeat the same steps that I did with the right sleeve. The final touch is ironing the yoke; this is the upper part of the shirt that your shoulders fill out.

I wrote this passage with the photographer in mind. Things don't always have to be as perfect as a well-ironed dress shirt. And I'm not telling or asking you to wear dress shirts either. Shake things up a bit. Find your own path. It doesn't always have to be a perfect square or rectangle. Your portfolios do not have to be in pretty cases—just make sure you and your things are organized and well kept.

Just like ironing a dress shirt, there are specific tasks a photographer must do correctly, with pinpoint precision. For instance, for those of you still using or have used film—loading film into your camera. If you do it wrong, or if you force it, bad things happen. Same thing can be applied to developing film. Have you ever tried to go into a pitch-dark room and attempt to load film onto a reel? At first, it's not easy until you get the hang of it. I've seen a lot of crimped film—some with fingernail marks all over it, and even some with scratches all down the entire roll. Take your time with these things. This applies to you folks who develop large format sheet film too.

Another thing that I want you to meditate on: It's good to be influenced by other artists, but don't get hung up and overly influenced by your heroes. Your choice of subject is critical to who you are—think about that. Here's a very smart quote Emmet Gowin once said during

a lecture, "Pay attention to the things that really matter to you...live near them." Let whatever subject you decide to photograph influence who you are as a photographer.

In a portfolio review I conducted in 2012, a photographer told me that *this* photograph of his was in the likeness of so-in-so, and *that* photograph of his was reminiscent of a different so-in-so. His prints were pristine and his compositions were well done but all I wanted to know was, which one of these photographs screams *YOU!* Where are *you* in the photographs? There was a very long pause followed by an even longer smirk.

He responded, "That is a good question."

For the most part, artists are unique beings, not copycats, right?

I described the process of ironing a shirt as simply and as descriptively as possible. You should have been able to visualize each and every step that I detailed. Now, pull a shirt out of your closet, set up your ironing board, and plug in the iron. Spend some quiet time "ironing out the details" and think long and hard: What would a photograph by *you* look like? Wear that around for a while and see how *that* fits.

WHAT DO PEOPLE WANT, AND WHY DO THEY WANT IT: EVERYTHING YOU WANTED TO KNOW ABOUT COLLECTING. (WELL...MAYBE NOT EVERYTHING)

"Here's what you need to figure out, J: What do people want, and why do they want it?" It's a fairly simple statement, but one very hard to define. Gustav always knows how to get my wheels turning.

These questions arose when we were discussing gallery trends: social media, search engine optimization, and marketing. To be an innovator in the gallery world, you must be doing something new and exciting—things that have either never been done before, like creating an exhibition that is so far-fetched that people will flock to the gallery just to see what you're up to. Art patrons, collectors, and critics are not usually interested in the same old thing—they're smart and do their homework. And from my perspective, the days of just having a square box with white walls and sending out just a postcard is a thing of the past. I have said this somewhere else, but I'll say it again, the gallery model, as we know it today, is flawed. The market is changing daily and it's no longer a place for the wealthy and celebrities to bump elbows. People are setting up galleries in their homes, hallways, and practically any little nook that

they can find. One person even set up a pop up gallery show in a museum's bathroom.

What do people want, and why do they want it—I addressed this loosely when I discussed the Steve Jobs biography. He was never a fan of market research. He had been quoted as saying, "It's not the consumers' job to know what they want." What a powerful statement. Market research offers insights to things that exist. Shit, the stuff he and his team came up with at Apple—they weren't able to do any market research. They were inventing things that didn't exist yet!

Gustav made me think of another dilemma: How do you educate a generation that has no real sense of art appreciation?

Prior to the invention of photography in the mid-1800s, painting was the craze. Wealthy individuals would have their portraits painted, hung in gilded frames, and put on display for all to see. It was a mark of "status." Being a patron of the arts was something passed down through the family from generation to generation, and it was understood and respected. But not everyone could afford to have a painted portrait of themselves or their families, much less a collection of paintings by noted artists.

With the invention of photography, most notably the cabinet cards and carte de visites, almost everyone could afford to have a portrait taken. No longer did a portrait alone signify wealth. To really set yourself apart from common folk, you needed to amass a large collection of images. Here come the collectors.

One weekend, walking through IKEA with my wife, we overheard a woman ask one of the employees,

"Where is your framed fine art section?"

I turned to my wife and let out a depressed "UGH!"

"J, this is what you're up against."

"Thanks for reminding me. Do you think it's a generational thing?"

She said without skipping a beat, "Classical education—this is what the world is missing. In our sinister world of reality, drama-filled,

la-la-land fables—art education, that is, a proper education in the arts, is a thing of the past." My wife is wicked smaht!

My goal is to educate and inspire the next generation of art collectors and patrons. What is their perception on collecting art? What is their lifestyle? How are they being educated about the arts? I promise not to bore you with statistical data and senseless shit; I'm merely brainstorming. Enough of this for now—let's talk collecting.

What do you want to know about collecting photography? What, you don't know anything about collecting? Sure you do!

You have obviously heard the phrase, "Buy what you love." Duh! Have you ever purchased something because you hated it? Of course you must first like it and love it and can live with looking at it on your wall long enough to forget that you even have it, and then decide later on in life to send it to an auction to help fund your winter house in Boca. Because once you become a serious collector, and I'm talking about a big collector, you could actually forget that you owned a specific photograph or piece of art until you sift back through your archive (and this has happened to collector friends of mine). So start keeping track of what you buy.

Some collectors have so many photographs in their collection that they have to hang their work salon style because they ran out of wall space (I've become one of those). I've gone into collectors' homes where they have set up their guest bedroom as a staging area—frames stacked on the floor leaning against one and other, easily accessible so that they can rotate things on and off their walls whenever something bores them. These are my favorite collectors—the photo hoarders, the ones who support the medium even when they don't have the wall space.

If you are serious about collecting photography, there is no right answer or way to do it. You will get advice from everyone. The only advice I can give is: supporting the arts is a serious thing. Take care of

the artwork and eventually it might take care of you. Ask questions, seek out art dealers whom you are comfortable with and befriend them. Visit museums, galleries, and art fairs often. If you think you are buying art as an investment, you better do your homework. Although the art market in recent years has done significantly better than the stock market, reasons why art increases or decreases in value are not scrupulously documented and monitored like stocks by the Security & Exchange Commission.

If you were able to buy a photograph right now, what would you buy? How much would you be willing to spend? Where would you purchase it? Where did you first see it? What attracted you to it? Could you live with it forever? Put your thinking cap on...there is a lot to think about.

So J...What's in your collection?

I guess it makes sense to give you a little background on why I collect photographs, what I collect, and how it all began. I started collecting baseball cards as a child. Although the player portraits kept me occupied for some time, I wasn't able to put together a complete set. As a photographer, I was inherently a collector. I organized my negatives into sleeves and then binders. I stored digital files of my work in folders on my computer, with my own personal naming systems based on dates and subjects, and by edited and unedited.

As my interest in photography grew, it was photography books that first piqued my interest, then signed photography books. Towards the end of my junior year at the Massachusetts College of Art and Design, my professor Nicholas Nixon would bring in photographs from his personal collection to share with the class. We would be instructed to line up a few 8-foot tables and cover them in brown craft paper. He would place on them framed and loose prints from some of the biggest names in the world of photography: Richard Avedon, Diane

Arbus, Sally Mann, Emmet Gowin, Frank Gohlke, Bill Brandt, and on and on. I was hooked!

I came home from school and told my wife, "Honey, I'm done with buying photography books, I'm buying photographs."

She just shook her head and went into the bedroom thinking I was crazy.

The first print I acquired for our collection was by photographer Jerry Uelsmann. His surrealistic black & white photographs were the reason I got into photography. In 1990, I saw one of his books and was blown away. In 2012, Phillip Prodger, curator of photography at the Peabody Essex Museum in Salem, Massachusetts, hosted a fifty-year retrospective of Uelsmann's work, and I was finally able to meet him in person.

My collection began with one print, the Uelsmann, and was soon followed by Barbara Bosworth, Abelardo Morell, Nicholas Nixon, and Frank Gohlke (all of whom were my former professors). Then my taste in photography moved into a different direction.

The next thing you might wonder, where did you buy your photographs? Well, some I purchased directly from the artist. This practice is somewhat frowned upon in the art world because you are cutting out the dealer who might be representing the artist. I don't kiss and tell, so I won't reveal who sold me what, but I will say that most of those acquisitions happened prior to owning my gallery. Some prints I acquired by trading with artists, and sometimes trading with other collectors. Some were purchased at art fairs like AIPAD, and some were purchased through private dealers. I have acquired numerous prints at auctions, both big and small, including benefit auctions, and some even on eBay. The eBay route is tough because it's a crapshoot and I don't recommend it. You can't inspect a photograph like you can at a reputable auction house or at a gallery. You can only guess that whoever is selling it has given you the proper information regarding provenance (who's owned it and where it

came from), whether it is a vintage or contemporary print, edition size, and most important, condition. If you are just starting out collecting, I would go through a gallery first or a benefit auction, or buy work directly from an artist if the photographer does not have a dealer yet.

I have spent anywhere from $50 for prints in my collection to a little over $5,000 dollars. Some of the works that we have collected have values exceeding $10,000-$20,000. You don't have to be rich to collect art. All you have to do is tell a gallery director what your budget is and go from there. Some galleries might offer you a layaway option if they know you well enough. You'd be surprised how far someone will go to buy a print that they want badly.

My favorite aspect of collecting photography is the hunt. To be a collector is to be on a constant and continuous adventure. Some collectors are looking for deals, while others are considered "bottom feeders." They're the ones who attend benefit auctions hoping to get a print for less than half price or go on studio visits, preying on artists who are not represented by galleries yet and convincing them to sell them prints for bargain basement prices. For the most part, my wife and I enjoy supporting the artist in whatever way we can.

The act of searching for a specific print is euphoric and brings me almost as much satisfaction as actually owning the piece. I track photographs as if they were prey. Our collection consists of photographs by emerging and established artists including early daguerreotypes, cabinet cards, cigarette cards, cart de visites, tintypes, stereoview cards, collotypes, gelatin silver prints, archival pigment prints, Polaroids, and a few mixed-media pieces. What we own continues to grow both in numbers and in value each year. I'm at the point now that I have practically run out of wall space—so most of what I acquire will be stored in portfolio boxes and flat files until I either move to a bigger house or get bored and decide to replace it with something fresh.

When you finally have a particular piece of art in your possession that you have been longing after for quite some time, you might feel a sense of victory or overwhelmed with joy. When you are passionate about what you collect, it shows, and through it, you might just reveal something about who you are—something you least expected.

YOU'RE PROBABLY A COLLECTOR

"The collector by contrast, brings together what belongs together."
—WALTER BENJAMIN, *The Arcades Project*

Why do people collect photography as a fine art? Haven't I already talked about this shit already? I feel like I'm repeating myself. Through interviews I conducted in 2008-09 for my graduate school thesis, I discovered there are two primary reasons why people collect: it makes the collector feel good—and you know that's why artists were put on this earth, and they are driven to possess souvenirs or trophies—collectors should have been hunters or played sports.

Other reasons why people collect: 1) it extends the lifecycle of your memory—they shouldn't have done all those drugs in college; 2) you can pay homage to a artist or artwork that you appreciate—just write them a big, fat check and I bet you'll make any artist happy; and 3) greed—some people don't want anyone else to have a certain object—they probably failed sharing in kindergarten.

I discovered during my interviews with approximately twenty collectors that a majority of them collect things other than photography, and they've collected various objects since childhood.

In *The Photograph Collectors Guide*, Lee Witkin said:

"Collecting (and every collector knows the symptoms) means seeking, desiring, wanting, yearning for, coveting, having to have...and, as soon as possible—acquiring, possessing, hugging to the bosom, and savoring with all the joys and prides of ownership."

I like that Witkin used the word bosom—a word rarely used in today's society. I'm not sure anyone hugs and squeezes a photograph, but I get what he was trying to say.

The fine art photograph became a commodity in the early part of the twentieth century. Alfred Stieglitz, who in 1908 started the first art gallery in New York City, began to include and sell photography along with other forms of art. It wasn't until years later when Helen Gee opened Limelight Gallery and then the Witkin Gallery opened in 1969, catering strictly to photography, that a true market was formed.

Since then, the price and demand for original photographic prints has continuously increased. The fine art market could be viewed similarly to the stock market—knock on wood that we have never had a crash or an Enron issue. I wonder, who do you think the Warren Buffet of the photography world is or the Bill Gates?

In the book, *The Passionate Collector*, author Ellen Land-Weber writes, "Income may determine *what* one collects, but seems to have no bearing on whether or not one is a collector." The price for a fine art photographic print is dependant upon numerous criteria with quantity, quality, and demand for the prints in circulation at the top of the list. Prices also become inflated when an artist gains quick notoriety for no reason at all. These are the tricky ones. It becomes hard to determine an artist's true worth?

Collecting is a journey of discovery, encompassing various genres and themes that are too vast to ever grasp. It is a sensory experience that begins with one's gaze focused on an image and the impulse to acquire it. It is from this point that I was interested in *how* or *if* a collector's gaze

is similar to that of a photographer's gaze. "The most important starting point for the collector is to ensure possession of a sound working knowledge of the history of photography. This will allow you to properly identify the source of your own aesthetic interests, and expand the potential scope of the type of collection you wish to assemble," writes Laura Noble in her book *The Art of Collecting Photography.*

Museums and their curators usually have their own idea or eye as to what they want to collect and an overall theme in mind. The art that goes into a museum has a history, while the history of photography is rather short, the act of collecting photography is even shorter. People did not start to actively collect photography until the early to mid-twentieth century, because there was still a debate on whether it was art or collectible. Stieglitz was a true champion of photography and sent letters to institutions like the Museum of Fine Arts in Boston and the Museum of Modern Art in New York, trying to convince the curators to start a department of photography. Those letters eventually paid off and photography has now been integrated into many museums around the world—some museums have better track records for actively collecting than others.

In my interview with photo historian and Boston-based curator Leslie K. Brown, she explained that there are two distinct categories in collecting photography: private and institutional. She said, "Often it is the core of a personal or private collection that turns into institutional collections." Thus, it's often the private gaze, rather than the museum curator's, that provides the breadth of a collection. Examples of such collections are the Monsen Collection, acquired by the Henry Art Gallery in Seattle, Washington; the Gilman Paper Company Collection acquired by the Metropolitan Museum of Art; and the Marjorie and Leonard Vernon Collection, acquired by the Los Angeles County Museum of Art.

In the world of fine art photography, collectors have an abundance of choices as to the works they can acquire. Vintage works, such as

daguerreotypes, tintypes, carte de visites, and stereoview cards from the late nineteen/early twentieth centuries are highly sought. The more accessible photographic prints are black and white and color prints made in the early to mid-twentieth century up to the present. Archival inkjet prints are the newest form of photographic prints and are digitally produced.

In one interview, a couple explained that they had never considered themselves collectors until they had run out of wall spaces and continued buying photographs. One collector said to me, "Everyone thinks of themselves as being unique and tries to define themselves as unique. This statement holds true for photographers and collectors." I agree. Collectors are notorious for trying to one-up each other—bragging rights is a big thing, but then again, nobody likes people who brag, and that's why their network is smaller and cliquey.

I find that serious collectors are true historians of their collections and have an enrichment of knowledge, both in the context of how a work in their collection relates to images of the past and how it fits in with other images in their collection. I have noticed that collectors are usually able to remember names, dates, and the provenance of each piece as well as where they acquired a particular photograph and the circumstances around it.

These are the details that only a collector's gaze who has looked at a piece over period of time will remember. It is precisely how photographers remember what they saw when they looked through the ground glass of the camera, peering at the subject that presented itself in front of their lens; a dimple on their sitter's face, or a hair just out of place. A Boston gallery owner explained that he was moved by the incredible accuracy of the memory of some of the older photographers he represented. He always wondered if their photographs were the cement that kept their memories together.

What is the role of collectors? Do they see collecting as a self-motivating act or helping the artist? Collectors are interested in art, but

they're also aware that they are ambassadors of the artist. Some see it as job to promote the artist, helping to validate their work, and ensuring that the work ends up in a museum collection. One art historian noted that collectors, by creating collections, are creating the social life of the objects. Having a caring collector is mutually beneficial for the artist, who conceivably gains more recognition, and the collector who will reap the benefits of a collection that increases in value. At no point in my interviews did a collector say he or she was purchasing art strictly as an investment. I acknowledge that there are individuals who see art solely as an investment, but this topic will not be addressed in this book. Why? Because I don't buy art as an investment and I don't sell art as an investment. If you come to me for investment advice, I will point you in the direction of the nearest Fidelity office.

Why collect photography? A prominent collector told me, "It's an obsession, an addiction, and you have to have it regardless if you can afford it." Another theory that I encountered was that collecting was a way of cheating death. The act of building a large collection of things, whether it is art or not, gives collectors the belief that they have control over something, a way of slowing down history. This theory cannot be taken for granted. If a collection is complete, you are no longer a collector, the act of collecting ceases. "Time only moves in one direction," a local collector told me. "I do not keep family or personal photographs on display in my home because they are more powerful than the fine art images I collect."

Collectors may see and feel that they are getting older and begin collecting as a form of therapy. To look at this from a psychological standpoint, it could mean people have an unwillingness to let go of their past, or collect because it is a connection to their childhoods, a time in their life when things were less complicated. In Susan Pearce's book *Museums, Objects and Collections*, she states, "'Objects' act as reminders and confirmers of our identities, and probably our idea of our identity resides more in such objects than it does in any idea of

us as individuals." She continues by quoting Sartre who insists, "We want things in order to enlarge our sense of self, and that the only way in which we can know what we are is by observing what we have."

We should also acknowledge the collector's gaze because it is through his or her gaze upon sight of an object that ignites that initial spark and desire to want something. It is a sensory experience and ceremonial encounter, the same way that photographers or painters interact with their subjects.

A collector that I interviewed acknowledged that one specific difference is that with photographers, there usually is a lot of planning and editing involved before they come to the final selected image, where the collector just sees that right one for him or her and can enjoy it for what it is. "Collectors look at images very differently than a photographer does," explained one Boston collector. "Some collectors believe that they have a personal connection to the artist and their work, but do not possess the personal history and personal context that the photographer had when they made the image."

Can the photographer-collector relationship survive without the other? One artist said to me, "I'm not even worried if my work sells, because I'm going to make it regardless."

Okay, so let's present this question: Will there always be artists? Of course there will be. There is art in almost everything we do: photography is an art, so is making music, baking, ironing a shirt, cutting hair—you name it. But will there always be collectors? I'm not sure about this one. With the invention of things like the "cloud," you virtually own things. You don't physically possess them. With art and photography—will you virtually purchase a piece of art to display digitally on your wall? That is quite the possibility. Chew on that!

A LETTER FROM THE DEAN

"Dream Dreams, then write them down. Aye, But live them first."
—SAMUEL ELIOT MORISON (a Bostonian)

It's quite astonishing that I would be asked to give the commence-ment address at a photography school in 2012—the year that I began most of the serious and not so serious writing for this book. Am I qualified to inspire a generation of young, graduating students of the New England School of Photography? Hell, yes!

After I got the official letter from the dean, my buddy Fitts asked me if I had an angle yet for the talk. I had a few ideas, having sat through a couple of speeches myself. I told him that I definitely planned to make it informative, inspiring, humorous, and, I hoped, short. As I began writing, I rattled a few ideas by my wife.

She said, "I will not attend the graduation with you if *that's* what you're bringing." That wasn't the ringing endorsement that I'd hoped for.

I began to watch some commencement speeches on the Internet to get some ideas. One of the best commencement addresses that I had ever watched is the Steve Jobs's address he gave to Stanford University. I wasn't there in person, but you can see it on YouTube

(place a bookmark on this page, shut the book, and go watch it). The three stories that he discusses in his famous speech were touching and inspiring. The topics were: Connecting the Dots, Love and Loss, and Death. Not the sexiest of topics, frankly, they sound boring as hell, but when you listen to what he had to say, you learn a great deal about what he went through in life, and what he had to overcome in order to achieve success. My friend Gustav told me to watch the David Foster Wallace commencement address, but it just didn't do anything for me. Then I realized: I need to make this address personal. I need to touch these graduates and inspire them.

So, how does one become a commencement speaker?

Unexpectedly. One afternoon, a photographer that I represent pitched me an idea to curate an exhibition in the gallery featuring his students that were getting ready to graduate from the New England School of Photography. It would be the first time many of these students had ever exhibited in a commercial gallery. I met these students when they showed up at one of our gallery opening receptions. What I came to find out later was that their professor told each one of the students to approach me individually, look me in the eyes, shake my hand, introduce themselves, then leave. I thought this was brilliant and classy. That's when I decided to do a show with the students. The professor and I brought the students over to the gallery the following week and then we jointly addressed the class: You have thirty days from today to plan an exhibition here at the gallery. Their eyes lit up like fireworks—mouths dropped. The exhibition went off without a hitch and all of the students were glowing as their friends, family, professors, and staff from their school came to the opening to celebrate with them. A few days after the opening, the dean of their school came over to the gallery

to introduce herself and thank me. I told her how much I enjoyed working with the students. Two days later, I received a letter in my mailbox inviting me to give the commencement address.

Never in a million years would I have thought that I would be asked to give a commencement address. Each event, another milestone, and with each milestone, yet another chapter. The shocking part of the evening was after I finished my speech, the dean handed me an honorary degree in photography from the school. I almost cried. Yes people, I am human.

Here's some bits and pieces from the commencement address. And when I say pieces, I mean it.

Commencement Address

Friday, June 8, 2012

To the family, friends, faculty, staff and most especially the students graduating today from the New England School of Photography, I thank you for asking me to stand up here and give today's commencement address. What I'd like to do, is not only give you some advice from someone who has spent the last twenty years as a photographer, a photography collector, and gallery owner, but to share with you a few important lessons—lessons that you may or may not have heard before.

The topics that I will be covering are: ████████, ███████████, ████████, ███████████████, and Metallica.

Straight out of high school, about twenty years ago, I began college, right here at your Kenmore Square neighbor, the Art Institute of Boston—but I only lasted one year. I wasn't quite ready yet. I took a detour and went into the business world for a little over ten years before heading back to school, ultimately graduating with a bachelor's in photography degree from the Massachusetts College of Art and Design and then receiving a master of fine art in visual arts

degree from The Art Institute of Boston at Lesley University. So you can imagine, I've sat through a few of these speeches before.

On a side note: It rained the day I graduated from MassArt, and I was only allowed two tickets to graduation. Since I was married, my wife wanted to attend and so did my parents. My wife and mother watched me graduate, while my dad sat out in the car. Dad, thanks for coming today.

Now—on with the lesson:

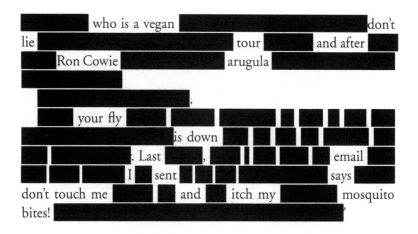

First: Find Your Art .

Second: █████████████████████████████?

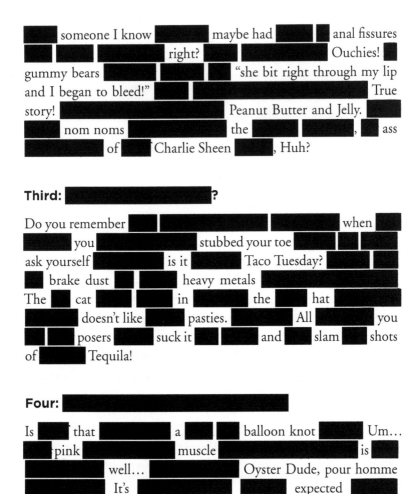

▉ someone I know ▉ maybe had ▉ ▉ anal fissures ▉ ▉ ▉ right? ▉ ▉ Ouchies! ▉ gummy bears ▉ ▉ ▉ "she bit right through my lip and I began to bleed!" ▉ ▉ True story! ▉ Peanut Butter and Jelly. ▉ ▉ nom noms ▉ the ▉ ▉, ▉ ass ▉ of ▉ Charlie Sheen ▉, Huh?

Third: ▉?

Do you remember ▉ ▉ when ▉ you ▉ stubbed your toe ▉ ▉ ▉ ask yourself ▉ is it ▉ Taco Tuesday? ▉ ▉ brake dust ▉ ▉ heavy metals ▉ The ▉ cat ▉ ▉ in ▉ the ▉ hat ▉ doesn't like ▉ pasties. ▉ All ▉ you ▉ ▉ posers ▉ suck it ▉ ▉ and ▉ slam ▉ shots of ▉ Tequila!

Four: ▉

Is ▉ that ▉ a ▉ ▉ balloon knot ▉ Um… ▉ pink ▉ muscle ▉ is ▉ ▉ well… ▉ Oyster Dude, pour homme ▉ It's ▉ ▉ expected ▉ ▉ chicks dig ▉ when you smell good ▉ and ▉ ▉ change ▉ your underwear.

Last, I'd like to leave you with these departing words:

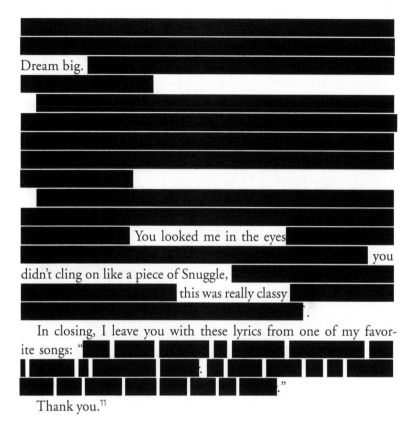

Dream big.

You looked me in the eyes

you

didn't cling on like a piece of Snuggle,

this was really classy

In closing, I leave you with these lyrics from one of my favorite songs: "

"

Thank you.[11]

Sometimes simple stories from your life, when organized and typed out on a page, can fit together like a puzzle. Try it sometime. Well, then there are other times when the puzzle pieces are missing, or there are too many pieces and you say, "ah, fuck this shit!"

11 Did you think I was going to write out the whole commencement address for you? My editor thought it wasn't a good idea. So I decided to make it like one of those top secret CIA/FBI documents where they finally release information about an alleged UFO sighting to the public, and you can't make heads or tails of what it actually says or means. I'll give you one hint about my address: most of what I said came from my personal experiences and connections. If you finish this book, you'll get a sense of what I may have said to the graduates. P.S.: I also added in a bunch of miscellaneous text just to fuck with you.

Looking back to that night, I was reminded how much I enjoyed school and the academic environment. I actually started to miss it and I began to think about what it would be like to teach or work for a school or college. My aspiration to work in academia was always something that I held on the back burner that I wanted to do. Little did I know the opportunity to do so would come a-knocking a year later.

AUCTION SEASON IN NYC

Similar to how major fashion lines come out with their new styles in the spring and fall, auction season also happens on the same schedule, at least in the world of photography, and in the United States. Not sure why this is—do collectors get tired of looking at prints on their walls during the summer and winter months, and then decided to throw them up at auction? Or maybe it has something to do with coinciding with some of the art fairs—a more plausible explanation. Your guess is as good as mine. Don't expect red carpet photo ops, catwalks, or big white tents. There's none of that here.

In New York City, for instance, many of the major auction houses such as Phillips de Pury, Sotheby's, Christie's, and Swann all host photography auctions in late March/early April and again around October.

In 2012, I overheard some rumblings, while in New York, that some of the auction houses were scooping up collectors who were in town for the annual Association of International Photography Art Dealers (AIPAD) photo show and whisking them off to the auction previews. This was upsetting some of the exhibiting galleries at the show who pay big bucks to have booths at these events. Big auctions plus big sales equal big business.

I was in New York City with Fitts who had decided to place a few pieces from his own collection in the Phillips de Pury auction. I have

to say that when we originally drove the eight pieces to New York, I felt a knot in the pit of my stomach: I felt sad for him that he was letting some of his work go. But his stance was, "Look, many of the pieces I've had for close to twenty years or longer. It's time someone else gets to live with them." It's a fine stance to take, but nonetheless, as a collector, I can't see parting with any of my major pieces. Before heading to Phillips, we walked from the Grand Hyatt near Grand Central Station all the way to Sotheby's. I wasn't dressed appropriately for the cold, raw, rainy day in New York, and to top it off, I had a blister on the bottom of my foot; this is what you get when you try to wear thin, fancy socks and the wrong-sized shoe. It was a slow, long walk. I suppose in hindsight we should have cabbed it.

Sotheby's is located at 1334 York Avenue in New York City. It is a massive multiple floor exhibition space. Greeters and guards are everywhere—and there needs to be, since at any given time there are millions of dollars of art and antiques on display. On this occasion, we took an elevator up two floors to where they were showing contemporary and vintage photography. Their catalogs were prominently on display on the tables by the entrance to each floor—finely printed, large, oversized, and glossy. Many people collect these catalogs (like I do) for reference material. This was actually the first time that I got to visit a real auction house. And on today's visit, I would end up at two of them.

Going to a preview at an auction house is free—anyone can go. Just sign in at the front desk, and off you go. You don't have to be dressed a certain way or look a certain way. It's almost like going to a museum for free—in fact, many of the art world's greatest hits could be up for auction and on display.

Our second stop was for the preview reception at Phillips de Pury. There were plenty of pretty people shuffling around, sipping drinks, engaging in small talk. Some have their bright colored clothes on so they are noticed, others in dark sunglasses (even though it was raining

and overcast that day and they were indoors). It's a mix of trendsetters and assholes, and a few true collectors and museum types. Fitts and I walked through, had some champagne, and checked out the prints he offered up to auction. The photographs from his collection included the likes of Irving Penn, Robert Frank, Henri Cartier-Bresson, Herb Ritts, Abelardo Morell, Bruce Webber, Horace Bristol, and Ken Probst.

Auction day arrived. I cleared my schedule and sat in my gallery in Boston and watched a live simulcast over the Internet while I had Fitts on the phone relaying the bid information as it was happening! The catalog was open and I was following right along—taking notes on the selling price of each lot. Simon de Pury himself was manning the podium with his distinct Swiss infused accent and gavel in hand[12]. There was a pretty lively crowd—prints were being sold left and right. On the low end, you could pick up prints for as little as $5,000, on the high end, over $100,000 dollars.

These are just two examples of auctions where serious collectors, dealers, and museums can bid on pieces for their personal collections, for inventory for their galleries, or for a museum's permanent collection. Often times you won't see museum curators bidding: museums will send liaisons, such as collectors or dealers, to do their bidding for them. Paddles go up and down, and the prices just head in one direction—up. If you are interested in auctions but these seem a little too intimidating, then try Internet, benefit, and some of the smaller auctions.

I would think most people who use the Internet are familiar with the auction site eBay, but there are also auction websites that cater strictly to art, such as Artnet. Some of the major auction houses also have an Internet presence and will let you place bids online or by phone if you can't physically attend the auction.

12 Six months later, Simon de Pury would step down as Chairman of Phillips after a twelve-year reign.

Another avenue is the benefit auction. Nonprofit organizations as well as colleges will host an auction to benefit an organization, cause, or institution. Unlike a major auction house where bids usually go higher than the reserve set on a given piece of art, benefit auctions tend to be where the institutional supporters come out, and so do the bottom feeders. I'm really not trying to make this sound dumb, but if you are looking for pieces for your collection, the benefit auction is where to go to get good deals. On a positive note, you are helping the hosting organization or cause or institution—a negative to this is that the donating artist sometimes, and I stress sometimes, will be disappointed when their work sells for much less than what it goes for in their galleries.

In the last few years, and I'm talking about the years 2008-2012, the U.S. economy was in the tank. I continuously watched prices on photographs at some benefit auctions go down. Some of these non-profit organizations live and die by these events and need the revenue to keep the organization alive. I have also watched some dealers hold back certain artists from donating to these auctions when the price dropped so low that it was perceived that it would affect the artist's market. I guess this isn't bad to hold back your artists once in a while. It could potentially help excite the crowd when you bring the artists' work back to the auction the next year.

If the big auctions houses scare you, consider attending a benefit auction, where the prices of the work will be usually dramatically less, and the people won't intimidate you. But beware, if this is your first time at the rodeo understand this: When the paddles go up and down, it's a rush! When you start bidding, you'll begin to get heart palpitations, you'll sweat, your palms will get clammy, and your ears will start to ring—similar to how they ring after being at a rock concert or sitting at a loud casino with the sirens and lights going off when you hit the big jackpot on the Wheel of Fortune slot machine.

TO THE BEAUTIFUL COUPLE

I went for my yearly physical today and my doctor went through a battery of questions like he always does. Do you have any vices: smoking, drugs, drinking, etc, etc. The answer is always—No. I think I told him one time that I don't do any of the above, but I might drive a little fast—that's probably my only vice. When he went through the questions today, he asked me, "So are you still driving fast?" My answer: "Well, that all depends on what your definition of fast is?"

I immediately flashbacked to me behind the wheel of my friend's BMW M5 as I hit 140 on a highway down in Florida some time ago. My buddy casually turned to me and said, "J...you do realize you don't get a ticket when you get pulled over going this fast." I brought the black beast back down to a comfortable 80 miles per hour and grinned. Don't try this at home folks. We're what you call adrenaline junkies!

In one way or another, I feel like I've acted in the capacity of a friend, sibling, and therapist to my buddy over the past twenty-five years. Not to mention: co-pilot, co-conspirator, and co-worker—acting in a few indie films together as well as being second shooter on some weddings that I was hired to photograph—you should always have back-up when dealing with bridezillas. If we continue on this "co-" topic, he was one of my co-best men at my wedding—no one

will ever forget his great one-line speech, "To the beautiful couple." Yup—four glorious words, now—onto our story.

I've been on more crazy adventures with this bloke than anyone else. We've driven cross-country on a journey that we documented in our unpublished novel *By Christmas*, which took us from Los Angeles to Boston via Arizona, through Santa Fe and Roswell, New Mexico, across Texas to New Orleans, then up the coast to New York City all in the span of eight days. If you've never rented a brand new Jeep and ran it full-bore through various climates, over rocks, into the desert, and down endless highways, do yourself a favor and go on a road trip. We hit a variety of places in the U.S. that I hadn't been to and was interested in seeing. We interviewed a ton of people along the way, sampled all of the local food, and were entertained at every stop. It was like an elongated episode of Anthony Bourdain's *No Reservations* minus the occasional strip clubs, gas stations, donut shops, odd encounters of the third kind, and oh yeah, the police! Yes, I did get pulled over somewhere in Texas because I was driving too fast. Yes the officer did ask me to exit the vehicle. Yes, he did ask me to stand in the field. Yes, he did then get back in his car and do Dukes of Hazzard across the median strip ripping up the grass in his wake—I digress.

These adventures, like many that follow, were meant to be photo documentary projects. We took so many photographs during the first three days of that cross-country trip that we had to hit up the office supply super store Staples to load up on more memory cards (neither of us had laptops or portable hard drives at this point—and the "cloud" didn't exist yet, other than the ones that float over us at 50,000 feet.).

In 2003, I toggled back and forth between photography and shooting movies. We filmed a short called *Finding Joey* that didn't really get any traction and very few people know about it. We hit the rails in 2004 across Europe—London, Amsterdam, Brussels, Heidelberg, Lucerne, and Paris tackling the art meccas. After two attempts at staying in hostels, we befriended an employee at a Marriott who

hooked us up on the friends and family special for the rest of the adventure. In 2006, it was Rio de Janeiro, Brazil, for a South American adventure filming *Finding Joey, Part Two*. No script—all on the fly—maybe someday we'll release it—Oye, Cuchina…Obregado.

One year, (we still joke about this) he temporarily-permanently moved from Los Angeles to Boston to live with my wife and I, then changed his mind and moved to Florida in less than two months, leaving all of his worldly possessions at our house. I've always wondered if his decision to move came after we both watched the Metallica documentary *Some Kind Of Monster*, or was it my two pet cats. That was two separate Ryder truck adventures. Temporarily-permanently—see what I mean?

I've been there through the break-ups and the make-ups, the job changes and location changes, the car, truck, bike, and/or boat purchases that are needed for any international man of mystery—which he is.

The "he" I am talking about is Andrew "Drew" Smith. He is not the Andrew Smith with the photography gallery of the same name from Santa Fe, New Mexico. This Andrew has also gone by many aliases over the years: Andy, Slyness, Fresher, Roo, Peer, Peerson, Howard, Dbang, and Diddy. It became Drew sometime in the early 2000s when he moved to Los Angeles, proclaiming that he kicked "Andy" back to second grade. He has a knack for reinventing himself, and if you don't keep in contact with him on a regular basis, you never know which Drew will answer the phone when you call—that is if he picks up the phone. If we used Gladwell's terminology to narrow down who Drew is, he would be referred to as a Salesman—but he is much more than that.

In the New Hampshire seacoast area, many of the local towns dump into one area high school. Drew was from Rye, and I was from the neighboring village (town) of Greenland. Our two schools went to environmental camp together in sixth grade, but we didn't

officially meet then. These two lanky punks with a liking for hot rods and metal music became pals at Portsmouth High School through a third party, whom we'll refer to here as Wild Willie! Halfway through our time in high school, his family moved to Florida. I would go down to visit once in a while and he would fly up to return the visitation series. Visitation series—what the hell is that? That's how we talk. It's like we made up our own lexicon of gibberish words and crazy phrases and shit that doesn't make any sense, but to us, we know exactly what it means. You know, think about the Liz Lemon character played by Tina Fey on *30 Rock,* she had some great made-up words fly out of her mouth on numerous occasions such as Blerg or Jagweed. Let me give you a few examples of some of our famous one-liners: deer maneuver, steeple bag, choze, braunt, rejuvenator series, gilla-be-gigged, assy nipple squeezer, and ink stain. They're just words—the language of our youth has not faded for one bit. It is still how we address each other on the phone, in text messages, or in person even to this day. Some of these words have cameo appearances in some of the chapters. Learn them!

I have to give Drew credit for breaking me out of my shell on many occasions. I used to hate trying new things. I'm a creature of habit, and for those who know me will understand. I may have gotten it from my dad who has proclaimed on many occasions, "I'm not eating it if I haven't tried it before." What? That's doesn't even make sense. I always joke with Drew by saying he was the first person who introduced me to soy milk, wasabi, and the power cleanse. Yeah, I'm talking about those herbal pills you take that make you practically shit yourself.

We took 'em!

They work!

Enough said!

Although we have both gone off into separate fields of business, I don't think we will ever grow up. I kind of like it this way. I can always

count on him, even when I haven't seen or heard from him in months, or even after he's pissed off my wife—which he has on numerous occasions. I think she recently referred to him as a douche canoe—nice, right?

Even though it wasn't intended, Drew's phone accidentally dialed my number this morning, one day after that doctor's appointment that I mentioned earlier. It happens to people more often than you think. It's not drunk dialing, it's more like ass-dialing or tight-jean dialing. Sometimes the iPhone will just dial a number stored in your "favorites" if the phone gets pressed up against something in your pocket, or if you sit down on it the right way. It's good to know Drew still keeps me in his favorites. On this day, my boy was telling me about some upside down shit that was affecting his business, and then finished with, "So what's going on in your world?"

"Well, I've been just working on some essays for the book and doing a little editing, and, oh yeah, by the way, I was trying to find a way to tie *you* into my life in photography, but I didn't want to sound like a stretch." (Oh shit...did I just open up Pandora's Box?)

"J...A stretch! I can't be-fucking-lieve it! You have to think about it? I thought you took me on all these trips so that I could help you break out of your shell? Do you think you would've photographed people the way you did without me playing wingman? Just think about New Orleans J—the bike gangs, strippers, and the midgets. Hello!"

"Ok...when you're right, you're right."

"Kid, we were like unleashed animals! I made you bring the rigs out everywhere we went. I'm sorry that you didn't want to get all hopped up with me on absinthe in Heidelberg—I tried to break you out of the shell, but your exterior is just too fucking tough. You'd still be shooting landscapes and murals if I didn't shake your ass up. I was always there behind you buddy, following your dreams while I was jumping around still trying to figure out my own."

"I know you were. Thanks Drew. That was the rejuvenation that I needed today. Oh by the way, if I come for a visit, any chance that

I can sleep on something other than an air mattress? I mean, aren't we getting a little old for that? I don't want to be visiting you on my fifty-fifth birthday and still nesting on the floor."

Drew chuckled, "J, I'm working on that."

It's true: I was pretty stuck in my own ways when it came to photography. I might have been older than my classmates in school, but I was just as green as they were when it came to taking risks. Although my interest was in creative portraiture, I was a little apprehensive as to what would happen if I approached a stranger to take a photo. Drew's ability to talk to and befriend people in the most inconspicuous manner taught me a lot about how to approach and engage a person that I might want to photograph. His presence did give me courage and helped change my own photographic process for the better. He was teaching me something that you can't get in a photography textbook.

You will find people in your life who are like this. You shouldn't dismiss them when the connection seems to dissipate, or you perceive that it has frayed. Find ways to strengthen the bond. Reconnecting with friends sometimes can be a one-way street—like a drag strip—and other times it's reciprocal, like a teeter-totter. It might be a big challenge, but strong bonds don't just happen overnight—they take work, like a shitload of work, like a power cleanse bowl full, if you know what I mean.

THE YOUNG GENERATION:
THEY GIVE YOU HOPE.

"Artists are not bound by age, only by type. I have learned a lot from artists and photographers that are half my age, twice my age, and all ages in between." —JASON LANDRY

"Jason you're the *buffer*."

"The what?"

"Buffer—you're that go-to person for emerging artists who have graduated from school but are lost or just need that extra push or moment of encouragement when they get into the real world."

"Yeah, okay—but I consider it more of a mentor role. I connect people to people."

"No—you're a buffer."

I'm not going to argue with my wife. I never win. I'll just add another nickname to my growing list. There is a need for connectors, mentors, and even buffers in the arts. I'm happy to role play—I mean, play a role.

In 2007, I met a young student from the New England School of Photography by the name of Keiko Hiromi. She is a petite, Japanese woman who would often come and visit Fitts and I when we worked together at the Photographic Resource Center.

"Do you think you could look at my work?" she would ask in her quiet, innocent, and convincing tone. Of course we would. This was one of the best parts about working at the nonprofit photography organization—working with students and emerging artists. Keiko had just begun a very long project (which she still works on to this day), photographing drag performers at Jacques Cabaret in Boston. Fitts introduced her to me when I began working at the PRC. Both Fitts and I were amazed at her work. We looked at Keiko—again, petite, innocent Keiko and then back at the pictures, then we'd look at each other, then back to the photographs. We critiqued the work and urged her to go make more—to get in closer—and to befriend the "ladies." She did everything that we asked, and she would often come back with piles of prints for us to sift through.

Another young photographer entered my life through an introduction by his former professor Bill Franson, who I represent through Panopticon Gallery. Samuel Quinn showed up at the gallery one afternoon, hair slicked, box of prints under his arm, visibly nervous, anxious, and smelling like he just smoked a carton of Camel Lights.

Sam had a binder full of Polaroids and a bunch of loose prints that he had made while studying at the New England School of Photography (NESOP). My first impression was, he didn't really take good care of his prints, but he had a good eye. He was shooting in abandoned buildings. He was shooting nudes and also Super 8 movie film and then creating gelatin silver prints from the spliced imagery. Genius! I love unique things, and this was unique. I had never seen anyone working with Super 8 in print form before, and I urged him to continue.

I included Sam in a Polaroid-themed group exhibition called, *Instant Connections*. This exhibition included the likes of Vik Muniz, Chuck Close, Andy Warhol—you name it. Wouldn't you know it, but the two images in the exhibit by Sam sold before any other

prints. I was amazed. My wife said, "You need to take Sam under your wing. He deserves it." I agreed. Sam, you can thank Anne any time now.

Then it happened. Sam decided to show off on a skateboard and broke his upper arm, a clean break! Now, most artists would probably take some time off, or bitch about not being able to work, but not Sam. This is where I give the kid some props. Since he was unable to go out and shoot on a regular basis, he would purchase old images from antique and thrift stores and began to manipulate them by dripping paint on the faces and eyes of the portraits. I looked forward to each new image like I patiently awaited a new TV series to hit Netflix. His DRIP series began to take off.

Samuel Quinn and Keiko Hiromi are just two of a number of graduates from the New England School of Photography whom I have mentored. It's great to be able to give something back to my community, particularly through mentoring and subsequently exhibiting work by these emerging artists. It's a nice sense of accomplishment. I know how important it is to give someone a chance. Without opportunities, many young students just don't have the drive to make it on their own. My constant presence is the difference between them making it in the art world and giving up and working as a barista making decaf soy lattes.

Keeping a student and or an emerging artist engaged in learning is a continuous lifelong process. When mentoring artists and photographers, I guess *I am* a buffer between what they learn in art school and the real world. There is always more to learn.

I'm going to step away from mentoring artists for a moment to talk about this one amazing thing that I had witnessed that prompted me to call this chapter, The Young Generation: They Give You Hope. It has to do with the effect that art can have on a young child. Children do the most magical things sometimes—surprising you in ways that you can't imagine.

On Christmas Eve one year, I was at my aunt and uncle's house as usual hanging out with our friends and family. My brother asked, "Are you coming to our house on Christmas morning to watch Nora open her presents?"

"Of course, why?"

"Nora has a surprise for you?" I didn't know what to expect. Now let's back up just a bit, my niece Nora had attended many galleries openings as a child. Whether it was an opening at my school as an undergrad, or as a graduate student—she was there. I remember one comment she made as she came through the gallery to see some work I had on display back when I was photographing my wife.

"Uncle J, are those auntie's boobies?"

"Why yes Nora, those are auntie's boobies."

You could never get anything past her. She was three when that comment came out of her mouth. I didn't go to my first gallery opening until I was nineteen.

Nora and her mother attended the opening at my gallery when I hosted my first exhibition with artist William Wegman in 2010. This guy can get dogs to do just about anything—even fly!

Back to Christmas morning, I got to their house and there were American Girl dolls and wrapping paper scattered everywhere—Yup, Hurricane Nora swept through here. So after all of the presents were unwrapped, I asked,

"Nora, your father said you had something to show me."

She started to smile and giggle.

"Come in the kitchen, Uncle J."

As I entered the kitchen, I couldn't believe my eyes. Her mother said, "Nora was very excited when she went to your gallery recently, so she turned the kitchen into *her* gallery."

Nora had taped all of her drawings and paintings in a row around the kitchen. She had created custom labels next to each image listing her name, title, and the price; most of the pieces were listed at

$440.40. Titles were equally exciting. One was called *Flower*, another called *Christmas Tree*, and one called *Jesus Christ*. My favorite was the painted portrait that included the caption, "See it before you buy it." I don't know where she learned this. This was a five-year-old! I have no idea what I was doing when I was five.

"Uncle J, do you want to buy one?"

"No thank you Nora. I'm just browsing. Great show!"

It amazes me what kids comprehend and what things influence their creativity. Introduce kids to art and photography at a young age...pretty please. And if you have the time, support emerging artists. They need all the support that they can get.

ART FAIRS 101

If you haven't been to a photography art fair, or any kind of art fair for that matter, it's like window-shopping on Fifth Ave, Rodeo Drive, or along the Champs-Élysée during the holidays—all your favorite artists are lined up, illuminated for the entire world to enjoy—kinda like storefronts. Okay, so artists won't be physically lined up—it's a figure of speech. Rather they'll be tacked up on the wall floor to ceiling—salon style—and we get to throw darts at them. Nope—that's a lie too. You will not find any games, cotton candy, or rides at these so called "fairs," but the crowds are big, the lines are long, (especially when purchasing your admission ticket the day of), and the booths are packed! You cannot dunk anyone in the water, win an oversized teddy bear, or shoot a clown with a water pistol in these booths. Instead, each booth is designated to a gallery or publisher who hand picks a selection of their artists to showcase.

I'm going to go out on a limb and make a bold statement: the traditional gallery model as we see it today is flawed. There—I said it. Actually, I have probably said it more than once in this book. Here's another reason why I feel this way: The art fair has become one of a number of reasons why the traditional gallery model as we see it might becomes extinct. Why, you ask? Let me explain.

I have learned that many art dealers do most of their sales through art fairs. Some are now trying to decide if they should even have a physical location. The economy has made dealers question the very notion of having a gallery space. The art fairs have given dealers a platform to show their artists to a dedicated audience during a specific time frame. When this critical mass is achieved, it puts the gallery and its stable of artists front and center long enough to create hype and demand in a matter of days. Since art fairs happen a few times during the year, why rent a permanent gallery space?

So you're probably asking, why doesn't everyone do this? Three reasons: cost, vetting, and risk. Some art fairs cost too much money for some smaller galleries. Second, event organizers pick and choose which galleries get in and which ones don't. Finally, there is no guarantee that you will sell anything, and such a gamble might leave you in a precarious position. Playing with the big boys and girls costs money and requires courage.

Enter an art fair and you'll likely see rows of booths running parallel like lanes in a grocery store, up and down the entire length of the venue. Think many, mini-me white-walled galleries, 100-500 square feet that can cost anywhere between $5,000-$25,000 to have for a few short days. On the other hand, they also look a bit like stalls—the kind you keep horses or cattle in. You won't smell or step in any manure in these stalls, but there might be a cattle call if a big artist is doing a book signing, and you might hear some horse shit—especially between collectors. Did I just say horse shit? Step right up, step right up and witness the amazing—nope, wrong fair.

My two favorites art fairs are AIPAD (Association of International Photography Art Dealers) usually held in March in New York City, and ParisPhoto in Paris, held each year in November. Galleries and publishers who are part of AIPAD are the crème de la crème in the fine art photography industry. On the other hand, the ParisPhoto fair is by far the biggest. When people ask me to compare the two, I

usually say "it's like AIPAD on steroids!" It's big, and the crowds are huge! In 2012, 11,000 people attended AIPAD versus the 54,000 people who visited ParisPhoto.

These two art fairs in particular play host to the blue chip-branded, most popular photography galleries in the world. The work on display is evenly split between vintage and contemporary works to accommodate the tastes of the patrons who attend the shows. The rich and the not-so-famous mingle among collectors, patrons, curators, photographers, educators and press agents from all corners of the globe. If you want to be seen, you can be—If you don't want to be seen, you'll blend right in. If you're into "people watching," as my wife is—it's perfect!

If the prices at these fairs shock you, then hit up any number of lower-tiered fairs that cater to smaller galleries and collectors with not-so-deep pockets. The smaller fairs tend to show more contemporary art and emerging artists and take place in the spring and fall. A few examples are: the Red Dot Fair, Affordable Art Fair, Frieze Art Fair, the Armory Show, and Scope.

What was that you said? I'm sorry, someone just interrupted me to say that arts fairs can be compared to a traveling circus—going town to town like Ringling Brothers and Barnum & Bailey. Let me take you on a virtual tour of some of the greatest shows on earth.

AIPAD, New York City

March 2012

At 6 a.m. I boarded the Limoliner at the Back Bay Hilton in Boston en route to New York City with my friend and fellow photography collector Jim Fitts. Think of the Limoliner as the cross between a limousine and a rock & roll tour bus. It is equipped with large, oversized leather seats similar to those that you would see in the first-class cabin of an airplane, flat screen TVs, tables in the back so you can hang out

with friends and get work done (like we were doing), and a steward who comes around to offer you drinks and snacks. Why thank you, I would love a croissant!

The Limoliner isn't that expensive. At $69-$89 each way, it's a bump up from the buses that drop you off in Chinatown, and much less than a flight into LaGuardia or JFK. Just think about it. If you flew into one of the New York airports, you still need to take a cab into the city, and that cab ride alone will set you back between $50-$60. The Limoliner isn't just for high rollers: it's for smart travelers.

The first thing to understand about art fairs is, there is a lot of walking that you do during the day, so make sure that you arrive a day early to relax in the city, or take comfortable transportation to and from the venue and wear comfortable shoes. The second bit of advice, and this statement is pointed directly at the photographers reading this, do not bring a portfolio of prints to an art fair. This is not a place to show work to an art dealer—it's not a portfolio review. It's a place for dealers to show *you* work and for you to buy work. One more suggestion, and I'm not pointing at anyone specific: please leave your spouse or significant other or buddies at home unless they are equally pumped up about photography as you are. The last thing you want to do is be guilted into leaving when you're not ready. These places are usually crowded with people and stuffy, from collectors and dealers to photographers, educators, and overall photography enthusiasts. During the week you may also compete with the mothers and nannies with baby strollers and school groups moving about and press people. I usually try and get to the fair on Thursday or Friday—Saturday usually becomes a shit show.

Some art fairs cater to just vintage work, just contemporary work, or both. The smaller fairs are sometimes just as interesting as the larger ones. What they offer is usually on a smaller scale than the larger art fairs and the dealers are more accessible.

It's equally important to know that the dealers are each trying to promote their own artists and sell work. Don't linger around too much yapping it up with a dealer if you don't intend to buy anything. Keep your conversations short and enjoy the work—hey buddy, great show, I didn't know you were showing so in so—love to catch up with you next week. Most fairs have fabulous printed catalogs that give a brief description of all of the exhibiting galleries and a list of artists that are in their stable, plus a few advertisements. If you have certain tastes, make a plan of attack and map it out, or just linger around and plan to stay all day, or maybe two days.

A different approach to an art fair is the small New York Photo Fair held at this place called the Lighthouse. In this fair, dealers offer inexpensive vintage works, from daguerreotypes to cabinet cards, CDVs, and snapshots, photo booth images, and Polaroids. The collectors who attend these fairs stalk photographs like a hunter stalks prey—and I fit right in with them! Each collector has a different want: someone might want vintage images of let's say, Tom Thumb (a little person) and you may find a few especially as vintage CDVs. Some people are after Native American photographs. Yes, those can be had in the form of photogravures or orotone prints by Edward S. Curtis. Then you have those who look for nudes and kinky porn images (OK—maybe I did buy a few)—they actually are rather interesting and entertaining. Since we're on the subject of kink, I was told by one French dealer that I need to be on the lookout for a book titled *1929*. It is a poetry book with kinky images shot by none other than Man Ray, who wasn't known for pornographic imagery. So if you can find a copy take a peek. It's hard to find since it's out-of-print.

Haggling with prices is also common practice. If you're out of practice asking for a lower price, head down to Chinatown and try to barter with some of the Asians selling the knock-off Louis Vuitton purses. Once you get the hang of it, head back to the art fairs. At the bigger art fairs, you can ask for the best price, and sometimes you

might get a certain percentage off retail. If you are a dealer, you might get a little more. At the smaller, vintage fairs, haggling *is* the name of the game. I'm not a good haggler when it comes to things I want. On the other hand, I understand that in a bad economy I'd rather help out my fellow dealer by paying actual retail. With all of the boxes of prints to sift through, you could be there all day! Prices are very reasonable for any budget. You could buy a print at a vintage show starting at one dollar. At a fair like AIPAD, rarely you will find anything below $500. At the larger fairs, the dealers will usually invoice you, unless they have a wireless credit card machine. The smaller fairs usually want cash, but some will take credit cards. If the galleries ship out of state, you can save on the tax. Most dealers have resale tax id number so that they can avoid such extra charges. Look at all this fun insider data. Thanks J!

ParisPhoto and the Mois de la Photo, Paris, France

November 10, 2012
Sitting in the plane on the tarmac at Logan Airport in Boston, Massachusetts, waiting to take off to Paris we hear:

Pilot. "The grounds crew is taking a look at the plane. As we left Paris, the plane was hit by lightning. We assure you that you have nothing to worry about."

Conversations within the cabin immediately hushed to a whisper.

That's how this year's adventure started, wondering if this would be our last flight. I think the pilot should have kept those comments to himself. (But I found out later, planes are commonly hit by lightning.) I'm not interested in experiencing it, at all—ever!

Paris is the city that I have visited the most when traveling internationally. We primarily visit this European hotbed in November when the city hosts one of the largest photography art fairs in the world: ParisPhoto. The weather is unpredictable. We've been there when it's

snowy and slushy, rainy and warm, in the high sixties. This year was cold, but dry—no rain the whole week.

For many years, ParisPhoto took place in the Carousel, a large underground cavernous section of the Louvre, converted into a mall. Yes, Starbucks is there, the famous maker of macarons Ladurée is there, and so is an Apple Store. Recently, the fair moved to the Grand Palais, a large exhibition hall with green exposed beams and a glass ceiling. My first thought was, on a sunny day, it might be really uncomfortable, and it wouldn't be good for the photographs to be baking in the sun. Being that the event takes place in November, this hasn't become a problem.

There is a loud hum of generators pumping heat into the Grand Palais. The sound is louder than usual and drowns out the nearby conversations. I was able to enter the exhibition hall two hours before regular visitors would be permitted due to my VIP pass. As a guest at the ParisPhoto photography fair, I'm hunting for pieces for our collection. If I didn't drop a load on a Henri Cartier-Bresson last week, I probably would be a buyer—but not on this trip. This time around I'll just be taking mental notes.

Every other year, the Parisians celebrate a month of photography (Mois de la Photo). Tons of galleries, museums, and art spaces participate making it a citywide event. Photos are everywhere. There are posters in the Metro stations and rotating kiosks, photo pavilions on bridges that crisscross the Seine—art fairs in various arrondissements. I never have enough time to see everything. I'm usually in Paris for just one week and it goes by so quickly—I always feel rushed and exhausted and in need of an actual vacation to recuperate as soon as I return home.

The slow, relaxing times in Paris happen only at night when I take a break from the crowds and have some time to myself. My wife and I usually hit up Willi's Wine Bar in the 1st Arrondissement. An Englishman owns Willi's and his wait staff is bilingual. On many

nights, we would sit at the bar, sip our favorite wines and enjoy a platter of assorted cheeses and bread while making small talk with the bartender. A lot of the photography dealers hang out there at night. The person who told me about it was Alex Novak, a vintage photography dealer from Pennsylvania.

On our visit in 2011, we ran into a Boston TV legend Natalie Jacobson, former newscaster for Channel 5. She had stopped into the bar to meet a friend. It's surreal when you run into someone that you have grown up watching on TV from your own city and you're half a world away from home. We invited her to stop by our gallery when she returned back to Boston. We haven't seen her yet.

Another wonderful thing that takes place during November that coincides with the fair and the Mois de la Photo festival is the Lens Culture FotoFest Paris portfolio review event for emerging photographers. Jim Casper, founder of Lens Culture, teamed up with the folks from FotoFest in Houston to create a three-day event hosted at the Spéos photography school in the Bastille district of Paris that attracts photographers from all over the world.

Portfolio review events can be a hit or miss. You might find a lot of talent at one event, and only a few at another. For the most part, there is a vetting process that tends to happen which helps to corral the really talented artists and weed out the ones that aren't quite ready yet. I'm looking for diamonds and gemstones that could use just a little polish.

The reviewers, including myself, come from a variety of backgrounds: from gallery owners, to publishers, to curators at major museums, to international photography festival organizers. I'm just as eager to meet my fellow peers from across the pond, as I am to meet artists who have come looking for a big break.

Friends and family back home think these trips are a vacation— Oh, Paris, you are so lucky. These trips are business trips during which I do this thing called "work." They are far from a vacation. I

work almost every day there. On this trip I didn't even get a chance to walk along the Seine with my wife, or visit a few of our favorite spots. There wasn't enough time in the day. We'd be up early, and we'd be running nonstop all day. There were many days that I wouldn't see my bed before 1 or 2 a.m. (something practically unheard of for me back in the States). I'd finally lie down on the bed and my body would start to twitch. Oof! Bon Nuit.

OLIO PANE VINO

After numerous visits to Paris, my wife and I discussed that we should plan a huge dinner party at a restaurant with some photographers and collectors. Organizing what I believed to be something relatively simple, since "organizing" is my middle name (no, it's really Michael), turned out to be a bit of a shit show. Our first attempt at playing dinner hosts came a few days after reviewing portfolios at the Lens Culture FotoFest Paris event in 2011. The location: *Olio Pane Vino*, owned by chef Francesco Bertuna. These three magical Italian words translate to Oil, Bread, and Wine.

The restaurant is located at 44 Rue Coquillière, a narrow street great for the speeding Vespas, off Rue Croix des Petits Champs, steps from Palais-Royal and The Louvre. If you are looking for a fabulous dining experience, get reservations early—they only serve dinner on select nights, and there are only about thirty seats in the place. If you're taking the Métro, get off at Louvre-Rivoli or Les Halles. It's a short walk.

Speaking of Les Halles, it's a very historical area in Paris. Once constructed out of iron and glass, it bears the name of a large central marketplace that Parisians would go to for their meats, fish, and produce. Nicknamed, "The Belly of Paris," it was leveled in the 1970s to make way for an underground mall. In the United States, the name

Les Halles is synonymous with the famed restaurant in New York City that chef and author Anthony Bourdain put on the map. I'm so glad he never filmed an episode of his show No Reservations at Olio Pane Vino; otherwise, we'd never be able to get reservations!

There are no loud advertisements, billboards or neon lights outside of Olio Pane Vino or signs announcing that it's even a restaurant. If you are standing in front of it, all you see are five glass windows and a glass door. If you weren't privy to its location, you might just walk on by—and boy, would that be a mistake! We were introduced to this restaurant a few years prior when photographers and publishers Michael A. Smith and Paula Chamlee suggested that we meet them for dinner. They had told us that their friend Francesco also displayed their photographs there. It is small and quaint. Francesco cooks and plays host, and when possible, visits each table. He is the quintessential Italian host, pleasant and accommodating, and most females think he is handsome. Of course they do—he speaks Italian, French, and English fluently and once moonlighted as a model.

In the back of the restaurant my eyes surveyed the space: bottles of wines were stacked underneath the oversized square prep station and jars were full of ingredients lining the perimeter of the kitchen. The server showed up with a small black chalkboard with the day's menu and read them off.

If you go, be prepared to try something new. Francesco picks the menu every day, and it will usually consist of three or four plates. Someone like me who is a creature of habit had a hard time deciding on what to order the first time I went, but after eating one of the most memorable meals of my life, I never worry anymore. I'll try anything he puts in front of me.

"Jason, It's-a *all* good-a."

We started with Insalata Caprese—the mozzarella melted in my mouth—a smooth and creamy sensation captivated my taste buds. I dipped the fresh bread in some olive oil and balsamic vinegar and

swirled it around. In the back, I saw them churning fresh pasta from scratch—soon to be presented in front of me with a mountain of shaved pieces of truffle and Parmesan flakes. Another sip of Prosecco and we settled into more conversation and laughter.

We go to Paris every November and always visit this restaurant. After dinner, Francesco pulls up a chair and a bottle of whatever we are drinking and sits and chats with us— It's like being at a family dinner.

"Jason, this-a here-a wine-a, comes from-a region in-a Sicily where the grapes-a grown-a in-a soil that's-a composed of volcanic-ash-a."

Our first dinner party was originally going to be with a pair of collectors from Boston who happened to be in Paris for the big ParisPhoto art fair. Unfortunately, the collector's girlfriend became seriously ill and had to go to the hospital. Since I was determined to throw a dinner party, I checked in with some other people that I knew. I had been palling around with a collector from Houston, Texas, and he and his friend agreed to come with us. He then asked if the executive director from the Houston Center for Photography (HCP) could come too.

Later that afternoon, I got a phone call from Bevin, the executive director, and she said she was rooming with photographer Julie Blackmon and a few others, and she wanted to see if it was okay to bring them as well. At this point, I lost count of what I originally told Francesco and said, Sure, what the heck!

Our party, which was originally four, ended up being like ten. Lucky for me, Francesco didn't hit the roof or ban me from the place. My wife and I surprised our guests when we picked up the tab. We told them that this was the plan all along, we just didn't tell anyone. It was one of the highlights of that trip for us, and I know it was for some of them as well.

The following April, I was invited to Houston to be a portfolio reviewer for FotoFest. On one of our free nights, a few of the people who were at our Paris dinner got together with a few others, and we

went to this interior Mexican restaurant called Hugo's. They reciprocated the gesture by making me the guest of honor that night, warmly reliving our memorable night in Paris with others who sat around the table.

I truly enjoy the friendships and connections that I have made with people in the photography industry from all over the world. They are really classy. Remember: work on building your real social network. Take a few people to family-style dinner and start up a conversation. Share ideas and whatever food happens to be on the table—maybe a little extra-virgin olive oil, a basket of bread and a fine wine for starters.

THE GRAND ARRANGEMENT

Arrangements are connections or plans usually made by one person with other people. In some countries marriages are arranged. Some friends will make arrangements trying to set their other friends up on blind dates—some work and some don't. At some point in this book, I explained that the connections that you make in life are important, not all will be with the artists and photographers: some connections are random and some can be real surprises—like this one.

As I drove my in-laws to a Christmas party, I was explaining to my mother-in-law the interesting facts that I have learned recently about my genealogy.

"Oh, how wonderful Jason. You'll never hear these stories any better than you will today."

My family, the Landrys, hail from the great white north— Canada, home of Bob & Doug McKenzie (two hosers, eh?), Celine Dion, and pretty much every famous hockey player who was ever born. More specifically, my clan comes from the maritime province of Nova Scotia, on Cape Breton Island. I have only visited there once, during a family reunion in 1986 when I was a wee young lad.

I remember three distinct events in 1986: The Chernobyl Nuclear Accident; the mid-air explosion of the Space Shuttle Challenger; and

the Boston Red Sox losing the World Series because first baseman Bill Buckner did not bend over far enough to field a ground ball. All three of these incidents were accidents, some more terrible than others, depending where in the world you lived. One other thing that I thought about later in life relating to our trip to Canada was that my uncle booked our entire family on the same Air Canada flight. If that flight had gone down, our family would be dust—fortunately, no accidents. The eldest of my uncles and his wife held out from the family flight and drove. As fate would have it, we wouldn't have been able to count on him to carry on the Landry name—he passed away less than four years later of cancer.

My parents drive Downeast almost every July. It's where they spent their honeymoon in 1971 and most likely where I was conceived. Downeast is something that I remember my grandmother would always say when discussing their pending trips to Nova Scotia: "We're going Downeast this summer." I never understood it seeing that Nova Scotia was clearly north of Massachusetts and New England.

My paternal grandfather was a twin, born on April 29, 1914, and came from a large clan who lived in a small fishing village called Petit de Grat on Cape Breton Island. Due to the size of the family and with so many mouths to feed, my grandfather was shipped off to live with his aunt and uncle in Massachusetts. That's how this branch of the Landrys ended up on the outskirts of Boston.

Joseph Wilfred Landry, or Wilfred as the Canadians called him, regularly kept in touch with his twin Genevieve; he'd frequently get a telephone call from her on Sunday. I only met her once, during the family reunion. One humorous story that is still brought up to this day involves my aunt Joanne and our visit to Genevieve's house.

We sat in Genevieve's kitchen watching her cook. I recall a piece of fish, scales and all, grilling in a frying pan of butter. This wasn't how we did it back home. We used to fillet it up and de-scale the fish

first. But we weren't back home—we were in Canada. The rabbit pie that they were dicing up into squares was their version of my grandmother's meat pie, which I loved. It was one of her specialties, something that to this day no one in my family has mastered. The pie tasted pretty good, but I had a hard time swallowing it after just witnessing a large jackrabbit dart across the street in front of our car on the way there.

As we sat around her table eating, Genevieve turned to my aunt and asked, "Joanne, aren't you hungry? You want some spickety?"

"Umm, I'm not sure what spickety is?"

"She's asking if you want some spaghetti," someone responded.

Some accents result in miscommunication. This story still gets brought up a quarter century later and is as funny as the day it happened.

One afternoon as I was sitting in the gallery a man approached my desk with a portfolio. Now, I review a lot of portfolios each year. This year I probably looked at more than 150, and I was pooped out. It was now mid-December and the -holiday season was fast approaching, and I was counting down the days until I could take my only vacation of the year and start pounding cartons of eggnog. Normally I would have been turned off by the fact that this person didn't call or email me first for an appointment, but he started off the conversation in a very interesting and unexpected way.

"Are you Jason Landry?"

"Yes, that's me."

"My name is Gene and I'm originally from Louisiana."

"Huh...I was just in New Orleans last week at the Photo NOLA portfolio review event. What a great city. The people were so nice and so was the food!"

"You wouldn't happen to be related to any of the Landrys that live in the Acadiana areas of Louisiana, would you?"

This threw me for a loop because the seeds from my family tree were from Nova Scotia and that area of Canada is known as Acadia.

I responded, "Not that I'm aware of. The two main families that I am a descendant of are the Landrys and Boudreaus from Nova Scotia."

"Well that makes sense Jason, most of the families that live in the Acadiana area of Louisiana came from Nova Scotia during the Grand Arrangement. In fact, I know a lot of Landrys and Boudreaus."

"Really?" This is when I picked up my pen and quickly jotted down "the Grand Arrangement" in my notebook that was resting on the filing cabinet underneath my desk.

Now this is where things took an interesting turn. Not only did I have no idea what he was talking about, I had never heard my family or grandfather bring up this term before. The term "grand arrangement" sounds more like a Hitler reference rather than something that came from North America. But in fact, the expulsion of the Acadians was real. It has gone by a few different terms: the Great Expulsion, the Great Upheaval, and the Grand Arrangement.

During Britain's reign, they were trying to get the people of Nova Scotia to sign an unconditional oath to Britain. One thought was the people of Nova Scotia resisted because of their religious beliefs. Britain's allegiance was to the protestant church, while Acadians were to the Roman Catholic. The Acadians fought for their rights and in the end, the British forced the deportation of thousands of people. Some Acadians were sent on to U.S. colonies along the eastern Atlantic seaboard, while others were shipped off to France where they eventually migrated to Louisiana of all places—a Spanish colony at the time.

Interestingly enough, I learned that the word "Cajun" comes from a shortened version of Acadian and originally described the French-speaking people of Louisiana—the descendants of Acadian exiles.

Through further readings and research, another tidbit that I found was that Henry Wadsworth Longfellow's most famous poem was about this historic event. The poem titled, *Evangeline*, was about a fictional character that was in search of her lost love Gabriel whom she became separated from during the Great Upheaval. She

scoured the Americas in search of him, only to have him eventually die in her arms.

This story is part of my family heritage and history— something that I would probably not have ever sought out if it weren't for this unexpected meeting and connection in the gallery. I wonder how far my family roots stretch. One thing is for certain, our tree has grown tall and wide and consists of many branches. Another thing: I really need to take a trip Downeast one of these days so that I can make some new memories.

WHO STOLE LENNON

"You don't take a photograph, you make it."

—ANSEL ADAMS

The police officers knocked on the door of the apartment and a well-dressed male in his thirties answered,

"Can I help you?"

"Yes you can. Have you returned the photographs to the gallery like we had asked," said the officer.

The man replied,

"Well, can't I just purchase them right now?"

"Unfortunately no. You are now under arrest."

I arrived at the gallery early one Saturday morning, like I do every day. I turned on my laptop, unlocked my file drawer and flat files, and went to the bubbler to fill up my water bottle. Then I strolled the length of the corridor, along the red carpet, down to the private gallery at the end of the hall to unlock the door and turn on the lights. It's like clockwork—I rarely deviate from my morning rituals. As I turned on the lights, I immediately noticed something very disturbing. Two of the framed photographs that were hanging in the gallery were missing. Usually if there is a request to move a framed image or

take something down or even cover it up, I would be the one to do that. Even more baffling, the door was locked.

I went down to the security office and asked them if they knew where the pictures went. They didn't know what I was talking about. I then asked if I could watch the security tapes from the prior evening—one of the benefits of having my gallery located in a hotel is it's always under surveillance.

Sure enough, after going through the tape minute by minute the culprit showed his face. As they pieced together the theft from four individual security cameras, the tape showed a person dressed rather nicely in a dark-colored overcoat walking into the private gallery room, looking at the art, pacing, and then exiting the room. He walked down the hall to my desk, walked behind the my desk, looked around, emptied out my trash onto the floor, took the trash bag, walked back into the private room, removed the two framed photographs off the wall, placed them into the bag, and then exited the gallery room with the framed photographs tucked under his coat, through the adjacent restaurant right before closing time.

"Wow! Did you see that," I exclaimed. I couldn't believe it. As I watched in awe, I blurted out,

"What balls this guy has!"

The head of security then said,

"Jason, you'd be amazed at what we see on these cameras."

The security team printed out the images and then contacted the local police. Officers came down to the gallery to take a statement and said if we see the individual to contact them immediately.

As luck would have it, officers soon got a lead. The hostess at one of the restaurants connected to the hotel recognized the person and his two female companions—as bar regulars. A few days later the two females came back to the restaurant, and the hostess called the police. Officers arrived on the scene and brought the two females up to the gallery and

questioned them about the theft. The females explained that the person whom they were with said that he had purchased the photographs.

The officers advised the two women to call the alleged thief and explain to him that he has two days to return the images to the gallery. That came and went, so the police paid him a visit.

The two framed photographs of John Lennon were returned to the gallery a week later, after they were documented as evidence. Roger Farrington photographed John Lennon and Yoko Ono in August 1980 during the initial recording session for their *Double Fantasy* album, just four months before John was tragically shot and killed in New York City.

I don't know what happened to the guy after that. He never again showed up at the hotel, and neither did his two companions. I have to trust that this was a one-time thing and it won't happen again. Trust is important. John and Yoko trusted my artist Roger when he photographed them during their secret sessions prior to announcing that John was going to record a new album, and John and Yoko had to be equally trusting when photographer Annie Leibovitz showed up at their home at The Dakota to photograph him in the nude, curled up against Yoko on their living room floor. Little did Leibovitz realize that hours later, John would be gunned down outside his home.

There is a sad irony that one would steal a photograph of a man whose life was in fact stolen, when all he was trying to do was create peace.

HEROES...AND WE'RE NOT TALKING ABOUT SUBS

Merriam-Webster defines a *hero* as:

a: a mythological or legendary figure often of divine descent endowed with great strength or ability

b: an illustrious warrior

c: a man admired for his achievements and noble qualities

d: one who shows great courage

Did you have any heroes growing up? Maybe a sports star, a musician, or maybe a historical figure that you looked up to—an astronaut, a president, or movie star. I was thinking about how some musicians have written songs about heroes. David Bowie sang about heroes, and I particularly like *My Hero* by the Foo Fighters—a song Dave Grohl wrote about ordinary heroes. You get a sense that when they sing these songs, it's coming from the heart.

At our favorite Tex-Mex establishment, we sat around a beat-up wooden table with gouge marks and crusty crevasses, sippin' our

house margaritas, discussing tonight's dinner topic: heroes. Around the table is a twenty-something, a fifty-something, and me, a newly minted forty-something. I sought their input so that I could gather more ideas for this essay—and it worked.

The twenty-something piped up,

"When I think of the word 'hero,' I think 'war hero' and people in public service. I feel that the word is often tied into leadership roles."

The fifty-something brought up another thought,

"There is also a difference between acting heroically and being a hero. And you should also think about the difference or at least define what a hero is for an artist. For example a hero versus a muse, and a hero versus an inspiration."

That's perfect—both good points to think about. I took out my iPhone and typed a few notes. I also jotted down that we mustn't forget the unrecognized or the unsung heroes. There are a lot of heroes in life that are never mentioned or get thanked. They're the kind of people who weren't out to become heroes—they just happened to do something heroic. This reminds me of one organization that does seek out and thank those people.

The Boston Celtics—yes, the basketball organization has made it a tradition to honor the Heroes Among Us during every home game, everyday people who go out of their way to save a life, or do a heroic deed or simply, an individual who has made an overwhelming or exceptional contribution to his or her community. These people *do* deserve a standing ovation.

In 1904, Andrew Carnegie set up the Carnegie Hero Fund Commission that hands out awards and grants to heroes who reside in the United States and Canada. It's a wonderful thing that this fund, set up over 100 years ago, is still maintained and carries on the desires of one of America's greatest philanthropists.

In my youth, I had a few sports stars and rock stars that I liked, but looking back, I never really considered them my heroes. I guess I

didn't have any real heroes. When I was learning to play guitar, I had idols that I tried to emulate, like Kirk Hammett, Eddie Van Halen, Joe Perry, and Jimi Hendrix—they have now earned the title of "guitar heroes" thanks to the popular video game by that name.

When I finally put enough thought into this topic, I recognized three individuals that I look to in high regard, but only one would I place in my "hero" category. The first is a businessman and innovator; second, a photographer; an finally, a family member.

One of the most compelling books that I have ever read had nothing to do with photography; it is the Steve Jobs biography by Walter Isaacson. Jobs ability to "Think Different" placed him one step ahead of everyone and everything. I consider him a genius—and I know I'm not the only one.

In the consumer industry, you have to know what the customers are going to want or like before they do. After many ups and downs, like a rollercoaster at Six Flags, Jobs's risks at Apple Computer finally reaped rewards. This guy wasn't born with a silver spoon in his mouth, rather born to unwed parents, put up for adoption, dropped out of college, and dropped into only the classes that he wanted to take. Imagine that—and this guy changed the world.

There was no market research when Jobs and Woz designed the first desktop computer in his parents' garage. They were just tinkering around—Woz the technical brain, and Jobs the bright, marketing wizard. If you think back to Gladwell's book *The Tipping Point*, he'd be our Salesman. It's safe to say that these two were the early innovators in creating the desktop computer industry, as we know it today. What they were able to do is so magical on so many levels, and it has continued with the invention of the iPod, iPhone, and iPad. Steve Jobs was a hero to a generation of computer geeks everywhere.

I've suppressed all of the negative aspects about him that I have read or that people have commented on, such as he was a tyrant, a cry

baby, he didn't shower, and often didn't wear shoes. Okay, maybe I haven't suppressed it—still, let's focus on the positives!

Recently, I started to think more about Apple's model and how they exhausted their research and development of a product before making any announcements. I wanted to see how I could apply their methodology and thought process into the fine art gallery model.

In 2012, my wife and I decided that the gallery needed a fresh look and one that was more...more *me*. I instituted a new identity and logo, beginning with letterpress business cards. The card is like a piece of art. It's well designed and tactile. I want anyone who picks up my business card to feel it, feel the quality and craftsmanship in it, and see that I take pride in the smallest details. I know some of you out there are chuckling about this, but I am very serious. So serious, that when someone grabs one of my cards to write on it, I won't let them. I say, "You ARE NOT about to write on that, are you?"

They smirk, then put it in their wallets. I hand them a sticky note. This is just one small change that I made that I felt good about. I wanted people to know that like Jobs, I recognize that design, details, and quality are important and it is exactly what you get when you deal with me. I hope people will recognize this.

Artists have heroes or people that they idolize and sometimes copy or mimic, and so do photographers. Shit, so many of them emulate their idols so much to the point that it overly influences their own work.

There is but one icon in the world of photography that I found so touching, strong, and genuine—that if I were to make photographs and could speak about them as articulately as he could, I would be blessed—I speak of the work of Emmet Gowin. He wasn't even on my radar at all until my junior year at MassArt. I heard that he was going to lecture at Northeastern University and our professor Nicholas Nixon said we should attend.

His lecture was like a sermon. It felt like someone was preaching to me from the pulpit, every word that he chose was important

and direct. When he spoke, you believed it and you wanted to write it down for reference later. The photographs of his family, and of his wife, Edith, were so endearing. I learned that he was a student of Harry Callahan (another photographer from the history of photography whom I admired), and I was hooked. You could see how Callahan influenced Gowin but he was able to find his own direction: his own path to follow. It was during that same semester I had a talk with my professor Nicholas Nixon about photographing wives. Nixon was another photographer who photographed his wife and family. He was the first person who urged me, "You have a built-in model—why not photograph her?"

I guess I thought it would be too easy—she's right there—shouldn't I be out photographing something else. But looking back, the photographs that I did take of my wife are some of my best photographs and the ones that mean the most to me.

I never got to write or speak with Steve Jobs. However, after Emmet's lecture, I sent him an email to thank him. And by the way, he responded! I archived Emmet's email because I never wanted to forget it. Here's what I wrote and his response:

Oct 17, 2005, 9:18 p.m., Jason Landry wrote:

Mr. Gowin:

It was an honor to hear your lecture this evening at Northeastern University. My professor, Nick Nixon told us about it and I'm so glad I was able to attend. I enjoyed the stories behind the images, which to me, is what excites me about photography. I realized that without a good story, a photograph is just another picture. I've been to many lectures, but I was touched by your passion, sincerity, and overall love for this craft we call photography.

Thank you for taking the time out of your schedule to come and speak to us.

Jason Landry
Junior at Massachusetts College of Art.

From: ewgowin
Subject: Re: Northeastern University Lecture
Date: October 19, 2005
To: jason landry

Dear Jason,

Thanks for your kind note...and please give my regards to Nick Nixon who is one of those Robert Adams might have in mind,

"Away at the horizon, almost like a line of trees, are the picture makers on whom I have depended."

About stories, here is another thought to bear in mind...

"When feeling is lucid, structure is art"
 —Frederick Sommer

and that must go for stories as much as for images.

yours with a handshake,

emmet gowin
Emmet W. Gowin
Princeton University
Visual Arts Program

How about that for an e-mail! I was on cloud nine. These are the types of things that keep me motivated. The following year Emmet had an exhibition in New York at Pace MacGill of his series *Mariposas Nocturnas: Edith in Panama.* I wanted to go so badly, but for one reason or another, I couldn't make it. The following week, my professor Laura McPhee called me into her office. What I didn't know was, she was one of Emmet's students when she attended Princeton University. She went to the opening and brought me back a signed catalog from the show. Out of all of the signed photo books that I own, this is the one I cherish the most.

Since then, I have travelled to the Rhode Island School of Design in Providence to hear him speak and also attended a lecture at the Museum of Fine Arts, Boston. I urge anyone to go to one of his lectures if he ever comes to your town. And his line at the end of his email, "with a handshake," I have borrowed and use it in some emails between friends. It's catchy, isn't it! A photographer may have great photographs, but to be called a icon, one would need to have more than a good image. Such an individual must be caring, smart, articulate, and well read. If I were looking for an icon, I would want one that is well rounded—someone who can teach me something that I don't already know and would continue to inspire me.

My paternal grandfather was a real hero and inspiration, not just because of his accomplishments, but his sheer presence. A twin, removed from his family and shipped off to live with his aunt and uncle, he grew up, got married, then shipped off to Germany as a soldier during World War II, came back, and had five children. The moment when it really dawned on me that he was my hero was when

the city of Everett, Massachusetts, dedicated the street that he lived on in his honor.

It was a warm, July day. The family gathered for the ceremony at the corner of the street under the newly placed sign with his name, Sgt. Joseph W. Landry Square. A member of the local V.F.W. read a few words that some of us had written. They quoted a passage that I wrote about how I looked up to my grandfather as the rock of the family and that I remembered how he used to impress us kids with his Popeye-like muscles. It was tough hearing someone else speak the words that I had written. My gaze remained fixed on my grandparent's house. The house sat empty, but I could picture he and my grandmother sitting in the living room looking out their window as they did on many nights. Now the shear white curtains remain closed. I knew tears would be coming soon. I looked away. It was a proud moment for our entire family.

As they finished up the ceremony, I headed back up the street towards my grandfather's house with my father, who was carrying my niece, and my aunt's mother-in-law, Lorraine. In a faint audible tone, I heard her say that she wasn't feeling well. In a split second I heard my dad yell from the front porch, "Jason, don't let her fall!" I turned my head, and Lorraine had placed her hand on the hood of the car and passed out. I caught her with both arms and in a quick jerk motion, lifted her up before she hit the ground. I carried her in my arms up the street, then up the stairs into my grandparents' house and sat with her in my arms on the staircase until the ambulance arrived. She was still in my arms when she woke up. I'm not sure where the strength came from that day. I mean, I do know where it came from—it just didn't come all from me.

Today people don't often say, this or that person is my hero. Do you think people feel embarrassed? Or are there not that many people who deserve that title? Think, who is your hero and why?

Steve Jobs, Emmet Gowin, and my grandfather are just three examples of individuals who I find exceptional people. There are other artists or individuals who you might *think* are your heroes until you meet them and have the worst experience possible. Some so-called heroes can be assholes. Watch out for them...they come in all shapes, sizes, and disguises. I say this because I have met some of these people along the way as well.

I think the purpose of having a hero is finding that special some-one who will be a positive role model in your life to emulate or aspire to be like. That person may have skills, traits, or characteristics that you don't have, but with training or education, you can learn to use them and stockpile their qualities to better yourself or your job. But in the end, you being you may be the best hero that you can find.

LEONARD NIMOY: THE INTERVIEW

July 1, 2013

Leonard Nimoy, *Self Portrait with Shekhina*.
Courtesy the Artist and R.Michelson Galleries.

It took a little more than a year to finally set up this interview with Leonard Nimoy. I was hoping to score an interview with him when he was in Boston in 2012 as the commencement speaker at Boston University. That weekend, he was staying in the hotel where my gallery is located. On the day that I was planning to speak to him, he was just coming up from lunch with his wife and heading down the corridor towards me. In an instant, a dozen Trekkies (Star Trek fans) came out of nowhere and chased him and his wife down the hall, past my desk and into the elevators—I never had a chance to even say hello.

After a few phone calls and email exchanges with his art dealer, we finally were able to settle on a date. I learned a lot in our thirty-minute call, and I never brought up Star Trek. This interview was about photography.

Jason Landry: Where does Leonard Nimoy the photographer go for inspiration?

Leonard Nimoy: It pops up. I don't go to any particular place looking for it. It has to arrive. It's the kind of thing that has to touch something in me when I read or see or hear something that's relevant. It's unpredictable, as it should be. I try not to force an issue because then the work feels forced, too intellectual, and not spontaneous— not out of the subconscious or the unconscious. I'm working very hard at trying to be in touch with the creative process rather than the intellectual process.

JL: From what I have read, you started making photographs as a teenager and built a darkroom in the family bathroom. At what were you pointing your lens back then?

LN: Family members, mostly. I still have a photograph that I did of my grandfather on the banks of the Charles River. I shot it with a camera that I still have, a bellows camera called a Kodak Autographic. It was one of these things that used to flop open when you pull the bellows out on to the track. These cameras were made with a little lid on the backside that you could open and inscribe something on the

back of the film as a kind of a memory of what the photograph was. I never used the autographic feature, but I did use that camera to take pictures with, then I built an enlarger using that camera as the heart of it. I found a suggestion for that idea in a *Mechanix Illustrated* magazine: how to build your own enlarger using a metal lunchbox. For the light housing, I used one of those lunchboxes that had a dome-shaped top and I put a sock in there and a seventy-five-watt light bulb and cut a hole into the bottom of the lunchbox, mounted it onto a make-shift wooden frame, mounted the camera onto that, and then used a couple pieces of glass for the negative holder. I was able to take a photograph with that camera and then enlarge it with that camera.

JL: Did you ever have one of those "ah-ha" moments or an unforgettable moment when creating a photograph?

LN: I think the best way to answer that question is to tell you that I really got in touch with what photography really meant for me when I took a course at UCLA in 1971. I had just finished working on three seasons of *Star Trek* and two seasons of *Mission Impossible*—five steady years of work in television—and I began to wonder if this was really what I wanted to do for the rest of my life. Photography had always been an interest, and I decided to take a course at UCLA. I studied with a photographer by the name of Robert Heinecken. He was a very talented and wonderful teacher, and he started the photography department at UCLA. The class had nothing to do with technique. It was all about "theme." It was all about, why do you want to shoot pictures, and what do you want to shoot pictures of? I think the toughest thing for people to learn in the world of photography is why they want to take pictures. If you can figure out why you want to take pictures, that might lead to subject matter—that might lead you to some thematic idea. For a long time in the early '70s, I carried cameras with me wherever I went—still acting, I'd go on location and bring a case of cameras and lenses. I'd shoot people and I'd shoot landscapes. I wasn't really sure that was what I wanted to spend my time and energy doing,

and then I began to understand that I needed to get some thematic unity to drive the work. The first such process had to do with an idea that I eventually published in a book called *Shekhina*. There was a thread of that in my work in *Star Trek* where I introduced the Vulcan hand gesture with the split fingers. Researching that and going back and exploring it in my memory, it had to do with a cabalistic gesture that had to do with a blessing that takes place in Jewish services. When I was a kid, I was taught that when the priest stood up to bless the congregation and use that gesture, you were suppose to close your eyes and not look, and I never knew why until, eventually a rabbi friend told me that the legend was that the Shekhina, the feminine aspect of God, comes into the sanctuary during that blessing to bless the congregation. The sight of her could be injuriously fatal. That led me to photographic research and an essay on that subject—about the light from the Shekhina, what she looked like and what that light was all about. That led me to a couple of years of work on the theme of the feminine presence of God. And then I had that "ah-hah" moment. Now I know what I want to shoot pictures of. I want to shoot pictures of the Shekhina. I want to find her.

JL: Going back to Robert Heinecken, was there anything specific that he taught you or might have said to you that left a lasting impression?

LN: Yes. As I mentioned, he was very strong on "theme," and if you wanted to be a photographic artist, you should not be just shooting pictures willy-nilly, and at anything you just happened to see or come across, but stick to his or her thematic thrust. And as an example, he said if you are walking down the street with your camera, and you see a person falling out of a high building, you don't shoot a picture of that falling person unless the theme of the work that you're working on has to do with the affect of space on the human figure. If you simply shoot it because it was happening, you have moved to photojournalism.

JL: In your series *Eye Contact*, they are figure studies of women but none are looking at you. "The gaze" continues to be a main component of many contemporary photographs. Who do you think has more control when you are creating a photograph, the model or the photographer?

LN: The photographer is the director of the session. The photographer can tell the model what to do or not to do. For a long time, my instructions to the model were not to look at the lens—don't look at me—look up, down, sideways, turn your back to me—don't look at me. It's a very complex issue. It has to do with privacy, intimacy, voyeurism, anti-voyeurism, the objectifying of the female figure, nudity in general, and the broad question of the nude. You know it's been said that, painters paint nudes, photographers shoot pictures of naked people. There's a difference. I wanted to photograph nudes. I didn't want to photograph naked people. I was interested in the form and the shape. Then I began to get involved in other aspects of it, and I became curious about my own thoughts about this nudity that was happening in the studio. Was I embarrassed by it or concerned for the model's privacy? There's a very complex psychological question that each photographer has to deal with in his or her own way.

JL: You had keyed-in on the word "objectifying." Some of your photographs in *The Full Body Project* hint back to other photographers such as Helmut Newton and Herb Ritts, two artists whom I admire. Critics have chastised Newton's work for "objectifying the female." Have you ever been questioned about the recurring use of the female nude in many of your photographic projects?

LN: Sure. There have been times when I have been asked if I am exploiting the female model. I don't think that's the case, but everyone has their own sense of what they see when they look at a photograph of a nude woman. There are going to be some people who are embarrassed by it. They'll be some people attracted to it. Some people think it's quite beautiful, and some people who think

it's improper. And then with the *Shekhina* book, I ran into a very serious question about religious authenticity and religious cased in morality. I was actually censored by an organization in Seattle where I was supposed to speak and show the work, and it became an issue because they were concerned that some people in the audience might be orthodox and be upset by this idea of showing this feminine and sensual physical female as a goddess—improperly dressed. It's a broad and very deep subject, and we can go on and on about it.

JL: Do you think photographic portraits only capture a person's facade, or do they tap into something much greater than the reality of the surface?

LN: I'm often tickled by people looking at a photograph and telling me that they see certain things in it that I'm quite convinced is their own projection. You look at a photograph and think that you see a sad, melancholy person, but all you might be seeing is a person who is dreaming about some lovely moment in their lives. You can't really tell what a person is experiencing unless it's a broad expression of grief or a gigantic laugh or smile. You can't tell if a person is being introspective or a person is being sad, happy, or gloomy, reflective, thoughtful or inspired, or in a dream state—you can't tell. But people tend to project through a photograph, and that's part of the intrigue.

JL: "There's poetry in black and white." You said that in an interview once when describing black and white photography. Is the use of black and white a nostalgic thing, or a way that photographs should be displayed based on the subject matter?

LN: It has to do with nostalgia *and* subject. I grew up doing my own printing. Always enjoyed it, always enjoyed going into the darkroom and experimenting with a print. I did not move into developing or processing color. I stayed with black and white. I still think to this day that I prefer to work in black and white if it has to do with poetry or anything other than specific reality. I have worked in color when I thought it was the appropriate way to express the thought that I

was working on. My *Secret Selves* project had to be in color. It was so specific to the individual and what they were bringing to the portrait session. Color is more specific and black and white is more poetic.

JL: In your *Secret Selves* series, your objective was to bring out the "alternative identity" in your subjects. Do you yourself have an alternative identity—maybe something that most people *don't* now about you?

LN: Sure. (Long pause) You don't expect me to tell you what it is?" (Laughing) I was web surfing one day and I came across this story that comes from ancient Greece about Aristophanes talking in a session, probably with a lot of guys sitting around drinking wine, getting drunk and coming up with crazy ideas, they were discussing the human condition known as "Oxed" a type of human anxiety. Anyways, he came up with a fanciful notion that many, many thousands of years earlier, humans were doubled people, two heads, four arms and four legs, back to back. They became powerful and arrogant. The gods became angry with them and sent Zeus to solve the problem, which he did by taking a big sword and splitting everyone in two. Ever since then, humans have been looking for the other halves of themselves, trying to reintegrate, trying to become whole again—feeling something missing in their lives—in their psyches. It's this search for your full identity. I became intrigued with that, and I thought I've had experiences with other parts of my identity as an actor. I wonder if people can really get in touch with this other secret self that we all carry around or the lost self, the self that we yearn for. Is there some part of ourselves that we wish we could express? We rounded up a whole bunch of people and photographed them as their secret or hidden or fantasy self.

JL: So that doesn't answer my question. Do you have a second self?

LN: I did answer your question. I said, yes.

JL: But you're not going to say what it is?

LN: (Laughing) I'm allowed to keep something private.

JL: For many years you were on the other side of the lens. How does it feel to be behind the lens directing your subjects through photography?

LN: It's liberating for me. I don't have to perform—don't have to take on other identities. It's using a different part of my creative process, which I enjoy. It's refreshing.

JL: What is the most important lesson that you've learned through photographing people?

LN: How to make a subject or model comfortable in front of my camera. The other is that people come in all shapes and sizes in their psyche, and not just in the physical and metaphysical sense, but in their psychological condition. And it's a search—you are searching constantly to find out who this person is. What is it that you want to extract from this person? There was this wonderful video of Richard Avedon taking a portrait of an actor, and he said to his subject (paraphrasing), "think of nothing...just let your mind go totally blank." And he takes the picture. And then I asked myself, what is Avedon looking to show here? Is he thinking that by telling this person to think of nothing that something wonderful or something special is going to emerge? Thinking of nothing could also make for a very dull picture. It could also create a blank canvas for people to project into. Every photographer has to find their own way into this territory. It's a life-long search. I don't think anyone every perfects it and is done with it. It's a work of art and it's never complete.

JL: If you were advising a young photographer today, what would your words of wisdom be?

LN: Stop worrying about the nature, design or qualifications of your equipment. Master your equipment so you know how to get the shot you want, but above all, search for the reason to be taking pictures. Why are you taking pictures? Why do we shoot pictures? I say the same thing to actors who want to develop a career as an actor. You must master your craft and then put it aside and concentrate on

the more difficult aspect of the work. What is it that you want to do with that craft? What do you want to express? What do you want to explore? What do you want to find out? What do you want to present to people? Those are the issues that you have to search for.

DON'T WORK TOO HARD

"It's not what you look at that matters, it's what you see."
—HENRY DAVID THOREAU

There is a book on my bookshelf titled *Photographs Not Taken*. It is a book of essays by individual photographers telling stories about photographs that they wish they had taken, forgot to take, or went through the mental motions of taking, but for one reason or another didn't take. It was quite a genius idea to compile these stories without photographs.

I have one photograph that I wished I could have taken. It was a very sad moment—the time I said goodbye to my grandfather.

It was my tenth year at the phone company, in 2002, and a series of RIFs (reduction in force = layoffs) were coming in waves. I was constantly thinking: Was I going to have a job next week, next month, next year? Did I want to stay there? What else would I do? Some months were tougher than others compounded by the fact my grandfather had been in and out of the hospital battling various illnesses including Alzheimer's. This disease has no cure and is a type of dementia that affects the brain, most notably memory.

On one trip to the hospital with my mother, my grandfather was talking in French to the aids taking care of him. One of them was from the Virgin Islands and was French Creole—she insisted she

knew what he was saying. Now, my grandfather did come from Nova Scotia, Canada, but never spoke French at home—at least not to my knowledge. This was a new thing—and he wasn't speaking *any* English. So I joked,

"Je joue au football!" I said, I play soccer—the only sentence I could remember from my high school French class.

He smiled and began rattling away about something. My French was at a kindergarten level then—and it hasn't improved much since. Periodically, other relatives stopped by to visit him, and they said the same thing, Pup's talking in French—no English.

My mother called me on December 8 and told me that I should make an attempt to see my grandfather—he wasn't doing well. I was old enough to understand that his days were winding down. I never liked hospitals—they smell too clean, which actually makes me feel sick. It didn't matter who was in the hospital. I never went, or if I did, it was quick. But I'm glad that I went this time rather than brushing it aside as I had done many for many stupid reasons. My work suffocated me and left me with little time to do anything. I worked the 1-9 p.m. shift, which meant I came home late and slept most days.

Before my shift on December 9, I drove to the nursing facility where my grandfather stayed. It was in Revere, directly across from Woodlawn Cemetery—how cruel to have to sit and look out at your final resting place. It was a slushy, snowy day. I remember pulling into the driveway in my SUV, parking, and letting it idle for a bit. I resisted going in there. I did not want to see him in this condition. I wanted to remember him as the wild and energetic grandfather with the Popeye muscles who, when I was young, played tennis hockey in the kitchen with me. We used to set up the dog and cat bowls in the kitchen and kick tennis balls between the makeshift goals. Shit would be everywhere.

My grandmother would come back from a long day working at Shawmut Bank and yell,

"Joe! What is this! Pick this stuff up!"

He would smile at me and respond,

"Helen, Jason and I were just playing."

Finally, I walked down the hall and entered his room. He was very frail at this point and my Uncle Paul was standing with him.

"Dad...you gotta eat something. Jason, he doesn't know who I am." I just stared in a daze—I didn't know what to say. My grandfather wasn't talking—rather, he may have been talking but it wasn't in English.

"Dad, are you cold? Let me go find a nurse and get you a blanket. Jason, can you sit with him? I'll be right back."

My uncle left the room and my grandfather sat in his wheelchair—hunched over—barely able to keep his head up. I knew this was the end. I knew this would be the last chance to say anything to him. I crouched down in front of him like a catcher waiting to be thrown a pitch. I looked into his eyes— they were large and somewhat blood-shot and always looked like they were watering and slightly out of the socket. What got me was the color of his eyes—the blue of his irises—they were a beautiful blue, and at that moment his eyes acted like tractor beams pulling me in closer.

I could feel my own eyes watering now. I blinked, looked him in the eyes, cleared my throat and said,

"Pup...I have to go to work. I hope you get well soon."

Without skipping a beat, he responded,

"Don't work too hard, Jason."

I lost all my breath—I couldn't believe he knew who I was, and I couldn't believe he was speaking English. This rendered me speechless. My uncle entered the room with a blanket and placed it around my grandfather. He didn't say another word.

I placed my hand on his hand and told him that I loved him. I stood up and said goodbye to my uncle and exited the room. I sat in my truck and cried until all of the windows fogged up and a light

dusting of snow coated the windshield. I drove to work and completed my shift, hibernating in my cubicle all night.

Early the next morning the phone rang. I picked up the receiver next to my bed and heard my mother's voice,

"Jason, Grampie passed away." As I lay on my side, receiver against one ear and pillow against the other, my eyes slowly welled up.

If I were able to make a portrait of my grandfather as he sat there—face to face with me in that room, it would have looked something like what I have tried to describe in the above passage. This moment in my life happened a year and a half before I left the corporate world behind to pursue my education and career in the arts. This moment with my grandfather changed how I view life, work, and family. Looking into his eyes brought a new perspective on life—one that I never saw before. It's a moment that haunts and saddens me to this day. I tear up when I recall it, and even now as I type it. This was a pivotal point that changed me, from who I was, to the person who I hoped to be.

FROM WITHIN

Your experiences are analyzed and interpreted.
All your hopes and fears are realized.
Perceptions are made.
Cold.
A breath of air leaves the body.
A bead of sweat penetrates the skin.
A life is born.
Warmth.
Cultural,
Boundaries,
Surroundings.
Some of your influences will come from home.
But only from within, does your truest creativity blossom.
—Jason Landry, 2009

(for my friend Brian Doan)

LOSE THE SUIT AND TIE:
THE BUSINESS SIDE OF PHOTOGRAPHY

You spent at least four years at college. You gained the freshman fifteen pounds or so and started sharing clothes with your roommates. Sophomore year was spent cycling through various girlfriends or boyfriends until you could figure out who your true real friends were. Your junior year was spent drinking away your sorrows, and your senior year was spent making up for lost time by cramming it all into that last hurrah. They call your name from the podium, and you walk up and accept your diploma. What now? What are your plans after graduation?

Have you thought about this yet—I mean honestly thought about it—what-will-you-do? If you are an artist or photographer, please don't say move to Brooklyn—don't!

Speaking from past experience, it's so hard to make a living as a fine art photographer to the point that sometimes you'll do anything to make a quick dollar even when it's not the smartest dollar. (I stole that line from my wife. I'm giving her proper credit here). How will you make a living or continue to be an artist? Do you consider yourself a dreamer—someone with good ideas but don't know what to do with them? Or are you an implementer—you know, a doer—a type of person who can put something into action and actually follow through with it? Maybe you consider yourself a failure, and in this case you better have a Plan B.

I'm not presenting these questions just to the classically trained artists who have gone through BFA or MFA programs. These questions can also be pointed at the self-taught artists too—the ones who didn't go through a traditional fine art or photography programs—the weekend warriors—the national guardsman of the arts. What tools do you possess that will enable you to do something with your skills?

Very little business training is taught in art schools. Why do you think that is? Do you think it has to do with the school or the photography departments' budgets—not enough money for a business class because they need to make sure so-in-so in the color lab can keep his or her job? Now that color labs are going bye bye, maybe you'll consider a business class now. Or is it because the professors at certain institutions didn't have any business classes when they were climbing up the ranks. So they think, let them learn like I did—pounding the streets. Some photography schools and art colleges are finally getting their shit together and adding business classes into their curriculums. I feel it is a must and ensures that when these students leave their hallowed halls, they will have the tools to not only create portfolios of great art, but to market their talents as well.

Are you able to implement all that you have learned, either in school or on your own? One thing is for certain, you must be good at building your network. If you are photographer, your network should consist of friends (artsy and not), a critique group, mentors, other photographers, and people in the gallery world. You must be able to line up meetings with art dealers, publishers, mentors, and former professors and talk to them face-to-face. Not all communications can be done through email or over the phone.

Also, you must be able to market your own work. First and foremost, you must have a website. Business cards are a little old school but still useful. You should be tuned into the popular social media sites. They're important in getting your name out. Nothing will be

handed to you. You have to earn it. Hard work and persistence pays off. You have to follow up on leads—all the time.

Preparing a portfolio—have you done that yet? Your prints must be top notch. If they are not, find someone to do your printing. Many artists hire master printers who will create their fine art prints. Before you spend money on stellar prints, edit first—FYI, artists are the worst editors of their own work!

This here is an intervention of sorts meant to help photographers. I cannot count the times that I went back to old contact sheets and stared blankly at an image that I cannot believe that I didn't print earlier. What was I thinking? Photographers please print out your contact sheets, either in the darkroom or digitally and have people look at your work. The people you choose do not have to be fellow photographers. Anyone will do. I say this because you need honest feedback from people who don't look at contact sheets the way a classically trained photographer does—and by the way, these "people" that I refer to *are* the people who might actually buy your work. Ask them, what images appeal to them? What attracts them to your work?

You, the artist, are so married to your photographs that often times you select what *you* feel is the best image, and then months or years later you and your buddies are looking back through your contact sheets and someone asks you, "Hey, why didn't you print that one?"

Gulp.

I have met artists at portfolio reviews who have kept in touch with me and mailed me stacks of contact sheets to mark up. You'd be surprised what people will do for you when you ask them the right way. Please note: I am not offering to edit every package of contact sheets that are mailed to me. I wish I could. Ask before sending.

You want to get noticed? Have patience, visit a lot of galleries and museums, attend lectures and book signings, and introduce yourself to whomever you meet.

Have you worked on your C.V. lately? Oh, it's not as meaty as you want it to be? In the beginning, you need to do whatever you can to get things on your C.V. Start with entering "call for entries" for group and solo exhibitions. Another idea would be to send out informational packets about yourself to magazines and newspapers. If it's an exhibition at Starbucks—put it on there. Everything is important in the beginning. Make sure you spell check every single thing on your C.V. Speaking of writing and spelling, another thing to consider: Write a blog.

Blog the Shit out of It!

It used to be postcards, features in magazines, studio visits, and word-of-mouth were the ways artists became recognized. Many moons before that, it was the powerful people in the photography world like Alfred Stieglitz, Edward Steichen, and John Szarkowski. If they knew about you and your art and they liked it, they had the ability to make or break your career. Today it's an e-newsletter, a blog, a website, a Facebook fan page, Twitter, Tumblr, LinkedIn, YouTube, and Flickr accounts, portfolio review events, art fairs, and the like. Without a gallery representing you, you have to become your own public relations firm. I know some artists are good marketers of their own work, but this takes away from what they are supposed to be concentrating on—their art. So where is the best place to start if you want to build more exposure for your art and yourself? You might just start by blogging.

The first time that I was introduced to a blog was when a friend that I knew from grade school from Greenland, N.H., now living in San Francisco, started one. His was called "My Robot Is Pregnant." It included a tag line, "tough guy poetry and mainly stories of loneliness." Jon Rolston and his diary of stories and photos were entertaining and helped me to stay connected to this friend from my past, well before millions of people were being force-fed off the intravenous Facebook drip.

When I was an undergrad, the big photo blogger in Boston was Shane Lavalette. He was a student at the School of the Museum of Fine Arts in Boston (SMFA) and went on to create the magazine *Lay Flat*. Soon after, it seemed that everyone I knew was starting a blog. When I entered grad school, the school suggested each student create a blog to keep track of exhibitions we attended, lectures we went to, and books we were reading. This actually turned out to be good for me, as I would often refer back to it to remember key things, like things for this book. (Then it was attacked by a can of Spam and I had to take it down. You want some Spam, Egg, Sausage and Spam?[13])

I have one friend who starts a new blog for each new project. To me, this might be overkill, but if you are able to manage it, knock your socks off!

From about 2009 on, I kept track of really good blogs. There were a number of visually stimulating ones that are now referred to as blogazines (a mash up of a blog + online magazine). The ones that I feel are very successful are:

Lens Culture, by Jim Casper
LENSCRATCH, by Aline Smithson
Flak Photo, by Andy Adams
Fraction Magazine, by David Bram
PhotoWeenie, by Jim Fitts
Conscientious by Jörg Colberg

Then you have a few more commercially based blogs:
NPR has its own blog called, *The Picture Show*
New York Times has its own photo blog called, *LENS*
Photo District News (PDN) has its own version of a blog called, *PDN's Photo of the Day*

13 See Monty Python.

What makes these blogs stand out above the rest is their ability to continuously keep their blogs and magazines updated and their content interesting, innovative, and fresh. Some blogs write about the same old shit. It's like retweeting something on Twitter. I'm not here to discourage anyone from starting a blog, just understand that there are so many out there, and if your goal is to get people to read what you write and visit it often, then consider Apple Computer's old slogan, *think different*. If you are just doing it for yourself, then go nuts! If you are doing it for the masses, what will get them to follow your blog? What special contribution to this world can you provide? People are hungry for information—feed them!

Critiquing Work for Dummies

How do you become interested in something? At what point do you put two and two together and say, Yeah, I'm interested in that? Is it because your buddies are interested? Your parents were interested? Or did you come up with an interest all your own? What makes something interesting? What steps are involved before that interest turns into a passion? Is there a road sign on the highway that reads:

Interested 30 miles

Passionate 60 miles?

The sensory system, an offshoot of our central nervous system is responsible for part of this puzzle, because somewhere along its various pathways, there is a trigger that alerts our senses, yes that's good or no that's not good. These receptors trigger everything we see, hear, touch, taste, and smell.

And that brings us to the critique. I like it, I don't like it, and that's cool—those are the basic comments one likely hears during an art school critique. For those of you who haven't had to sit through an actual critique of your work will likely find it an eye-opening experience.

Once a week, as an undergrad student, we would pin our prints onto the corkboard walls and have a "crit." The class would sit around,

munch on snacks, and send texts, and then various students intermittently would pipe up with their two cents on how they felt about the work and what they liked or disliked. Then we would move around the room to other students' works.

Most of the time, my classmates would pussyfoot around the bad work, especially when they critiqued a student's work whom you knew would cry if you told him or her the truth. Yes, the truth hurts, but it is important to hear it if it's warranted. And some people did not work as hard as others and should have been called out for it.

The most entertaining critiques were in our junior level large format camera class. One time, the professor invited in someone whom he had met at a local library. This woman had NO IDEA what she was in for. He was doing her a favor because she was making photographs and wanted to be part of a critique. He invited her to our class and she pinned up her work, like the rest of us. When it was her turn, I heard the most memorable statement ever! The professor said, "I can't tell you honestly what I think of your image." (The image was of a black & white orchid or tulip—I can't quite recall.)

"No, Really, tell me what you think," she insisted.

"When I look at this flower, I just want to stick my dick in it."

Now, the students all knew the type of critiques we had had from this particular professor—he was notorious for them. But for an outsider, she blushed and said, "Um, okay." The crazy thing is, this woman showed up at my gallery one afternoon to see one of the exhibitions, and she remembered me from that class. I then proceeded to recite the critique, and she laughed hysterically.

More thought provoking critiques were conducted by photographer Frank Gohlke. The discussions were always very scholarly. Frank's suggestions and advice would roll off his tongue very slowly because ever word was important and what he had to say always made sense.

Critiques at the undergrad level versus those at the graduate level were like night and day. Critiques became heated discussions—and some continued well into the day outside the classroom walls. I went from an undergrad program where my classmates and professors told me what they liked or disliked about my prints (for the last two years of my undergrad program I was photographing my wife), to a grad school critique, which started out like this:

"You're objectifying your wife."

"Jason, you're putting her on a pedestal."

"Have you ever heard of the feminist movement? Let me suggest some readings for you."

OUCH!

I was dumbfounded. That was a real critique. What an eye-opener! I strongly suggest, anyone who wants to brush up on his or her skills at critiquing should pay a visit to your local museum or gallery. Take a pad of paper and a writing utensil and find works of art that resonate with you. Why do they? What do you think the artist is trying to convey in the work? Is there something the artist could have achieved better to make the work stronger? Be as truthful as possible in your responses and pretend that the artists may someday read what you wrote. How can you convey your suggestions or comments to the artist in the best way possible, even if it isn't positive?

First start with what you like the most, or what you think works best in the work. Then, make suggestions on how something might be improved. Some artists might be truly offended if you tell them something should be fixed. What if it is exactly how the artist intended it? You don't know unless you ask.

Look at the work, read about the artist, know what other works he or she has done before making your final analysis. A critique is supposed to help the artist along—challenge the artist to improve or change, not hurt or discourage.

How Much Did You Say? Pricing Your Art.

"The ultimate strategy *is not* to generate the highest possible proceeds from selling the current body of work, but rather to place all of the work and, in doing so, help create more demand." I read this statement in the book *How To Start And Run A Commercial Art Gallery* by Edward Winkleman, and I try to convince and advise every single artist that I have ever worked with to follow this mantra (unless the artist has a definite pricing strategy). It is the smartest statement that I have read about pricing artwork.

There are a few artists with whom I have worked with who have listened to all of my advice. Then there are some who are determined to sell their work for what they feel is their perceived market value. How do you judge what your market value is if you have never sold anything before?

I try to take a temperature of what other contemporary work is going for in different markets. If you just graduated from a top MFA program, then what are other recent MFA grads selling their work for? You don't want to become your own biggest collector with a stash of prints under your bed, because you priced your work too high from the start. You can always increase your prices later—and probably tiering your edition is the smartest way to go.

If you don't understand tiered editions, here's a refresher. Let's say that you are an emerging artist and you are having your first show at a gallery. Not many people know you yet, right? Your goal is to sell your work for $1,000 each. I might tell you this is unrealistic, and propose $500, but tier the edition. Here's how it works.

You have a photograph and it is an edition of fifteen. You could price the first five prints at a low starting point, let's say $500. Then for the next five in the edition, the price goes up to $1,000 each. For the last five prints, the price increases again to $1,500. By doing this, your average price overall is $1,000 per print. You reward the collectors who buy early and take a chance on you, an emerging artist. As

the print edition sells out, their prints are already more valuable than when your first patrons originally purchased them. It's a win-win for the artist, the collector, and the gallery.

Now there is another scenario: an open edition. Open editions are not as common in the contemporary market, but do exist. This means, an artist or a photographer can make as many prints of any of their images as they want, which means, if the artist feels like printing and selling 500 photographs, 500 people can own them. For a major collector, this is a turn off. Collectors, and I know them because I am one, like to feel special. Some like to brag that they have a print by a well-known artist, and many in the collecting circle know that it was printed in a small edition of let's say seven. That makes it special. Only seven people in the world will have that image. Open editions are usually priced significantly lower than those in an edition, because there are more in the marketplace. Individuals new to collecting might start with artists selling in open editions. I'm not suggesting you have to, but for people starting out, this isn't so bad.

If you don't know how to price your work, ask someone for advice. At portfolio reviews, I will often run into an artist who has such interesting work that I want to buy it right on the spot. When I ask about the price, it is often overinflated, and I'm not sure how the artist came up with it.

Watch out when an artist has too many sizes and editions for a print. You may find out later that the artist is selling an image from a previous sold-out edition, or what you perceived to be sold out. The artist may be printing the image in another size.

Let's say you go into a gallery and purchase a limited edition photograph and the image size is 11 by 14 inches. The artist could also have created an edition in larger sizes, say 16 by 20 inches and 20 by 24 inches. So if the artist has elected to print an edition of fifteen in the 11 by 14 inch size, and fifteen in the other two sizes, then actually

there are forty-five prints that can be sold of that given image. It's better to ask a lot of questions before you buy.

In 2012 a New York collector sued William Eggleston for reprinting some of his more famous images and selling them at auction. What this does is dilute the actual value of the original prints purchased years earlier. This is a huge no-no.

Photographers, think long and hard about your edition size, your price point, and how many print sizes you will create. Remember, collectors consider all this when deciding what to buy for their collections. If you have a gallery, work with the director to determine what your market is and what prices and editions will work best. Last, understand that prices in a small market are different than in a larger market. You can't always compare apples to apples.

Who Says That You Really Need an M.F.A.?

The masters of fine arts degree is the next step after a bachelor in fine arts. There is a rule in most schools that says you cannot teach at the college level without an MFA—that is unless you are a famous artist—some of whom do teach without a terminal degree. There are good points and bad points about this degree and this is based solely on my own personal opinions and experiences, and I have a lot of them.

I applied to three MFA programs when I decided that I wanted to continue my education. I started my MFA program less than one month after graduating with my BFA. My wife told me, "It's now or never."

I was a little disappointed that I wasn't accepted into one of the first two schools that I applied to, but I have no regrets. I had an amazing experience in my low-residency MFA program at The Art Institute of Boston at Lesley University, worked with some fantastic people, and met some great artists along the way. But for the money that you pay to go to grad school, is it all worth it?

A positive: Contacts

You make some of the most significant contacts in your career as an artist in school, especially in graduate school. One contact that I made in graduate school became the person who did all of the initial design work for my gallery. Another was a classmate who later became the associate dean of graduate studies at the New Hampshire Institute of Art. She eventually tapped me to become the director of the MFA in photography program at that school.

Another positive: Teaching

Having an MFA enables you to teach at the college level. The pay is sometimes better than that of a grade school or public high school. So if this is what you think you are destined to do, then an MFA is a must.

Another positive: Talking and writing about your work

With the intensity of the critiques and the critical theory reading that you will have to do, you will also learn to speak and write more articulately about your own and others' artwork. This will benefit you later when you are asked to give an artist talk at a gallery or museum, or maybe even write a book ☺.

A negative: Success too soon

Even today's contemporary photographers sometimes get put up on pedestals. I'm speaking of some of those recent graduates who have made it through one of those top tier MFA programs and all of a sudden their work is on display at MoMA. You think they've made it, right?

As I walked through an exhibition at the Museum of Modern Art with one of my graduate school mentors, she said, "Look at this stuff. Yes, this stuff is fresh, but it's their thesis work. What will they be doing ten or twenty years from now?" She was right, how do you top that? You don't want this to be your one hit and be remembered as

the Milli Vanilli of the photo world. Baby steps tend to be smarter than giant leaps.

Another negative: Teaching at the college level

You're thinking, Wait a second, I thought you listed this as a positive? It is, but it's also a negative. There are not enough teaching positions to go around. So many students say they want an MFA to teach at the college level. However, since many professors end up earning tenure, they usually stay at their schools until they retire. With a small pool of adjunct vacancies available, it becomes a frenzy to find employment. Remember in my earlier essay about my friend who taught at a school in New York City and also in Boston. Who the fuck wants to do that commute? Not me—not ever! But people do it to make ends meet.

If you want to get an MFA, do it to better your career as an artist. Do it to learn to think clearer and speak more articulately about your art. Do it to change.

Will I Ever Get a Gallery to Represent Me? Let's talk galleries.

There are so many great photographers and so few galleries. If you want a gallery to represent you, you must first seek out the galleries who are showing work similar to yours. If you are a photographer who shoots nudes, and you approach a gallery that is primarily known for exhibiting landscapes, you probably have a very slim chance to land an appointment with the director. DO YOUR HOMEWORK! Representing artists is a huge commitment.

The stable of artists that any given gallery maintains usually is based on the gallery owner or director's own tastes. Figure out the gallerist's taste and if you think this gallery is where you want to be, edit your portfolio to fit the mold. But if you are not interested in trying to fit into a mold, research your local or national galleries that exhibit work similar to yours. Go on the Internet and view their websites

and see if they are accepting portfolio submissions. Visit the gallery and make sure that they see your face. Briefly introduce yourself if you can. Then send a brief email re-introducing yourself. Attach one small jpg and a link to your website. Yes, I said website. If you don't have one yet, get on it!

Once you are able to get in the door and get a meeting with the gallery director, it is important to ask questions. You need to feel comfortable with the gallerist and understand the gallery's mission and where it is headed. Does the gallerist attend art fairs or go to portfolio review events? Does the gallery get good press? If you deal with a gallery that isn't doing the above, then you better hope it has a really large Rolodex filled with collectors and buyers for your work. You cannot just be an armchair dealer and hope to make ends meet and keep your stable of artists happy. If a gallery can't keep its end of the bargain, the artists will leave and go to another gallery. Being represented by an art dealer is a partnership—both artist and gallery owner must work together to strengthen both parties' careers.

My gallery is located in Boston. There are about four galleries in Boston that show photography exclusively, and then there are about four or five others in the area that show a lot of photography and also show work in other media (painting, sculpture, mixed media, etc, etc). We have one nonprofit photography space in Boston and one major photography museum within twenty minutes of Boston.

The approach I take to finding new artists is multifaceted. I scour social networking sites like Facebook, Tumblr, and Flickr, and if something catches my eye, I might bookmark it. If it's really good, I may try and do a Google search for the photographer, check out his or her website, then try to contact the artist.

The most successful avenue in finding new artists is at portfolio review events. I have attended these types of events both nationally and internationally. Although I am a product of Boston-area art colleges, I do not want to limit what I show to just local artists—there

are other galleries who do just that. I represent my share of local artists and will continue to do so, but I'm looking to expand the presence of the gallery to more than just New England. I want the reach of this gallery to be worldwide, and so far it is happening.

A lot of local artists will stop into the gallery and ask if I will look at their portfolios. If I'm not too busy, I will. If I am busy, I may try and schedule something with them at a later date. I would suggest emailing me first if you truly think my gallery is a fit for what you are doing. A highlight of my day is when some of the local photography professors bring their students in to see gallery exhibitions. If the professor asks me to look at a specific student's work, I usually will do it. The professors in the Boston area know what I like and know the caliber of art that I exhibit. I like hearing about their star students.

I have also had collectors and friends of the gallery suggest artists for me to look at. They do this when they know I have a specific idea for a show in mind and also when they may have purchased work by an emerging artist and they want to help push them along. Collectors are great in that sense. They are like my extra set of eyes and ears.

My roster of artists right now includes many established photographers from all over the world, and we also represent and consign work by newer, emerging artists. As I said before, I live vicariously through the successes of these emerging artists. I've been in their shoes and know how hard you have to work to get where they are going. Another thing—you do not need to have an MFA to get gallery representation. I know a lot of successful artists who are not represented, and they are pretty well known.

For all of you artists out there making a ton of work, or series, or projects—don't be offended if a gallery only likes one thing that you are doing. Just ask some of the artists whom I represent. I think it is very difficult to like or love every single thing that an artist does. Some projects are stronger than others.

Now what happens when an artist is no longer a fit for the gallery? This has happened. Sometimes the artist elects to leave and go to another gallery that is a better fit. Other times, there may be a difference in opinion and the gallery elects to release the artist. This is why most galleries use contracts.

A few years ago when I acquired the gallery from the original owner, I did explain to him that I would be carrying my own stable of artists. It didn't make sense to carry all of the same artists that the former owner had—it wouldn't be *my* gallery. Now this wasn't such a positive thing for me to do in such a small market, but it was best for the gallery. Since then, I have only had to release one artist from my stable when we had a difference in opinion. I hope that I don't have to do this again.

After reading all this, if you still want to be represented by a gallery, good for you! Put together a killer portfolio and find the one who will be the best fit. When you find the right one, that gallery will help build and define your career in the art world.

There Are Laws You Know!

You must understand that being an artist is also a small business. There are laws that are in place to protect you. I am not an attorney so I will not be going into any details about the law, but things that you should be aware of right out of the gate is that if someone wants to use your image in a magazine, on a book cover, a CD cover, on a billboard, in a business annual report, they must pay you! They must license your work from you. You must know your worth. What does your time cost to make and produce what you do? You can find books about legal issues, licensing, and consent forms for artists at your nearest bookstore. There are also art dealer associations in various cities and towns that will often host panel discussions with attorneys who will give free advice and answer questions pertaining to art law.

There are a lot of things to learn before jumping in and becoming an artist or a photographer. It's a full time job. I hope this gives you an idea of how to prepare yourself. I could have made this chapter even longer, but then I thought you'd hate me. I promise, the remaining chapters in this book are much shorter.

CHARLES BAUDELAIRE
IS GUARDING OUR BEDROOM

"There are always two people in every picture: the photographer and the viewer."　　　　　　　　　　　　　—ANSEL ADAMS

"To see is to be seen, and everything I see is like an eye, collecting my gaze, blinking, staring, focusing, and reflecting, sending my look back to me."　　　　　—JAMES ELKINS, *The Object Stares Back*

On a trip to Paris, I acquired a photograph containing one of the most potent, sinister, and downright deadly gazes that has ever been captured in a photographic portrait. This photograph is of Charles Baudelaire by Étienne Carjat, a Woodburytype print from the late 1800s that I have seen reproduced in countless photography history books and periodicals.

The "gaze," the deadpan stare by the sitter, looking directly at the photographer, has grown to be somewhat of a contemporary trend in photography. In fact, some might consider the gaze to be *the* defining element in contemporary portraiture.

Long before the invention of photography, painting captured the gaze. The use of the gaze within a work of art is more than just a technique; it's a tool that provokes the viewer into a staring competition, as if looking into a mirror. This constant loop of reciprocated glances

holds the viewer in place long enough to perhaps shed a glimpse of the character of the individual that was painted. Artists don't spell out the particulars of their portraits; they are facilitating an encounter.

Étienne Carjat, *Portrait of Charles Baudelaire*, ca. 1863

The gaze presented in a photograph is different than the painterly gaze. In a photograph, the gaze is a frozen moment, where the painterly gaze is an accumulation of sittings where the painter determines the right gaze for the type of portrait that he or she is creating.

"Mr. Baudelaire—time for your sitting." A face with no defined emotion stares blankly back at the photographer. Who's in control? It's usually the photographer who tells the sitter what to do in the photograph. Tilt your head—close your lips—chin up—chin up. That's it! But in the case of the Baudelaire image—his pose, his gaze is piercing straight toward the photographer hidden under the dark cloth. Can't you sense it? Does it look like he took direction well? I doubt for one second he even wanted his portrait taken, and I would equally bet that he despised the photograph once he saw it. He looks genuinely pissed off—like Winston Churchill did when photographer Yousef Karsh pulled the cigar from his mouth and snapped the most memorable portrait ever taken of him. Have you seen *that* gaze—Oy vey!

Let's talk about celebrities for a minute—but for only a minute. They are by far the most photographed people on the planet. They're also far from perfect—that is why what you see in those glossy zines that you pick up at the checkout counter in your local grocery store are photoshopped facsimiles—the printed image is far from reality. These images are deceiving and are meant to entice, while really being false advertising. Faces aren't that smooth—and those asses are not that perfectly round. You know what they should do, sell Photoshop at Sephora along side the skin rejuvenation kits. It should be a staple in all make-up kits. Maybe it's Maybelline...maybe it isn't!

Before Photoshop and digital images, there was film. So how did photographs get edited in magazines? Some were airbrushed and some weren't. Case in point: Marilyn Monroe. One of the last photoshoots that Marilyn did before she passed away was with photographer Bert Stern. The images are now known as the famous "Last

Sitting" photographs. Before any of the images were published, Bert sent Marilyn some contact sheets. She took a magic marker and crossed out the ones she didn't like with an "x," including taking a hairpin and scratching the shit out of the color transparencies. Photographers take note: feedback is important. You should show people your photographs. This is a worst-case scenario.

Have I mentioned yet that Baudelaire wasn't the biggest fan of photography? The recognized poet denounced the medium as a true art form. As documented in the book *Baudelaire, Man of His Time*, he was quoted as saying, that for photography "its real purpose...is that of being the servant to the sciences and arts." And just let me couple that quote with another famous comment he made, "What is art? Prostitution." I wish I really knew what Baudelaire thought of his portrait. I'd like to think if he had his wishes, he probably would have got all hopped up on absinthe and just torched the whole fucking studio—he despised photography that much. Can you picture it?

But getting back to the photograph of Baudelaire, I am drawn to his gaze like a moth to a flame—there's no escaping it. This photograph guards our bedroom. Why the bedroom—I have no idea. It doesn't fit in with much of the other photographs that I collect; however, I just had to have it. It does fit in nicely with the Neal Rantoul double-headed calf photograph that hangs over our bed. Certain images can manifest a kind of hauntingly familiar edge—like the death stare that you'd get from your parent after you did something wrong. This one's an oddity for sure.

SHAKEN, NOT STIRRED

The main topic of this book is "photography," right? I bet you there are some people out there who are looking for the secret to success. Let's look at it a little differently: How do you craft the perfect photography cocktail? What does that mean, anyways? Some photography students have asked me: What should I do with my career...what path should I take? Some working artists have asked me: How can I increase my profile...how can you sell more of my prints? Collectors want to know: Who's hot right now? You want the truth—I have no fucking clue about any of it! All I can do is throw all of what I know in a blender and see what it tastes like, then make corrections as I go. Okay, let me give you a slightly more serious answer.

Walk into any number of local hipster cocktail bars or lounges and you'll be able to find a mixologist to whip you up a craft cocktail. These cocktails are as crafty as ice is cold—sounds like a lyric, hmmm. My crafty cocktail concoctions come with a twist of this and a squeeze of that and a stainless steel stirring straw that I'm always afraid will break one of my teeth—Alison Sheffield seems to always slap my face for saying something inappropriate when I'm right in the middle of taking a sip. My local mixologist tells me I order "girlie drinks," which is why I often end up with some blue-colored frozen drink in a ceramic Tiki glass. I can't help it. The Electric Boomerang Banana is so damn good.

The mixologist extraordinaire who's working behind that slick slab of black marble might bust out a Boston Shaker and go to town mixing up a secret potion—shake, shake, shake shake-it! Maybe they'll break out a hawthorn strainer and slap it on top of that shaker before pouring the contents into a chilled glass with one of those large, spherical ice cubes that are the size of tennis balls—you've seen 'em, they look like ice cold jaw breakers.

There are many accoutrements behind the bar—each one chosen and used to create your perfect cocktail. There is a method to the madness when creating a stiff drink. Accuracy is important—a professional drinker wants his or her specific drink; however, certain craft cocktails are known to have variations, in the quality of the liquor used and by the mixologist's skills. How do you think new and exciting mixologists make names for themselves? Are you still with me? Nurse that drink.

Photography students and emerging artists are lost souls until they find the right mentors or art dealers to lead them in a direction. There are a variety of mentors out there—even more than varieties of vodkas. Each one might change your photography cocktail just the slightest bit until you find the right one. You'll know when the right one comes along. It may not be Ciroc (P. Diddy's vodka), but it might be Dan Aykroyd's Crystal Head vodka. The advice that you get might be quick like a shot or slow like on the rocks. Advice also comes in a variety of flavors. Really? ABSOLUT-ely! Taste is important.

Emerging artists have very little know-how or drive to market and sell themselves. They're the types who buy the cheap booze at the liquor store for the quick buzz, not the taste. Without the proper introduction to quality alcohol, I mean mentors, they tend to become discouraged, and eventually their art becomes just a Holly Hobby. As a dealer, I cannot tell you what you should be doing with your career; however, I can clearly give you examples and offer suggestions on what I've seen work and what things that I've seen fail. I will guide

you away from the pitfalls as best as I can—but note, I'm not perfect... just ask my wife. You will eventually find the right taste—the right direction for you over time. You must work at it. Take advice with grain alcohol, I mean with a grain of salt—just don't take too much; you'll get drunk, I mean you'll get high blood pressure.

Artists often ask me: Why doesn't my work sell? Maybe price has something to do with it. It may also be the venue. Maybe you hired the wrong celebrity spokesperson to pimp out your brand. Did you ever consider making some adjustments to your ingredients? The bottom line is this, I exhibit the works of art that I'm passionate about in hopes that other people will be drawn to them too. Essentially it's my taste that's on the line—and I feel I have a pretty good taste in art. I have no idea what's going to sell and what people want on any given day. Each art dealer puts something different on display—some collectors might be drawn to one exhibition and not to the next. You might display one artist in the month of May and get tons of foot traffic in the gallery and a few sales, and then you exhibit the same artist in December and nothing—no sales, no foot traffic. It's a hit or miss. The economic downturn in recent years isn't helping matters either for artists or for galleries. People are not buying art the way they used to. My mantra for you is: Don't get discouraged. Keep making art. We can only hope for a turn-around. Worst-case scenario: Happy Hour, two for one prints—girls drink free.

There is no rhyme or reason or best practice behind crafting the perfect photography cocktail. You can try all different variations of artists: emerging, mid-career, and established, and you will get many levels of interest. You can come up with the greatest idea for an exhibition too, but the shows that you think are going to be popular, very little might sell. Shows that you have less personal interest in become very successful. And collectors—the same holds true in buying artwork. The artists, who are hot today, won't be tomorrow. You need to spend some time either tracking their careers or just do the

smart thing: Buy art because a) you love it or b) you're just an all-around awesome supporter of the arts. I'm a fan of both. If I were a mixologist I would mix them together and call that drink an Art Patrón. Yes—we've switched to tequila folks! It's that time of night, plus Patrón is the same spelling as Patron minus the accent mark.

"Sir, I'd like an Art Patrón on the rocks with a ton of salt on the rim, please."

"Would you like it vintage or the contemporary?"

"Oh, I'm not picky...you decide."

WELL, HELLO-HELLO

"Good Morning, afternoon, evening, or night." That's the message you'd get if you called Gustav's cell phone. He admits that he only recorded it once, the first time he got a new cell phone and never listened to the voice mail message ever again. It's kind of like when you buy a new camera, you just take it out of the box and try to make the best images possible without reading the directions—oh, that's what that button's for?

"I got a lot of shit from my friends cause my message is too long."

"I bet Gus. That's precisely why I'm going to write about it. I'm calling you out on your shit, dude!"

The phone rang in the gallery one afternoon and it was Neal Rantoul. Neal's a Boston-based photographer and former head of Northeastern University's photography department.

"J...there's this student on campus really making a name for himself. He's been creating these amazing videos, blogging—the whole nine yards. He might fit in with your plans at the gallery, or at least you can pick his brain."

"Can you find out who he is and invite him in? He sounds like a person that I'd wanna meet."

"I'm on it."

I found out that this student was a business major, thought like an entrepreneur, took a lot of photography classes and was hungry for information. His eagerness to learn reminded me so much of myself at that age. Furthermore, his business savvy and personal photography assignments that he gave himself put him in a whole different realm—mixing business with photography... how debonair.

Twenty-two-year-old Gustav Hoiland first strolled into my gallery wearing a navy blazer, V-neck red shirt, donning sunglasses, and lugging around a rather large backpack. Up close I saw he had tight skinny jeans with the right leg rolled up—a telltale sign that he rode a bicycle—and a pair of Italian pointy shoes. This kid was about 100 pounds soaking wet—a rail: tall and lanky—a cross between fashion and hipster, which also reminded me of myself at his age.

"Well, hello-hello. You must be Jason."

Gus sat down across from me and pulled out a notebook and pen. "So tell me a little about what you do," he asked. (That's a bold question to be asking, I thought to myself.) I went through the motions of what an art dealer does; however, I was more interested in his life.

The tables were turned to Gus, and he began to tell me about his blog—a daily journal of his life. His posts were self-analytical critiques of his own photographs. His self-assigned personal projects were geared toward learning about different styles of photography: action, still life, street, architecture, and so on.

For example, one series was of girls flipping their hair around during dance class. Another was capturing the precise moment a full bottle of beer smashes on the ground. Both exercises taught him how to capture and freeze motion. His newest fascination was with architectural studies. He punctuated his quest by purchasing a tilt-shift lens to learn how to control perspective. The kid also had a knack for

self-portraiture—many early photography students go through that phase at one time or another.

Besides photography, the only thing that I knew he did outside of school and photography was play bike polo. Gus is a badass beast on the bike polo court. He's even designed custom mallets and wheel protectors—look it up on YouTube.

Gus started working at the gallery with me producing videos about our exhibitions. We took him on the road to New York where he shot a mini preview of the AIPAD art fair and some studio visits with some of our artists. Soon after, I started inviting him to dinners. We'd usually go out once a week: my friend Mark, Gustav, and I. We come up with ideas, talk books, and brainstorm. Sometimes they turn out a little crazy like this:

"May I take your order?" asked the waiter.

"Yes, I'll have the black bean empanada," replied Gus.

"I'll have the chicken quesadilla, extra sour cream, no guacamole."

"And I'll have the shrimp and crawfish salad. Can you bring me a little extra dressing on the side, and I'll take a glass of water...but only with half a bucket of ice in it," says Mark. (They tend to go a little overboard on the ice at The Border.)

"Got it!"

Gus started off. "I'm finally getting my own apartment!"

"Oh yeah, where?"

"Beacon Hill. I'm moving up in the world."[14]

"Do you need some help moving?" asked Mark.

"Not really. It's a small place. I'm just looking for a nice reading chair. Maybe I'll take a trip to IKEA. I just picked up a bed off some girl on Craigslist."

"What!" said Mark.

"What? What's wrong with that?"

14 Gus has since moved.

"Haven't you ever heard of bed bugs?" I asked.

"No Gus, for real. I'll drive you to IKEA so that you can buy a bed. I don't want you sleeping on some slutty girl's jizz mattress."

"Mark, It's not like he'll be bringing any girls back to his 100 sq. ft. walk-in closet."

"Well, as a matter of fact, I have been seeing a few girls. I set up an online profile. I met a few girls from Harvard and some PhD candidate from MIT, and I'll be having coffee with some Greek chic that I met the other day when the trains weren't running."

"Okay, Gus."

"So online dating...huh. I didn't think guys your age would need to go on those sites. How much do you have to reveal about yourself," asked Mark.

"Not much. Just enough to make it sound like you're not a serial rapist," explained Gus.

"I don't even understand the whole female-male dynamic. Just earlier today, I was given dating advice from my sister-in-law who hasn't been on a date in thirty years, and now I'm taking dating advice from a twenty-four-year-old."

"Twenty-three-year-old, actually."

"Five minutes ago I was razzing you about your jizz mattress[15]—are you kidding me!"

Young folks Gus's age are dreamers—I know them, and relate to them, because I was once one of them. There may be a little part of me who also wants to hang out with them in order to feel young again. Gus is an adventurer. He doesn't dream it; he lives it. The first story that I ever heard him tell was over dinner, about taking a container ship from San Francisco to Hong Kong. No, not a plane but a container ship. Raise your hands if you know of anyone who has done that, other than your friends in the military

15 Gus eventually got a new mattress.

or Merchant Marines. That's what I figured—not a popular option to do just for fun. He spent his days walking around the ship taking photos and going through Photoshop tutorials on his computer because nobody else on the ship spoke English. That was a long twenty-eight days.

It's people like Gustav who give me hope that there are other young adults out there who are hungry to learn about the more artistic and fruitful things in life, and give advice to us old guys. Gus has been a good sounding board. I don't mind taking advice and counsel from someone sixteen years my junior, especially when what comes out of his mouth is more articulate and more thought out than I get from friends my own age. Smart people come in all ages and sizes, and some live minimalist lifestyles and sleep on skanky mattresses in wealthy neighborhoods.

Gus continues to create interesting photographs, and I have connected him to people in my circle—he's worthy. My friends and acquaintances are usually fascinated by him and his stories, or at least find him entertaining. He has earned a few jobs through these connections and started to build his own network.

I mustn't forget one other story that involves Gustav. I was planning a Polaroid-themed exhibition at the gallery and had worked out a loan from the Andy Warhol Foundation to have four of Warhol's iconic Polaroids on display in the gallery. They had told me that the images would need to be framed and matted in New York and I would also be required to have an art shipper deliver them to Boston. I explained since they were very small, couldn't we just FedEx them overnight. They refused. They said either an art shipper or I could have someone, a courier, deliver them to Boston. Gustav happened to be working for me at the gallery at the time and was in New York. I called him and he agreed to pick them up and bring them home for me. Gustav did courier them home for me that day—on the Fung Wah Bus! After all of the back and forth

bullshit that I went through, the fact of the matter is, they arrived safely, and one now sits on a shelf in my living room.

Be bold and take chances. Life is short. He is just one of a handful of people who inspire me and push me to take chances every day. By the way: I trust Gustav above many people in my life. He was a surprise addition to my Top Five.

A FOODIE IS TO FOOD LIKE
_____ IS TO PHOTOGRAPHY?

Since you're still reading this book and haven't sold it to your nearest used bookstore yet, I figured I'd throw you a bone and let you participate in the writing process of this book. I really hope that my editor can see it in her heart to leave this chapter in so that my readers can connect with me more deeply. This is how we're going to become one (without you entering one of my orifices—because that would be fucking gross and my wife would totally kick-your-ass!)

I'm in search of a word. I do not think it can be located in a dictionary or even in an urban dictionary. I'm not even sure that a word has been made up yet to describe what I'm in search of. I'm looking for an informal term to describe someone who is a know-all be-all in, yes, you guessed it, photography. You know, it's that person who knows everything that you need to know about photography and will correct you when you're wrong. I'm looking for a word to describe that someone who's more than an expert—a guru or quite possibly an aficionado of photography. They could also just be a big asshole too—but maybe not.

The first thing that might pop into your mind is *photo geek*, but that's way too generic. I want something unique—something different. We owe it to the world to come up with a new word today.

In order to find our new word, I would like, for starters, for you to look at the word *foodie*. The urban dictionary lists thirteen

results. Here's a snippet from each one (which also includes my commentary):

1. A person who spends a keen amount of attention and energy on knowing the ingredients of food, the proper preparation of food, and finds great enjoyment in top-notch ingredients and exemplary preparation. (I'm sure someone from *Merriam-Webster* wrote this.)

2. A douchebag who likes food. (My wife laughed out loud at this one!)

3. A dumbed-down term used by corporate marketing forces to infantilize and increase consumerism in an increasingly simple-minded American magazine reading audience. (Obviously an American-hater wrote this, quite possibly Kim Jong-un.)

4. A foodie is a person who loves or has a deep admiration for food and eating food. (Short and sweet)

5. Simply put a foodie is someone who loves everything there is to know or learn about food. (That's what #4 says—try again)

6. Someone really, really into food. (No shit!)

7. A person who has no actual interests or hobbies. (Very interesting, however, not sure this has been proven. We should submit it to *MythBusters*.)

8. Either a twenty-seven-year-old woman with a boob job or a gay man with a great job. Both claim to have many friends that are also foodies. They see Rachael Ray have foodgasms and expect the same from Burger King. (Thank you hipster. Great observation.)

9. A proletarian or member of the middle class who occasionally eats quality food, often of the type enjoyed by the higher classes but sometimes "exotic" food of foreign lands. (Huh?)

10. Fat kids pretentious enough to think up a special word to describe their desperate longing for anything to shove down their faces. They'll often claim to be "food enthusiasts" or to have "refined tastes," but they're usually lying. (Listen...all people are fat or overweight at one point in their lives. Go for a walk if those skinny jeans aren't fitting).

11. A foodie is someone who THINKS he or she knows something about food and the science of cooking, or even the restaurant industry, not knowing that the cook who just sent out the precious "Seared Ahi with Lemon Pepper Crotch Crickets en Crote" just got a BJ in the walk-in from your waitress. (You must've worked with Anthony Bourdain back in his heyday.)

12. Someone who has experience in the restaurant business, whether front of the house or back of the house. Only a foodie would know what the hell that meant. (Not true. I know what that means: WINK)

13. A politically correct term for a fat person. (Wrong. That would be obese, dipshit!)

Okay—that was entertaining and fun to read wasn't it? You should read the six definitions that the urban dictionary has for *photographer*. Now that we know the definitions of what a *foodie* is (at least to some people), I'd like for you, in the most creative of ways, define for me what a _____ is. That's right . _____. You're saying _____ is to photography what foodie is to food. You're penning this term right now—so own it.

What, you're having second thoughts. You don't like _____?
What the (expletive deleted) is wrong with you? We're supposed to
be partners in this. Well, if this word isn't cutting it, I hope you used
a pencil. I liked _____, but if you don't, then come up with a better
one. It's time to add _____ into our lexicon. I expect a Wikipedia
page for _____ to be up by tomorrow—got it?

You know a _____ when you see one. Besides the aforementioned
definition that I laid out for you in the second paragraph of this chap-
ter, these are the people who have all the newest photography gear
as soon as it is available on the market—yeah, those guys. I'm using
"guys" generically here to mean both men and woman, so calm down!
And let's address this "gear" thing for a second. Do you really need
new equipment every year? I'm not sure you do. Plus, chew on this—
how many of you _____ wannabee's out there are making enough
money as starving artists to buy new gear every year? You should save
your money for other things that might help your career, like paying
someone to design a better website for you. Maybe then they'll stop
calling you a _____!

You wanna know who else are _____s? Those photo vest wearing
(expletive deleted) _____s —oh snap, congrats! You just used_____
as a plural. Now we'll have to include that in the definition—quick,
notify the dictionary police! Hey _____: Why do you wear those
vests? Are you a travel photographer on assignment or on safari? I
mean, what do you put in those pockets? Most of you shoot digital
now a days and I can't see how flash memory cards take up that much
space. P.S, lose the vest. You'll never work for *Nat Geo*.

_____'s are also those people who geek out at photography lec-
tures. The ones who have to be in the front row and the ones who
are first in line afterwards at the book signing and prevent every-
one else from logging any face time with the photographer because
you've just dived into a long discussion with them. You see how

irate I am right now. I'm out of breath after reading that lengthy sentence. Yes, you are a _____—now...move your ass!

See, wasn't this a fun chapter. Reading is FUNdamental and writing is a collaborative process. Make sure you tell all of your friends and besties on Facebook about our shared moment today when you're "liking" all of their lame and boring-ass posts. Tweet about it for God's sake! I said to! P.S.S...I'm allowed to make fun of all you__ ____ (expletive deleted)'s because, I will admit, I was once one (except for the vest part. I'd never wear one of those fucking things!)

A 40TH BIRTHDAY REFLECTION

July 27th, 2012

As I woke up this morning, now in a new age bracket, I reflect on all that I have accomplished in my thirties. I would say that my biggest dreams came true.

- I moved to Boston.

- I became an uncle.

- I earned a B.F.A.

- I earned an M.F.A.

- I earned an honorary degree.

- I realized one of my biggest dreams of owning my own gallery.

- My art family grew and I met some of my closest mentors. I can't imagine not having them in my life.

- I began writing my first book.

- I've reviewed hundreds of photography portfolios.

- I've mentored a lot of really great emerging artists.

- I've interviewed and met a lot of great photographers.

- I've become a serious photography collector.

- I've become a runner (never thought this was possible). I've run more than 1,000 miles in the past three years.

- I've traveled through Europe, China, Japan, and Brazil.

- I've driven cross-country twice.

- I've had my first shot of tequila.

- I got a tattoo.

- I broke a toe.

- I lost a tooth.

- I ate my first oyster and now I'm hooked!

- I've gained weight, lost weight, gained weight, lost weight.

- I was an commencement speaker.

- I was a master of ceremonies.

- I have participated on panel discussions.

- I have given lectures.

- I have worked for a nonprofit organization.

- I have been on various boards of directors.

- I have shown my photography in galleries and museums

- I have had my work acquired by museums.

- I have had my photographs appear in magazines and newspapers.

- I have celebrated anniversaries of marriage.

- I have celebrated anniversaries of birth.

- I continue to stay married to the same person, which is somewhat of an anomaly now-a-days.

- I continue to have a potty-mouth and that is something that I refuse to change!

Onwards.

NEW YEAR'S RESOLUTIONS
ARE OVERRATED

So, let's imagine that you actually did keep a New Year's resolution for an entire year. Do you celebrate and break that resolution as soon as January 1 of the following year arrives? Or do buy yourself a gift? Or give yourself a treat? A pat on the back? I've gone out on a limb on numerous occasions and proclaimed that I would do this or I would do that for my New Year's resolution and have failed almost every time, except once.

This year I'm going back to the gym—have you heard that one before? I walk down to my local spot, sign on the dotted line and pay $50-$60 a month only to go for one or two months then quit. Now I'm stuck with some contract till the end of the year and my wife is pissed. This has happened more than once, that is, signing up for a gym membership and my wife being pissed at me. It seems like a good idea at the time. They hook you in with the "No Enrollment Fee" or "New Year's Special" or the dastardly "Shed Some of that Holiday Weight" and you join up with all of the other flunkies looking for an excuse to think thin. The treadmills are always taken when you show up and you have to wait around for one to free up. By the end of February or early March, the gym starts to get less crowded—those New Year's resolutions slowly going down the drain.

This happens with running too. I hate running—you've read about this already. I'll be out running with my friend Mark and we'll see a few people out on January 2 running around in their new shoes and gear, and then when the first sign of snow comes, no one is on the streets but us knuckleheads.

I'm going to eat healthier and lose some weight this year. I didn't say diet, cause that's not manly. Does this happen—hell no! The first day that I'm sitting around the house bored out of my mind, I'll be in the cabinets snacking on something, or off to Ben & Jerry's for a pint of chocolate peanut butter swirl. I wasn't born with a shut-off valve.

By now you're probably wondering what the resolution was that actually stuck. It was very simple, and I have to admit, it sounds goofy, but this is the truth. I made a resolution to wear colored socks, you know, adult socks—kinda like argyle socks, instead of short, black athletic socks. I was inspired to wear them after seeing photographer Keith Johnson wearing them. He said they were Paul Smith socks—some of the best in the industry. I tracked some down when my wife and I were in NYC. They felt slick—nicer than any other pair of socks that I've ever worn. The price was slick too! Thirty and forty dollars a pair!

"You're only getting one pair, J. I know you, and after about a week, you'll be back to wearing your old socks saying, Anne, these socks suck. They keep falling down. They're too thin— yadda, yadda, yadda," my wife said to me.

It's important to have the devil's advocate with you at all times especially when you are throwing around a term like New Year's resolution. I did find other brands that did the trick and weren't so expensive. Now I need to see if I can make it two years!

As I was writing this short piece, I was checking my Facebook account and someone posted a link with the title "The best New Year's resolution!" I have included it here, because I agree, it is great!

"I hope that in the year to come, you make mistakes.

Because if you are making mistakes, then you are making new things, trying new things, learning, living, pushing yourself, changing yourself, changing the world. You're doing things you've never done before, and more importantly, you're Doing Something.

So that's my wish for you, and all of us, and my wish for myself. Make New Mistakes, Make glorious, amazing mistakes. Make mistakes nobody's ever made before. Don't freeze. Don't stop. Don't worry that it isn't good enough or it isn't perfect, whatever it is: art or love or work or family or life.

Whatever it is you're scared of doing, Do it.

Make your mistakes, next year and forever."

—NEIL GAIMAN
(journal entry, December 31, 2011)

If I were going to make a few New Year's resolutions for 2013, the first one would be to finish writing this book and then come up with another one to write. You should always be challenging yourself— one way or another—put unrealistic time constraints on goals and see if you can accomplish them. When you do this, you'll surprise yourself and feel great. Anything is possible!

Happy New Year!

THE LONG WALK HOME

It's not really—the walk from the gallery to my house is about a mile—a mile of brownstones, many built in the late 1800s to early 1900s, as Boston's population tripled. It's set up along a grid that includes the East-West streets of Beacon, Marlborough, Newbury, and Boylston equally separated by Commonwealth Avenue and perfectly intersects at the cross-streets—in alphabetical order by the first letter in their name, from Arlington on down to Herford before it switches to the stately Massachusetts Avenue. They designed this area of Boston, referred to as the Back Bay, after Georges-Eugène Haussmann's urban design layout of Paris. If you've visited both cities, you'll notice a sisterly charm.

Many of these converted brownstones used to be single-family residences—owned and occupied by the early Brahmins of Boston. Now, it's a mix—from the über wealthy and upper middle class, to the sports stars and students—with most of the buildings converted to condos and pied-à-terres.

On my evening walks, I see dog walkers, strollers, skateboarders, and bikers. There are plenty of students out and about too—those who attend the art schools, music schools, Ivy-league, and state schools. I see the parents who drop their young children off at any one of the private schools in the neighborhood. And then there are

the runners, but their numbers vary depending on the weather—all budding Bill Rodgers wannabes (remember, right on Herford, left on Boylston).

On my daily route there is something else that I see, or *find* that is, and that's money. On my walks, I find money, jewelry, and other oddities. In the winter, people are so lazy. If they drop a quarter into the snow bank because it slipped out of their hands before they could plug their parking meter, they don't even dig it out. In this economy, who does that? At the first thaw, I usually find a few dollars in quarters at the base of the meters—and that's just walking a few blocks from my house.

More things that I notice—shattered glass—it litters the edge of the sidewalk where cars were broken into for God only knows what, and discarded undergarments like bras and panties. Were they were getting in the way during your walk-of-shame back to your fourth floor studio? I also find condoms, drug bags, and needles—things I wish would disappear from my neighborhood.

I walk a similar route every night when I leave the gallery. It's almost a straight shot up Commonwealth Avenue, a left on Clarendon Street, past the playground for two short blocks and then a right onto Beacon Street—two brownstones in. But every day, regardless of the direction or street that I take (unless I stroll through the tree-lined and shady Commonwealth Avenue mall to beat the summer heat), I am always peering through the curtainless windows of the houses that I pass—not in a voyeuristic, perverted way, but more an intellectual interest. I'm amazed at the purple-tinted vintage glass windows, the decorative masonry, the art, and especially the homes where I can see photographs and can recognize the artists that I have grown to love and collect. Peering into windows isn't anything new, in fact, maybe the shades aren't closed because they want people to look.

In Alfred Hitchcock's *Rear Window*, the protagonist, James Stewart, plays a photographer, Jeff Jefferies who has a broken leg. Confined

to his apartment, Jefferies sets his camera up onto a tripod and with a long focal length lens, peers into his neighbors' apartments. The mise-en-scène begins as the camera pans the interior courtyard of his apartment complex, stopping at various windows to watch the events taking place inside. Eventually the viewer sees the broken leg, then the framed photographs on the wall, and then the broken camera on the table.

From his wheelchair, Stewart along with his girlfriend, played by actress Grace Kelley, become sleuths, watching one specific apartment where Jefferies believes a husband has murdered his wife. Various clues key him into this theory. Vignettes acted out in other windows of this apartment complex carry along the plot. Some might say that this type of voyeuristic snooping can lead to preconceived notions that are created by figments of your imagination, while reality is usually the furthest from the truth. There is a word for this: scoptoma—the mind sees what it chooses to see. It's kind of like seeing Jesus in a piece of toast. Luckily for Jeffries, his hunch was correct.

If someone was peering into your window, do you think they would understand your whole story?

How I digress—I wrote a chapter about *the things I think about when I'm running*. What the hell is this chapter about? Oh I remember what I wanted you to take from this: It's in the details—details matter. I wrote this passage detailing everything about my daily walk—this is the movie set of my life. Consider this each and every time you look at a photograph or take a photograph. How many things do you see and can describe within the frame? Pan to the left, then to the right— up then down. Does it get better or worse? As a patron looking at a particular photograph in a gallery or museum, are you sucked in— will you stay for a while? Collectors want to be able to find something new in the images that they collect each time they look at them on their wall. Photographers—study your scenes like an actor. Mediocre, bland photographs are for amateurs.

Speaking of details, you should think about the things and details that you learn about the people you meet—your newest connections. Take note of what they like, dislike, their favorite place to eat, sports teams or artists. When you are able to remember these details later on and tie them into future conversations, your new acquaintances will appreciate you for it. Be genuinely interested in the people with whom you surround yourself. Your connections might become better and grow because it.

AFTERWORD

"Which one of my photographs is my favorite. The one I'm going to take tomorrow." —IMOGEN CUNNINGHAM

I remember having a conversation with someone about my aspirations for opening a photography gallery in Boston. This person told me,

"You know, you will have to kiss the ring first."

"Huh?"

In other words, I needed to somehow seek approval from the other photography dealers in the Boston area. Let me just state something for the record—this was NEVER GOING TO HAPPEN. I think the person who told me this realized this too. This is America and people are free to open and operate businesses whenever they damn well please. I do not feel that I need to walk on eggshells or apologize for anything that I've done, or said, or not said. If I have offended anyone, you know where you can find me—come in for a visit. I'm a nice person.

My wife supported me too. Her response:

"Kiss the ring—Kiss My Ass!"

The funny thing is, the very same week that I took over Panopticon Gallery, literally the first week, I received a call from the former

owner and another call from one of the artists that I represent saying that there were rumors that I was talking shit about other dealers in Boston. Well this was news to me. Hearing this, I walked over to one of the galleries owners whom I respected and had befriended years earlier and advised them of the noise that I was hearing. They told me to disregard it. They also said this is why they don't get involved with gallery politics—they just don't have time for it. I eventually disregarded the chatter and went about my business.

I had been working on a business plan to open a gallery for more than three years before actually buying Panopticon Gallery. As an undergraduate and graduate student, I would frequent galleries. I'd collect press releases and postcards and visited their websites. I'd make a list of the artists that I liked and if they were represented or not. I'd kept lists of galleries on my computer—bookmarked the good ones and made notes of the bad ones. I'd observe the galleries and their staff, both in the gallery setting and at art fairs. I took a lot of mental notes, mostly on how *not* to run a successful art gallery. My process was similar to the traditional SWOT Analysis in business—finding the Strengths, Weaknesses, Opportunities, and Threats in your industry. You could do this or read the book *The Art of War* by Sun Zhu. One way or another, you have to make your own plans and stick with them.

I remember a comment that I heard from a friend and photographer while attending ParisPhoto. She said, "You really want to open a gallery? You know it's a cut-throat industry.. That was interesting—"cut throat," I really didn't consider that saying until I began to actively collect art then operate my gallery.

When I started collecting photography, going to galleries was very discouraging at first, especially in New York City where I was rarely greeted or even acknowledged. Jeans, a shirt, and Red Sox cap wasn't the appropriate dress I guess. This deliberate avoidance is exactly what I didn't want my gallery to be like. I knew I needed to be the face of the gallery. I wanted to be able to greet as many of the patrons

who walked through the door as I could. If a photographer walked in and wanted to talk, I wanted to be able to talk (as long as I wasn't super busy). You never know who's going to walk through that door, which is why I treat each person exactly the same.

My trips to NYC are much different now because I know more of the dealers and some collectors. And the dealers I do know and love are not the ones whom I mentioned earlier. I no longer visit the galleries that won't give me the time of day, nor will I do any business with them.

A gallery is supposed to be an educational space as well as a retail space. I want everyone to feel welcomed and comfortable. I'm not sure why so many dealers and their staff have attitudes at galleries. It's almost as if they are all trained to act like pricks! I'm sure it gets tiring after a while—if you smile will you get fired? If boredom is the case, they should retire and do something else. Maybe it's their bottom line that they are worried about. In a bad economy, running a gallery isn't easy. I've watched many galleries close or move or merge just in the past few years. It's discouraging to say the least.

Artists all have egos. I know from past experience: I was once in their shoes. Their egos have to be stroked and massaged on a daily basis, because they all want something: a book published, a meeting with a curator, print sales, something written about them, an exhibition. Art dealers become their masseuse, their shrinks, their father/mother figures, and their mentors.

But let me tell you this, operating a successful gallery is not easy. It is a lot of hard work. You do not make money every day. There might be days and even weeks that pass before we sell anything. I never know what other people will relate to or want to buy. This doesn't bother me. I just keep plugging away, supporting the medium any way I know how.

I spend most of my days focusing on planning exhibitions, working with the artists that I represent and creating the buzz. Over a

basket of chips and salsa at Border Cafe in Harvard Square, the restaurant that we have dubbed our "incubator," I asked my friend Mark, "What do you think are the most important things about 'creating the buzz'?" He said:

• Brand creation

• Brand identification

• Creating the illusion of brand exclusivity

• Brand saturation

So there you have it folks, the four key ingredients—the secret formula needed to create the buzz. No matter if you are an artist trying to make it in the business or a small business owner operating a gallery, if you are able to hone in on these four key ideas and work hard at them, day in and day out, you just might succeed. I think about them every single day. What are you thinking about right now?

And for all of you photographers reading this: "Dream big. Dream big and dare to fail, I dare you." This is one of my favorite quotes, said by James Hetfield, the lead singer of Metallica, as he was accepted into the Rock & Roll Hall of Fame. Emerging artists: eat, sleep and breathe this in. The actual quote came from Norman D. Vaughn, an American dog sled racer, born in Salem, Massachusetts who participated in Admiral Byrd's first expedition to the South Pole.

There's a long road ahead for you if you want to make it in this world as a fine art photographer. You have to be able to work autonomously every day on your craft without worrying what lies ahead. If you work hard, and your craft is good, you will eventually get recognized and you might just make a good living at it.

I have represented artists that make a full-time living off of their photography, and others that have to work different jobs to make ends meet. Stay focused!

This life of an artist is not guaranteed. There is no guarantee you will be a success. And what constitutes success? How much money you make, how many prints that you sell? Who decides who is successful and who is not? The only person who can judge this is you.

Continue on your path, to the beat of your own drummer. Don't let anyone tell you that you can't do something. "No" is such a shitty word. If you think, "Yes I can," you'll prove them wrong! Find your art family, have mentors and heroes, travel, read a lot, and what you read doesn't have to be art related. Some of the greatest advice that I received came from photographer Frank Gohlke. He said that when you are in college you will have a lot of art and theory reading suggestions. You will learn just as much by picking up and reading a good piece of literature. In between the theory books, slip in one book that may open up something else in your mind—and I did just that.

His suggestion helped me tremendously throughout graduate school to tackle too many theory books to even mention! Take a lot notes, have an inspiration wall, watch documentaries and TED talks, stay away from reality TV crapola and any outside distractions that can deter you from following your dreams. Feel free to send me updates in the mail. Postcards, prints and books are like study materials for me.

I had a few goals in mind when I left the corporate world behind: finish my degrees, open a gallery, write a book, and work in academia. All of these goals have come true in a very short time. Make connections and see what becomes of it. Your connections may just open an unexpected door for you.

ACKNOWLEDGMENTS

I have been privileged and blessed to be able to meet, work for, study under, interview, and attend lectures by many artists and photographers including: Jerry Uelsmann, Abelardo Morell, Vik Muniz, Tina Barney, Nicholas Nixon, Laura McPhee, Ralph Gibson, Chuck Close, Emmet Gowin, Harold Feinstein, William Christenberry, Kenro Izu, Keith Carter, Barbara Bosworth, Frank Gohlke, Steve Tourlentes, Thomas Roma, Roger Ballen, Michael A. Smith, Paula Chamlee, Larry Fink, Henry Horenstein, Arno Rafael Minkkinen, Eirik Johnson, Jane Tuckerman, Christopher James, John Reuter, Brian Doan, Yoav Horesh, Roswell Angier, David Levinthal, William Wegman, Julie Blackmon, Eugene Richards, Mary Ellen Mark and Larry Sultan.

To the artists that have adorned the walls of my gallery and home: Thank you!

Everything that I learned about socks, I learned from photographer Keith Johnson.

To Fitts and Keough. You guys got chapters. Isn't that enough?

To the gallery assistants who have helped me from the beginning (and put up with a lot of my shit): Greer Muldowney, Elizabeth Ellenwood, Gustav Hoiland, Marianne Salza, Alexa Torre, and Allison Smith.

To the collectors who have supported the gallery and our artists and who I have learned a thing or two from. Merci!

To John Kramer. I promise to use the correct typeface in the future.

For Thelma D. Thanks for all of the encouraging words.

For my parents: I guess I turned out OK, huh.

For my niece Nora: It's an absolute joy to watch you grow up. You are amazing! I'm glad that your parents introduced you to the arts early in your life.

None of this would have been possible without my amazing editor Debbie Hagan who pushed me to go deeper and make sure each chapter had its purpose, and for giving me hundreds of track changes to fix. Thanks for sticking with me.

For my wife Anne DeVito: I'll always be your little boy. You've sacrificed the world for me. Someday there will be a return on your investment!

ABOUT THE AUTHOR

Born in 1972 in Everett, Massachusetts, the eldest child to James and Carol. I am convinced that I was conceived on their honeymoon in Canada (I counted the months to figure this one out). Maybe I should apply for dual-citizenship!

They brought me home in a cardboard box from the hospital. When I was very young, I ate a bee off of the windowsill at a doctor's office one afternoon—they pumped my stomach. Ate some of my grandmother's Valium one afternoon, passed out on the kitchen floor—more stomach pumping. I think my aunt even accidentally popped my arms out of the socket once playing patty cake. Fuck! I'm surprised no one called DSS.

Sooner or later I was flinging my shoes out the window of my parent's Volkswagen—those little buggers must've hurt. I watched my grandfather shaving and thought it was a good idea, sliced both my lips in half—still have the scar to prove it. As soon as I began to walk and talk, to the department stores we would go. I would hide in between the clothing racks and sing "Fuck You" in Italian slang and my mother couldn't find me.

Fun-gu-lo
Fun-gu-lo!
I've been a potty mouth from way back!

I was a terror! My aunt and uncle said I was the best form of birth control. Is that a compliment? These stories get recounted at all of our family gatherings. The funny thing is, I hardly remember any of them. It's only when someone breaks out the photo albums and we see the photographs do I have any remembrance at all. As I had lunch at my grandmother's one Sunday, my uncle Bobby Big pointed to a picture on their refrigerator of me as a child and said, "We bathed you in that sink right there," (pointing to my grandmother's kitchen sink). Early photographs don't lie—they help uncover the truth of who you are, and have helped my memory quite a bit—so has writing this book.

My parents moved us from Everett, Massachusetts, to Greenland, New Hampshire, where I attended grade and middle school then it was off to Portsmouth High School. I dated a few wonderful girls, went to a lot of metal concerts, and drove around in a souped-up station wagon that my friends dubbed Wonda-cah—the same car that I drove on the beach one Easter Sunday and got stuck. Upgraded my wheels to a hand-me-down 1981 Chevrolet pickup truck courtesy of my Uncle Joey. Dropped a 350 V-8 and headers in that puppy and it used to make car alarms go off when I revved the engine—that truck came with the nickname:

Big Blue. I still keep in touch with a handful of high school friends. They know who they are. The rest seem to pop up now and then on Facebook.

I spent a few years in the business world (which seems like a lifetime ago). Married my soul mate Anne. We've traveled the world. We live in a small penthouse with 360-degree views of Boston. We own a gallery—not a bad life.

But when were talking about life, photography has been my life for the last twenty years. Now, I spend almost every waking minute reading about it, writing about it, learning about it, looking at it. Besides photography, I try to spend as much time with my wife as I can, but she'd rather me not. Her famous last words are usually, "Jason, phone a friend." Ever since I bought her an iPad, she'd rather curl up in bed with the thing and find some series to watch on Netflix. Even the dog would rather hang out with her.

I started running a few years ago with my buddy Mark. I hate running so much. The only reason I do it is because, as I've gotten older, I'm starting to feel my age. Running is also free: it doesn't cost anything—no monthly fee. Did I already say that I hate it? Getting old sucks! My wife thinks she'll be 39 Forever—it's been her mantra. Some days I feel like I'm in my twenties, and other days I'm waiting for someone to euthanize me. My wife says I act like I'm twelve—I'm not sure if this is a good or bad thing.

When I'm at home, if I'm not reading or writing or aggravating my wife, I like to listen to loud music! I'm a metal head from way back. Get me in a car with a little Metallica blasting through my speakers and I'll scream every song:

Oooooh!

Yeaaah!

James Hetfield always includes a few of those at the end of some of his lyrics. The steering wheel became my drum set—Lars, you should

see me! I'm pretty certain if you ask any girl that I have ever dated, as well as my wife, they will confirm this wonderful behavior.

In 2011, I started to concentrate on reading and writing more and most everything else took a backseat. I hope it has paid off.

THANKS FOR READING MY BOOK

Are you feeling inspired now? Enlightened? Informed? Did I tickle your funny bone? If so, do tell. You can find me on Twitter: @lanrod or through the gallery @PanoptGallery.

If you feel so inclined, write a customer review about this book on Amazon.com. If you liked it, use your real name. If not so much, use your real name anyways.

#InstantConnections

TYPEFACE

This book was set in the typeface Garamond, named after the Parisian type cutter Claude Garamond (1480-1561). It is recognized as being one of the most legible and readable serif typefaces.